Room for Wonder

Indian Painting during the British Period 1760-1880

Room for Wonder

Indian Painting during the British Period 1760-1880

by Stuart Cary Welch

The American Federation of Arts

Distributed by

RIZZOLI INTERNATIONAL PUBLICATIONS, INC.

© 1978 The American Federation of Arts
Published by The American Federation of Arts
Trade edition distributed by

Rizzoli INTERNATIONAL PUBLICATIONS, INC.
712 Fifth Avenue/New York 10019

All rights reserved.
No parts of this book may be
reproduced in any manner whatsoever
without permission of
Rizzoli International Publications, Inc.
Library of Congress Catalog Card Number 78-50093
ISBN 0-8478-0176-4
Designed by Michael Shroyer
Type set by Haber Typographers, Inc., New York
Printed by W.M. Brown & Son, Richmond, Virginia

Lenders to the Exhibition

This exhibition and publication have been supported by
grants from the JDR 3rd Fund, the National Endowment
for the Arts and special funds from the National Patrons
of The American Federation of Arts.

For Mildred and W. G. Archer

Contents

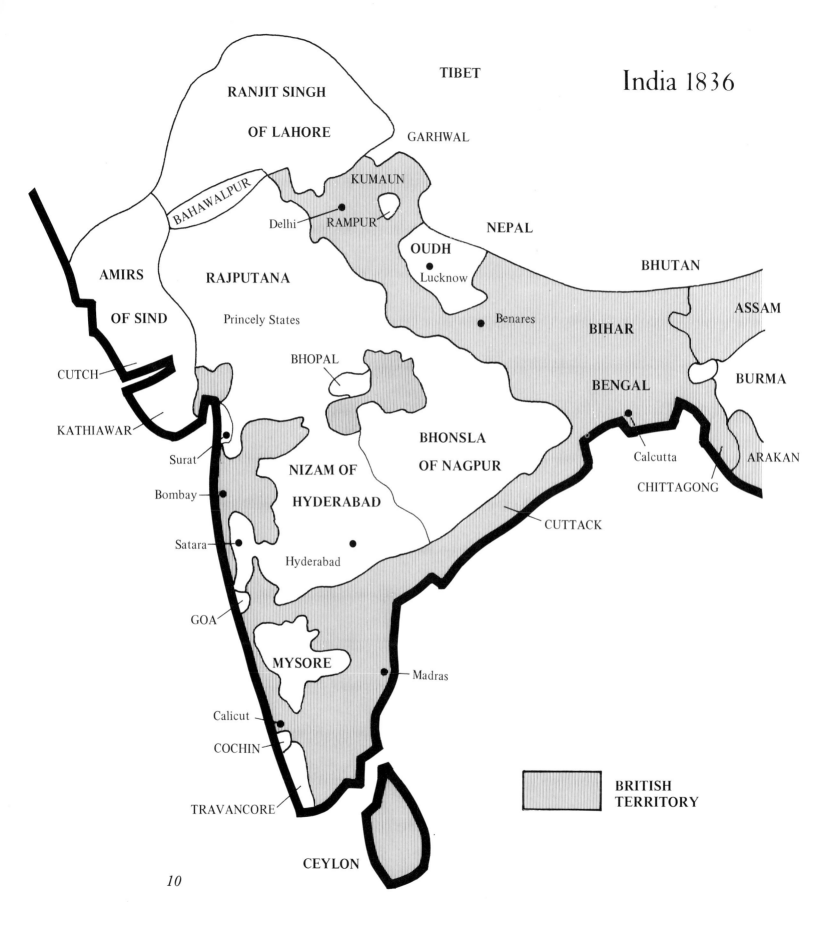

India 1836

TIBET

RANJIT SINGH

OF LAHORE

GARHWAL

KUMAUN

BAHAWALPUR

Delhi

RAMPUR

NEPAL

AMIRS

OF SIND

RAJPUTANA

OUDH

Lucknow

BHUTAN

ASSAM

BIHAR

Benares

BURMA

Princely States

BENGAL

CUTCH

BHOPAL

KATHIAWAR

Calcutta

ARAKAN

Surat

BHONSLA

OF NAGPUR

CHITTAGONG

NIZAM OF

Bombay

HYDERABAD

CUTTACK

Satara

GOA

Hyderabad

MYSORE

Madras

Calicut

COCHIN

TRAVANCORE

CEYLON

BRITISH
TERRITORY

10

I had never before seen the countries of warm temper-
ature, nor the country of Hindustan. Immediately on
reaching them I beheld a new world. The grass was dif-
ferent, the trees different, the wild animals of a different
sort, the birds of a different plumage, the manners and
customs of the wandering tribes of a different kind. I was
struck with astonishment, and indeed there was *Room for
Wonder.*

Memoirs of Babur, the First Mughal Emperor
(1526-1530), for the year 1504

Seeing an English amateur painter at work, an Indian
gentleman approached him, "Why, sir," he asked, "are
you doing that? Could you not employ some Indian to do
it for you better?" Although many sahibs and memsahibs
painted their own pictures (and a few were extremely tal-
ented), most took the view of the Indian gentleman. This
exhibition and catalogue are devoted to the pictures they
commissioned, and to others made for Indians under their
influence.

Foreword

British India was one of the grandest imperial experiments in world history. Long lasting, lucrative, intricately complex, involving vast populations, and lingering in its after effects, it earned the British a mixed reputation for compassion and toughness, efficiency and hopeless muddling-through. When colonialism was still respectable, prior to World War II, most Englishmen took pride in the Indian Empire, boasting of it as the central jewel of their crown. In a world that sees colonialism as wicked aggression, many of them now join the chorus deploring it, although some simultaneously look back upon the Raj with longing nostalgia. As an American at once Indophile and Anglophile, I try to see India's British period as neither its proudest nor bleakest years, as an unavoidable meeting between East and West. If, at times, I am horrified by English rapacity and duplicity, I also realize that many exceptional Englishmen loved India and Indians and served them devotedly. Philip Woodruff in his excellent study *The Men Who Ruled India: The Guardians* ([New York, 1954], p. 349) describes a significant change of attitude:

> Soon after the Kaiser's War, a brigand made himself famous throughout the United Provinces and far into Behar and the Punjab. His name was Sultana Daku; he was so much feared that at one time men in a lonely police-station would turn out and present arms when he went by. He left few women unviolated and no man alive to give evidence against him in the villages he raided. He was feared and hated; in the end, he was hunted down and caught by a policeman whom everyone knew as Freddy Young. There was a play *Sultana Daku*, a favourite at fairs all through Northern India, in which at first Freddy Young was the avenging hero and the crowd cheered when the villainous Sultana was brought to book. But as the play was repeated—it was probably never printed—and as the memory of the real Sultana grew fainter, gradually year by year the parts were reversed, until Sultana was the hero, a gallant Robin Hood who befriended the poor and robbed the English, while Freddy Young became the comic villain, fat and cowardly, continually calling for whisky.

Approaching the imperial colossus through one hundred or so pictures spanning not many more years might seem a ludicrous ambition, comparable to representing contemporary England by a few walls of paintings from the Tate Gallery. We believe, however, that the miniatures and sketches assembled here offer vivid insights to wondrous times. They sparkle with intriguing people and places. Perhaps because India is so geographically remote and so different from the West, she invariably has attracted people more intense and curious than most voyagers. Through these pictures and accompanying words, we meet many of them, along with Indian counterparts who are no less extraordinary.

While most of the pictures were made for Englishmen and other foreigners, all were painted by Indian artists, circumstances that imbue them with both the foreigner's open-eyed taste for the picturesque and the native's deeper understanding. Seeing them excites in us almost as many responses as a trip to India. Some are ludicrously comical, others disturbing, baffling, or horrific. Many refresh us with their beauty.

To assist an American audience unfamiliar with the formidable convolutions of Indian history, we have written a brief introduction, notes on each picture, and a chronology. Although some readers will want to progress through all this page by page, the less systematic approach of letting one's eyes lead the way, using the Chronology as a framework to consult when necessary, might be more enjoyable.

Had it not been for Mildred and W. G. Archer, who had lived and worked in India under the Raj from 1931 to 1948, we might not have had the opportunity of seeing this material, for they were among the first to recognize it as a meaningful and worthwile category of Indian painting. During their years of subsequent service in England (she in the India Office Library, he in the Victoria and Albert Museum—institutions which possessed large but previously unrecognized collections of such paintings), both kept lively eyes peeled in the auction sale rooms and dealers' establishments. They snapped up (for the proverbial "song" or in their case duet) additional pictures for their institutions. While W. G. Archer acquired excellent examples for the "V & A," Mildred Archer's discerning enthusiasm built up the India Office Library's holding into the foremost collection of pictures painted for the British in India during the years of the East India Company. Without many generous loans from both organizations as well as from the Archer family, this exhibition would be far less representative and appealing.

While gathering pictures, Mildred Archer also classified them by centers and produced a comprehensive corpus of publications in her field. Solidly informative, attractively illustrated, her books and articles (see Bibliography) are enlivened by enthusiasm and wit. Those who find this subject stimulating can look forward to the pleasure of her writings, to which the present author is greatly indebted. Without the generous assistance and encouragement of both Archers, I should not have dared venture into what I consider *their* territory. Fortunately they are most hospitable doyens in this enchanted preserve, to which they not only welcomed me but also provided maps, letters of advice, frequent personal tours, and an assortment of guide books. If, not withstanding all these, I got lost, I am wholly to blame.

Others who have helped in this rewarding exploration are: in this country, Wilder Green, Allen Wardwell, Porter McCray, Richard Lanier, Jane Tai, Sarah Bradley, Annemarie Schimmel, John Rosenfield, Pramod Chandra, R. A. Howard, Jane Watts, Marjorie Cohn, Wheeler Thackston, Brian Silver, Sheila Canby, Jitendra Sinh of Wankaner, Terence McInerney, Doris Wiener, and Mildred Frost; in England, Joan Lancaster, Robert Mackworth-Young, Robert Skelton, Betty Tyers, Laurence Impey, H. Clifford Maggs, Giles Eyre, Niall Hobhouse, Pauline Rohatgi, and Toby Falk; and in India, Pranabranjan Ray.

Stuart Cary Welch

Introduction

The British in India

Visitors in another man's land, few Britishers went to India to stay. While there, they fared as best they could, usually meaning in the closest approximation to English life, but with more amenities and servants (no. 22). Any and all such consolations were desirable, if not essential. Living in India was hard on Europeans, who suffered from loneliness in a land twenty times the size of Great Britain, with six hundred native states and 222 vernaculars as well as 14 major languages. It was also dangerous. Fear of illness and death was omnipresent, if seldom mentioned. Poisonous snakes and insects might strike suddenly, in one's tent, or hiding in a boot. Until the days of modern medicines, every "griffin" (new arrival) paled or giggled nervously at stories of predecessors in abundant good health who suddenly expired, moments after munching a bit of fruit or drinking a glass of water. Reading the dates in Calcutta's Park Street Cemetery, now a dense forest of eroded obelisks and mausolea, underscores how many died within a season or two of coming out. Only the hardiest survived, proof not only against the *mort-de-chien* (cholera) but against current European medical techniques, such as bleeding, cupping, or drowning fevers with wine. Those too strong to die could look forward to gentler miseries: the Biskra Button, Aleppo Evil, Multan Sore, or Delhi Boil.

Although tigers usually restricted their diets to villagers, the continuing wars did not. Well into the nineteenth century, these provided hair-raising challenges for brave young Englishmen, who might otherwise have lived longer if drabber lives back home. The bitterest anti-colonials must grant the British their "pluck." Compatriots were heartened by such heroes as Sargeant Strange of the Maratha Wars, who saved the life of an officer, "but in the act was himself speared through the lungs....[When the officer] begged the serjeant to fall in the rear,...he gallantly refused, and rode out the day. Captain Sale and others afterwards saw him, when in the hospital, blow out a candle from his lungs. The reader will be pleased to learn that the gallant serjeant recovered." (James Grant Duff, *A History of the Mahrattas,* ed. J. P. Guha [Delhi, 1971], vol. II, p. 473)

More discouraging than the horrors of disease and war were the minor but constant irritations. Brought up in a comparatively cool, even climate, Britishers had to adjust to India's extremes. Letters home repeated such phrases as "too hot to sleep," "perpetual sweat," and complaints about "sickening, sour smell of the *khas-khas-tatti,*" the grass screen of a thermantidote, kept damp to cool the air fanned through it. Only a few months of the year provided "good English weather," times for English activities: picnics, cricket, riding to hounds, flower and dog shows, and church fetes.

Why did they go? For trade? Out of curiosity and adventurousness? The move began during the late sixteenth century, a period of maritime expansion. The Portuguese and Dutch had greatly profited from the East Indian spice trade; and after the British had triumphed over the Spanish Armada in 1588, they further

flexed their muscles by pushing eastwards. In 1600, Queen Elizabeth chartered the East India Company; and by 1611 a trading factory had been established at Masulipatam to deal in textiles. In 1640, the English acquired a site at what is now Madras, and soon they built Fort St. George. In 1661, they were given Bombay, as part of the dowry of Catherine of Braganza when she married King Charles II. Gradually, trading stations developed into governments. In 1687, Madras was chartered as a Municipal Corporation, with a mayor's court; and by 1701, the English governor of Calcutta felt strong enough to prohibit the sailing of Mughal ships. Slowly and somewhat haphazardly, the British who had come to India as merchants were becoming politically and militarily more powerful than the Mughals, whose empire had been the mightiest in India since the sixteenth century. By 1757, when Robert Clive defeated the weak Mughal governor of Bengal and set up a more cooperative one in his place, the English had asserted their supremacy in one of the richest Mughal provinces.

Although the Mughals lingered as a nominal power until the last emperor, Bahadur Shah II (no. 52), was exiled to Burma in the aftermath of the Mutiny of 1857, their political and military effectiveness had begun to decline as early as the mid-seventeenth century. During the reign of Aurangzeb (1657-1707), their empire had reached its peak of wealth and magnitude; but the emperor's extreme Muslim orthodoxy, offensive to the large and essentially Hindu population, along with his aggressive expansionist policy, had sorely weakened the Mughals by the time of his death. Powerful and bitter rivals such as the Marathas gained strength during his reign. These horsemen and warriors from Maharashtra, whose guerrilla tactics earned them the most powerful role in the weakening Mughal territories, menaced much of northern India until they were finally brought down by the British in 1818.

With the defeat of the Marathas and domination over the Mughals, the British were well-nigh in control of India by 1820. Under the governor-general in Calcutta, and with major centers at Madras, Bombay, Delhi, and elsewhere, they had built up an effective civil service as well as powerful armies, composed largely of Indian soldiers (sepoys) led by British officers. India, however, is bafflingly vast and her people mystifyingly independent of spirit as well as confusingly varied. No sooner does a government *seem* in total command than the tables are turned. Guileless and seemingly simple, the typical village Indian, who may not even know the name of his ruler, will not tolerate being pushed too far. He is intuitively wise, hardy, and conservative; and in the last analysis, the power rests in his hands.

After 1820, the British in India seemed in the position to tune the fine machine of their government. A cadre of professional, excellently trained administrators, spreading from Calcutta to other cities and the hinterlands, increasingly exerted its authority. Much of the time, the sordid aspects of colonialism were tempered, or even cast aside, by higher motives. A large proportion of the magistrates, collectors, and other civil servants were truly devoted to India and Indians; and if major policies had rested in their hands, British Indian history might well read very differently and more happily. Unfortunately, less intimately aware officials set the policies, which too often collided with Indian ways. Victorian missionary zeal, for instance, however noble its

aspirations, alienated Hindus, Muslims, and other Indian religious communities. Tensions were increased by British insistence upon Westernization and modernism, which often ran counter to deeply rooted traditions. Such acts as suttee, in which loving widows sacrificed themselves on their husbands' funeral pyres, were as appalling to Europeans as they were glorious to most orthodox Hindus; and when the British tried firmly to outlaw the practice, they embittered many Indians. Frequently, their nobler causes, as for instance supporting the peasantry at the expense of the great landowners, only widened the rift.

The increasing isolation of Englishmen was another cause of trouble. While the outgoing, hot-blooded British merchants and soldiers of the eighteenth century mingled freely with local people, enjoying their food and often partaking of their ways, too often their Victorian successors were standoffish or even contemptuous of Indians. As British life in India became more prosperous and settled, institutions such as clubs were founded, which excluded natives. By the 1830's, few Britishers in India took an interest in oriental languages or culture, a far cry from the days of Warren Hastings (governor-general 1774-1785), who encouraged such studies and pursued them himself. As their remoteness from Indians increased, the Britisher's position in India weakened. Although the Mutiny of 1857 caught most Englishmen off-guard, it is clear in retrospect that such an outbreak was overdue.

Indian Painting and the British

Since ancient times, India has been freely receptive to foreign artistic ideas; but like insects enticed by the venus flytrap, after being received with disarming ease, they have been consumed, leaving few traces. Gandharan art, which began so markedly Greco-Roman in idiom, exemplifies this process in ancient times, for like all other foreign styles, it was soon Indianized. Naturalistic and slightly dry in its early stages, with true-to-life figures set in believable landscapes, it was soon transformed by indigenous sculptors, who added sensuousness and spirituality by abstracting its realistic earthy forms. Bosoms and hips were amplified, waists narrowed, and eyes were sinuously attenuated and turned up at the corners, becoming metaphors for peepul leaves. Formerly explicit architectural and landscape backgrounds yielded to less specific, far lusher and usually symbolic surroundings through which pulsed vital rhythms.

Later artistic imports received, and still receive, comparable graceful reception, followed by total Indianization. Soon after Vasco da Gama's discovery of the sea route to India, and the establishment of Portuguese trading posts, European art was transported to India in ever larger quantities. And, as always, it was accepted with open arms. Eager missionaries as well as merchants, the Portuguese brought Christian religious pictures and objects with them; and while these were of little artistic merit, their exoticism intrigued prospective Indian converts. Such Muslim rulers as the Mughal emperor Akbar (r. 1556-1605) and his rivals, the Sultans of Bijapur and Golconda in the Deccan, seem to have been far more receptive to Christian art than were the Hindus, in whose paintings such influences have not been found. Perhaps because Christians and Muslims were people

fig. 1 Madonna and Child, Mughal, ca. 1575, Private collection

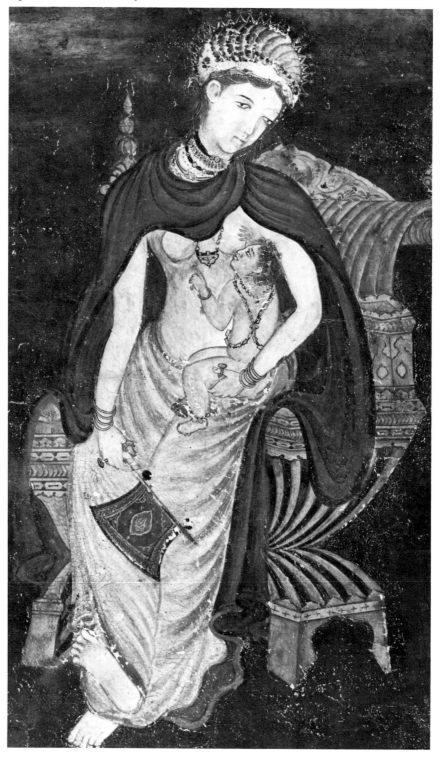

of the book, and because Christ was revered by Muslims as a lesser prophet, Muslims welcomed Christian missionaries along with their images. Seriously interested in religions of all sorts, Akbar sponsored and participated in night-long discussions of the meaning and relative merits of all faiths and sects. Christianity and Christians strongly appealed to him, and he invited missionaries from Goa to his court at Fatehpur Sikri.

Their influence can be seen in one of the earliest Christian subjects painted for Akbar, a "Madonna and Child" of about 1575 (fig. 1), which is very similar to a faintly discernible wall painting at Akbar's capital. The original Christian image must have been archaistically Byzantine, as can be seen from the poses, drapery, and throne-like chair. But Akbar's artist, working in the emperor's newly synthesized style, based upon Persian and indigenous elements, has revealed his Hindu background by interpreting the infant Christ as a pink-skinned Krishna; and the Virgin Mary is decked out in Indian jewelry, including a mirror-ring. Her throne is decorated with Indian motifs, and she holds a characteristically Indian fan—perhaps at the suggestion of Akbar himself, in the thought that Europeans' gods suffered in the Indian heat as much as their worshippers. How quickly the Indian artist "digested" this imported tidbit!

Several missions from Goa went to the courts of Akbar and of his son Jahangir (r. 1605-1627), ever optimistic of achieving imperial conversions, the keys to converting all of India. While this grandiose scheme failed, and Jesuits were denied access to Akbar's deathbed, their offerings of Christian art whetted artistic appetites. Both Akbar and his even more aesthetically and connoisseurly-minded son admired and collected European prints and other works of art, which were copied and emulated by Mughal artists and designers. Jahangir's magnificent albums included actual European prints and small paintings along with Mughal copies of them. All were set in sumptuous tinted borders, some of which were adorned with crucifixions, saints, and other borrowed motifs, drawn in light-catching shades of gold. More significant than these copies, however, was the influence of European art upon the development of Mughal painting. Probably because of their ingrained love of nature, the Mughal emperors were drawn to European art, and Mughal artists were encouraged to learn from the imported pictures. Abu'l Hasan, a brilliantly talented artist brought up under Jahangir's watchful and encouraging eye, made a masterful copy of a Dürer print when he was a lad of thirteen. (See: Leigh Ashton, ed., *The Art of India and Pakistan* [London, 1950], no. 665, pl. 128)

One of the most renowned episodes in Anglo-Indian artistic relations occurred during the visit of Sir Thomas Roe, the English diplomat, who was at the court of Jahangir between 1615 and 1619. He brought with him an English miniature, which the emperor so admired that he ordered his artists to make copies and boasted that Sir Thomas would be unable to discern them from the original. Although Roe claims to have been shown the pictures in dim light, the Mughal artists triumphed, at which the delighted Jahangir "craked like a Northern man," (a reference critical of the Scottish). (Thomas Roe, *The Embassy of Sir Thomas Roe to the Court of The Great Mogul,* ed. William Foster, [London, 1926], vol. I, p. 225)

If Mughal artists were strongly influenced by the European works of art they so assiduously copied and borrowed from, they were extremely selective as to which elements they chose. Akbar's artists eagerly partook of European landscapes, following their example in depicting distant towns set on craggy hills, winding

roads, and spatially convincing overlaps of form. By 1595, they had mastered many elements of aerial perspective, including the blueing of remote hills and fields. Another European idea adopted at once, perhaps because it was consistent with the Indian genius for sculpture, was the modeling of figures with brushstrokes suggestive of roundness. Scientific perspective, however, was seldom attempted by Mughal artists, who were disinclined—or unable—to grasp its principles. During the reign of Shah Jahan (1627-1657), however, vanishing-point and atmospheric perspective were effectively employed by progressive court artists. The best example is found in the marvelous illustrated history of the emperor's own reign, the *Shah Jahan-nama,* now in the Windsor Castle Library. "Prince Aurangzeb Spearing an Enraged Elephant" (folio 133 recto; fig. 2) is more successful than any other Mughal picture in depicting vast, flat fields and distant buildings. If we compare this picture to the eighteenth-century "Heavenly Palaces and Gardens" (no. 33 with its dozens of bounding, unnerving vanishing points, it is apparent that the Mughal artistic tradition had regressed in terms of subtlety, intellectuality, and technique—a regression paralleling the empire's political decline.

Although several of the finest and liveliest seventeenth-century Mughal miniatures were painted for Shah Jahan's son Aurangzeb (r. 1657-1707), during the years immediately following his seizure of his father's throne, his increasing religious orthodoxy led to a puritanical distaste for the arts. Patronage was withdrawn from music, dance, and painting; and as a result, the artists sought employment elsewhere. A few remained in Delhi, working for lesser courts, while others migrated to Rajasthan and Central India, where they were welcomed by Muslim nobles and Rajput princes, all of whom had admired, even envied, the masterpieces of the imperial ateliers. Patrons at Aurangabad, the center of Mughal power in the Deccan during Aurangzeb's ill-advised campaigns against Golconda and Bijapur, also provided work.

During the late seventeenth century, the imperial style spread from Agra and Delhi to remote districts, where its exponents, stimulated by new and eager patrons, developed fresh and often exciting variants of the classical Mughal style. These were further enriched by the spread of Deccani artists, many of whom also found work at Rajput courts after Aurangzeb's defeat of the Sultanates of Bijapur and Golconda. Their masterful styles, synthesized from Persian and indigenous traditions over the centuries, lent opulence and strikingly original palettes with much violet and rose pink to the ever busier workshops of Rajasthan, Central India, and even the distant Punjab Hills. A century or so later, by 1820, when the British had gained supremacy over India's hinterlands, artists trained in these new blends of Rajput, Mughal, and Deccani styles contributed their zest to the chapter of Indian art encompassed by this exhibition.

Although the Mughal Empire floundered for a century and a half after Aurangzeb's death in 1707, a few of the emperors were enthusiastic patrons. Muhammad Shah (r. 1719-1748) greatly liked music, poetry, and painting; and while his reign was marked by political and military disasters (see Chronology), it saw a revival of painting. His pictures are sharply focused and hard edged, with bright, enamel-like pigments and rich displays of classical Mughal ornament. But the faces are blank as masks, as though the sitters were in shock, or

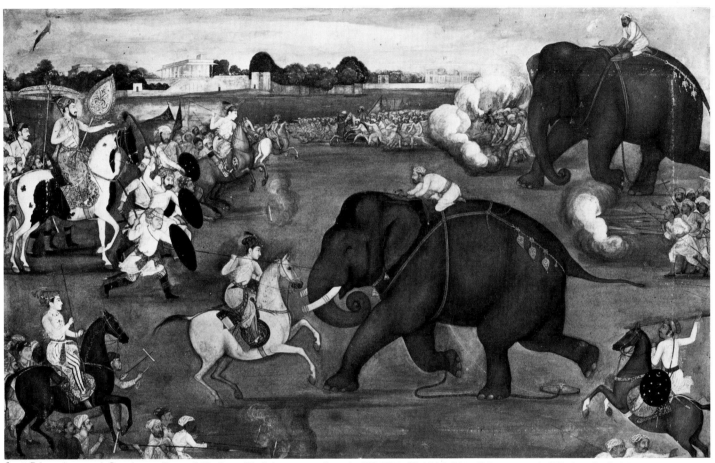

fig. 2 Prince Aurangzeb Spearing an Enraged Elephant, Mughal, ca. 1635, from the SHAH JAHAN-NAMA, (folio 133 recto), Windsor Castle Library, by gracious permission of Her Majesty Queen Elizabeth II

dared not express their justifiable miseries. A few of these invariably attractive miniatures are poetic and poignant evocations of the empire's sad, slow decline; and all are technically masterful.

Early in his reign, Muhammad Shah seems to have hired talented descendants of the great Mughal masters forced to leave the imperial ateliers during Aurangzeb's rule, but later on he lost most of them to other patrons. Many went to the courts of Oudh, Bengal, and the Deccan, hired away by his own governors, who became increasingly independent as the central authority weakened.

We have now reached the period documented by this exhibition, a time when the imperial style of Muhammad Shah's court had spread to Bengal, where new foreign patrons—the British—were on the verge of playing an active role in Indian art. Although isolated examples of Indian painting for the British prior to the 1760's might turn up, it was not until British power had gained stability, following Clive's victory at Plassey in 1757, that the British really counted as patrons.

While Bengal was not the only center of Indo-British painting at this time, circumstances favored its flowering there. By happy coincidence, Mughal and British taste in painting coincided to a remarkable degree. Both not only shared a penchant for true-to-life naturalism, but also preferred portraiture to all other subjects. Moreover, much British painting back home was almost identical to Mughal in technique: opaque watercolor or gouache on paper. Nothing could have been more natural, therefore, once they had seen the work of Indian painters at such provincial Mughal centers as Murshidabad, than for Company servants like William Fullarton to have commissioned portraits (no. 1). Looking somewhat amused by his native surroundings, hubbly-bubbly water-pipe (hookah), and attendants, Mr. Fullarton only differs from a "Grand Mogul" in his pink pallor, costume, and awkwardly undignified posture, evocative of the uncomfortable gyrations of recent European and American visitors when trying to sit on the floor, cross-legged in Indian style.

Having discovered the delights of hiring Indian artists, who were as talented and obliging as they were plentiful, English patrons soon thought up many tasks for them. Although portraiture was probably the earliest subject assigned to them, others soon followed, from both private and official sources. The world over, natives are less curious than foreigners; and the British propensities for exploration and documentation are as noticeable today as in eighteenth-century India. Soon, their inquisitiveness and collectomania were rewarded by the growth of a new idiom of Indian painting, usually known as Company School, after the East India Company, whose employees were its first and most significant patrons. (We have avoided this term, however, as it seems too restrictive for our exhibition which includes pictures made for Indian and French patrons as well as for Britishers.)

Many of the British were fascinated by India and its inhabitants; and although some of them were able draftsmen themselves, brought up in a culture where limning and watercoloring were taught as polite accomplishments, they employed native artists to record the picturesque. Views of ancient monuments, likenesses of famous Indian personages, such as the Mughal emperors, and sets of pictures portraying native castes, cos-

fig. 3 Lady Impey Supervising Her Household, Calcutta, perhaps by Shaykh Zayn-al-Din of Patna, Laurence Impey Collection

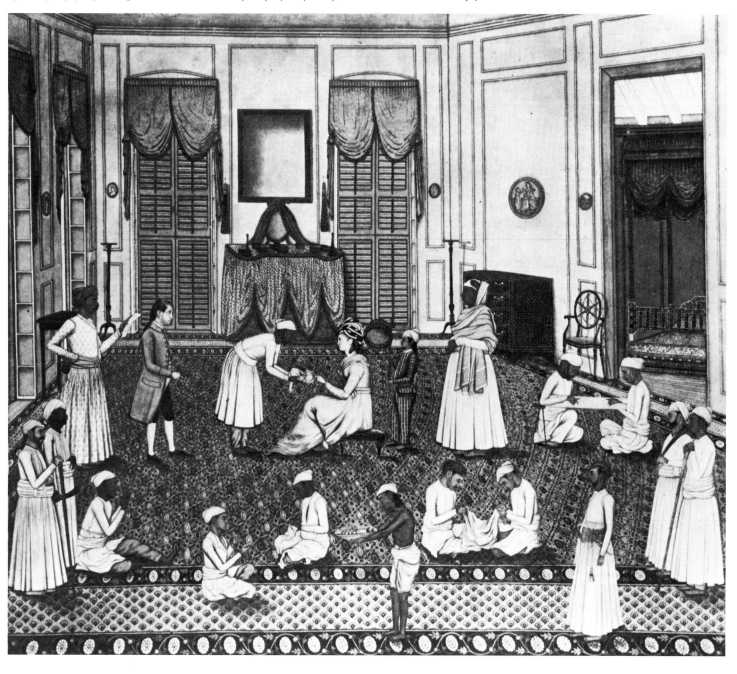

tumes, and occupations were supplied by painters who came to specialize in satisfying this new and lucrative market.

Pictures were available in many degrees of quality, from cheap street productions like latter-day postal cards to more serious, immaculately finished studies by established artists of repute. Over the years, specialists in certain kinds of subjects gained prominence. Natural history painters, for instance, became especially skilled at rendering quills, feathers, blossoms, or the proportions of animals; while other artists devoted their lives to documenting views along the Ganges River.

If, on one level, the pictures assembled here appeal for their reportorial accuracy, nostalgic as old photographs, they also move us in deeper ways. Some Indian artists have always been able to instill their subjects (whether princes or gods or palaces) with imaginative, intuitive painterliness. However late and superficially frivolous some of the paintings here might seem, we urge that you look at them closely, in anticipation of more profound rewards.

Although the descriptive matter accompanying each painting and the Chronology should provide ample guidance and further background material, we would like to end this introduction with a few words about a superb conversation-piece portrait, "Lady Mary Impey Supervising Her Household" (fig. 3). Lady Mary was the wife of Sir Elijah Impey, Chief Justice of Bengal from 1774 to 1782, during which years the distinguished couple lived in Calcutta. An enthusiast of painting, she devoted much of her time in India to commissioning and supervising the execution of a series of splendid natural history pictures (nos. 6-9), which were painted for her by three artists who signed themselves as "of Patna," long a provincial center of the Mughal school. Using imported English papers, which were probably larger and certainly smoother than the otherwise excellent local products, as well as supplemental English pigments, her artists rivaled Jahangir's comparable specialists in sensitive naturalism and perhaps excelled them in decorative effectiveness.

In the portrait (fig. 3), we meet this most charming of British art patrons in India while preoccupied with her milliner, who offers an elegant hat, contrasting with the stringy, turban-like one she is wearing. The comfortably formal salon, furnished in English taste and opening on her bedroom with its curtained four-poster, is mobbed with servants, including an Anglo-Indian butler in English livery, a colorfully dressed page, and the *mali* with his *dali* (her gardener with his daily offering of flowers and vegetables, pleasingly arranged on a salver). Probably by Shaykh Zayn-al-Din, the most accomplished of Lady Mary's flora and fauna artists (nos. 6, 7, 9), this nostalgic portrait lures us so blissfully into the heyday of British India that we are temped to forget the ills that accompanied its joys.

S.C.W.

Catalogue and Plates

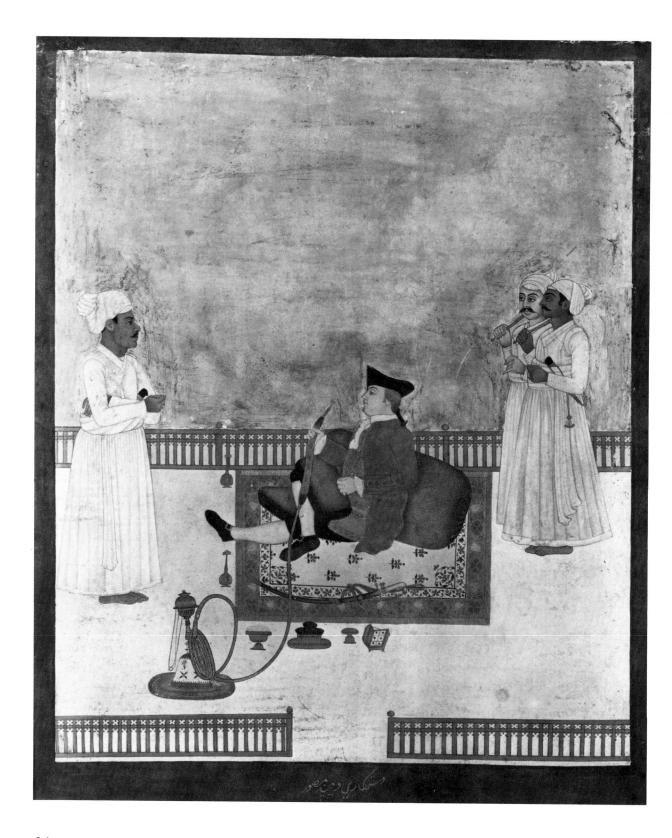

1. WILLIAM FULLARTON RECEIVES A VISITOR

Signed by Dip Chand
Eastern India, Murshidabad or Patna; ca. 1760
H. 26.4 cm., W. 22.6 cm. (including narrow border)
Lent by the Victoria and Albert Museum

Whom better to meet first than this portly British gentleman, taking his ease like a great Mughal, while interviewing a nervously formal Muslim. He seems typical of his self-confident, at times sharp-dealing generation. But he was not. For William Fullarton had overstepped the barriers between Britishers and Indians, barriers that even in the easy days of the eighteenth century marked him as eccentric or worse. His hookah (water-pipe) would have been acceptable; also his Indian bolster, carpet, sweetmeats, and native pose. But he lived in the Indian part of Patna; and he had too many Indian friends, including the historian Ghulam Husain and Mir Kasim, the treacherous son-in-law of Nawab Mir Jafar, against whom he conspired with the British in 1760, an episode involving bribery, land cessions, and duplicity. One wonders if the good doctor's smile here is related to the fact that he was the sole survivor in 1763, when his friend Mir Kasim massacred all the other British at Patna.

Dip Chand, who signed this painting, has been identified by Robert Skelton as one of the artists employed by the Nawab of Murshidabad, perhaps in this instance working at Patna. When the Company gained control of Eastern India in about 1760, Murshidabad, on the Bhagirathi River, was the Mughal political and commercial center. Its school of painting was a provincial outpost of the imperial idiom, lacking the subtleties of characterization, richness of coloring, and fineness of finish found in imperial works. The Murshidabad palette at this date tended to grays and off-whites, often relieved by a particular brownish red.

See: Robert Skelton, "Murshidabad Painting," *Marg* X, no. 1 (1956), pp. 10-22.

2. A COMPANY OFFICIAL SURVEYS THE RIVER

Eastern India, Murshidabad or Kasimbazar; ca.1770
H. 27.7 cm., W. 21.5 cm. (without border)
Lent by the Victoria and Albert Museum

Too much *ghee* (clarified butter), too many delicious *puris* (puffed breads), too little exercise (it was considered demeaning not to be carried in a palanquin, no. 24), and excessive loneliness probably caused this man's introspective gaze and generous girth. Or was his sense of guilt to blame? For *Kampani Bahadurs* (East India Company officers) at this time made fortunes through private trade and bribery, actions that would have caused later compatriots to blurt, "But have you no code?"

By 1767, the British had established military barracks at Berhampur, six miles south of Murshidabad, and many business people had joined the army in this area. By now, the Bhagirathi River had become the main thoroughfare from Calcutta to the Ganges River, which was the principal trade route to upper India until railroads were constructed in the mid-nineteenth century.

This snub-nosed, jowly officer resembles William Fullarton (no. 1), and his shoes too have been painted like black turnips, but the two pictures are more likely to be by the same hand than of the same sitter. Robert Skelton has argued that the twisted, European-inspired tree, watercolor wash technique, and distant landscape suggest a somewhat later date. The folded, dimpled shapes of the riverbank typify Murshidabad painting.

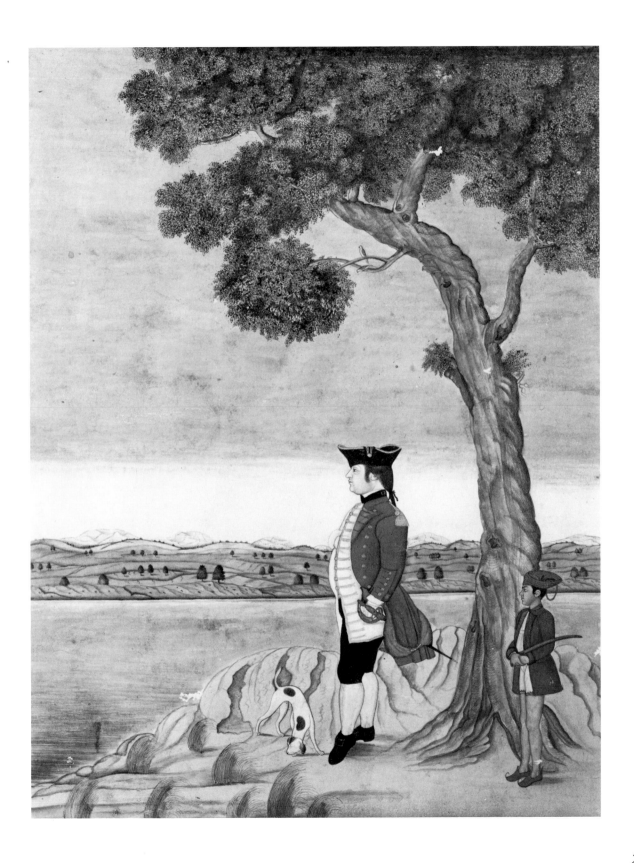

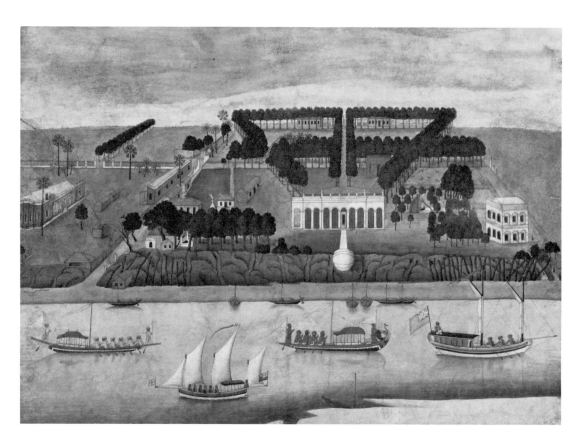

3. TWO VIEWS OF A EUROPEAN
 RESIDENCE

 Eastern India, Murshidabad or Kasimbazar; ca.
 1770
 a. From the River
 H. 38.5 cm., W. 53.8 cm.
 b. By Land
 H. 38.5 cm., W. 53.8 cm.
 Lent by Mr. Donald C. Macpherson

Like any Mughal patron, the English gentleman wanted
the artist to show not only his house but to itemize his en-
tire establishment—his pavilions and other out-buildings,
walled gardens, trees, four boats, indoor and outdoor
servants, crews, guards, soldiers, and their Hindu shrines
and Muslim mosques. No wonder he was proud! Houses
and grounds alike seem efficiently and devotedly main-
tained: a splendid creation before which to be painted in
one's palanquin!

The amused young squire, so carried while perusing a book in the shade of a parasol, brings to mind Bob Pott, William Hickey's jemmy (i.e. foppish) friend, whose carefree antics shocked and delighted fashionable circles from London to Calcutta and Murshidabad. Like the creator of this Bengali establishment, Pott could not avoid the aches and miseries that accompanied life in India. A true romantic, he built "Pott's Folly," a great classical column surrealistically planted in the tiger-infested Sundarbans at the mouth of the Hoogly River. It was erected in honor of Emily, his mistress, who sailed joyously with him from Madras to Calcutta in 1782. To quote William Hickey's fulsome *Memoirs,* she was

> then...in perfect health. She was, however, greatly annoyed by what is called the prickly heat, a sort of rash or eruption upon the skin very prevalent in hot countries...attended with a sharp pricking pain like the points of pins penetrating the body in every part....It is, however, considered a sign of vigorous health [as] newcomers are more subject to it than old residents.

Emily, impatient under the torture of this teasing complaint, and with an insatiable thirst..,had frequent recourse to draughts of extremely cold water...mixed with milk....Just as [the ship] was off Culpee, [Emily] drank two large tumblers of the...mixture, the last of which was scarcely down her throat when she complained of feeling faint and ill....She fell back upon the couch she was sitting on, and in a few minutes was a corpse....For several hours [Bob] would not be persuaded she had ceased to exist.... But too soon unanswerable evidence [proved] the fact...from the body's becoming black and putrid, emitting the most offensive smell....He employed [the Italian architect] Tiretta to build the column I before mentioned, amongst the herds of tigers at Culpee, because off that wild, jungly place she breathed her last....(William Hickey, *Memoirs of William Hickey, 1749-1809*, ed. Alfred Spencer [London, 1913-25], vol. III, pp. 139-140)

See: Giles Eyre, *Indian Painting for the British 1770-1880*, (London, 1972), nos. 20, 21.

4. MUHAMMAD REZA KHAN, DEPUTY NAWAB OF BENGAL

Eastern India, Murshidabad or Faizabad; ca. 1770
H. 44.5 cm., W. 36.0 cm. (without border)
Private collection

Muhammad Reza Khan, a Mughal civil servant of the old school, sits in a formal garden, beneath clouds auguring rain and bountiful harvests. He was born in Persia in 1717, and came to India at the age of ten. Industrious, tactful, and a talented administrator, he prospered under the Mughals. As *faujdar* (military governor) of Chittagong in the 1760's, he had dealings with the British, who admired his diplomacy and integrity. Five years later, when the Company took control of Bengal on the death of the Nawab, Muhammad Reza Khan was appointed Deputy Nawab and *diwani* (tax collector). According to the treaty of Allahabad, more than half of the revenues of Bengal were to go to the Mughal emperor, the remainder to the Nawab, except for any surplus amounts, payable to the Company. This was disastrous both for the people of Bengal, who were squeezed more than ever by rapacious officials, and for the Company, which received little or nothing. In 1774, Warren Hastings was appointed to carry out reforms. The dual system was abolished, and henceforth the Company collected taxes directly. The treasury was moved to Calcutta; the young Nawab's share was drastically cut; and the Deputy Nawabs, including Muhammad Reza Khan, were deposed. Indeed, he was subjected to imprisonment and a trial. On his acquittal in 1773, he was once again appointed *faujdar* at Murshidabad, where he died in 1785.

It is ironic that this picture belonged to Sir Elijah Impey, the chief justice of Bengal from 1774 to 1782. The painting bears his Persian seal, dated 1775. Like the subject of the painting, Sir Elijah served the Company with more honor than was usual, was impeached, tried, and acquitted. The picture is inscribed on the back, "Gen'l Dowdswell gift fr. E. Impey," along with a note in an early hand saying that "it is very valuable."

The rich coloring, fine finish, compositional strength—admire the contrapuntal "procession" of cypresses—and sumptuousness of this miniature hark back to the simplified brilliance of Emperor Muhammad Shah's portraits.

See: Stuart Cary Welch, *Imperial Mughal Painting* (New York, 1978), pl. 39.

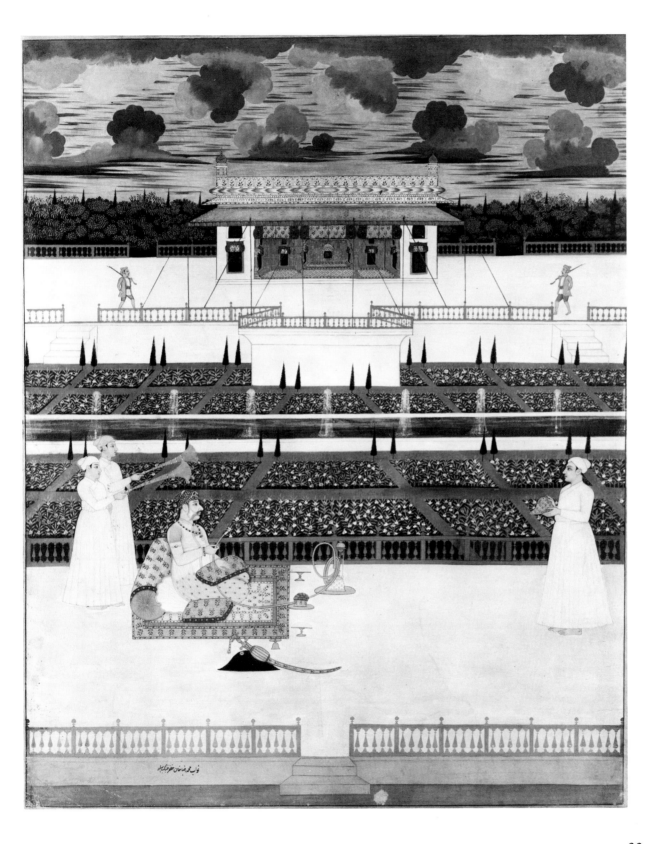

33

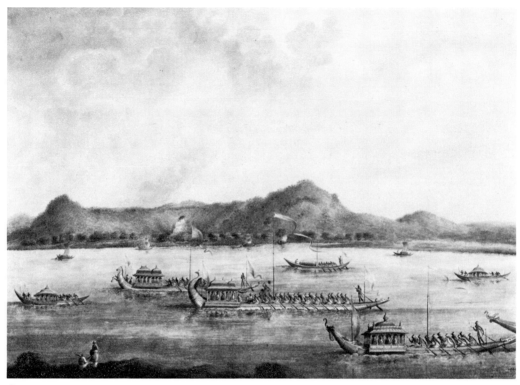

a.

b.

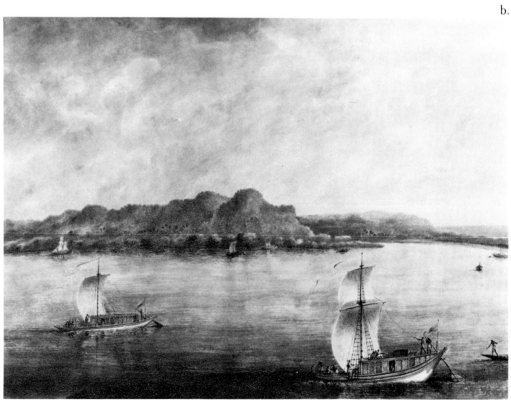

5. BOATING ALONG THE BHAGIRATHI AND GANGES RIVERS

By Sita Ram
Eastern India, Murshidabad; ca. 1810
a. The Mootee Jurna and the Nawab of Murshidabad's State Boats
 H. 45.5 cm., W. 64.1 cm.
 Lent by Mr. Edwin Binney, 3rd
b. Range of Hills Called Dowlah Geerapurvut. Between Ragemohl and Peer Pointy
 H. 46.2 cm., W. 64.1 cm.
 Private collection

The Bhagirathi and Ganges rivers were sources of pleasure as well as prosperity. In the early nineteenth century, an unknown Englishman employed an artist of Murshidabad to accompany him on river voyages, perhaps aboard the trim vessel depicted here (detail), with its comfortably high-ceilinged cabin and palanquin conveniently stored on top. Their tours were recorded in an extensive series of watercolors bound in two albums. One is inscribed, "Views by Seeta Ram from Secundra to Agra, vol. IX"; the other illustrates views along the route from Murshidabad to Patna.

Sita Ram's freely brushed wash drawings mark his sharp break with Mughal style. Although his colors retain the somber hues of Murshidabad, he has turned to the romantic manner of such English artists as William Hodges (1744-1797, in India 1780-1783) and Thomas Daniell and his nephew William (in India 1786-1793). These professional scenery painters traveled in many areas of India, sketching as they went. Their aquatints were widely admired in India as well as England, both by English collectors and by Indians (see Chronology).

With its softly rolling hills, Piranesi-like angular figures, and aerial perspective, Sita Ram's view near Murshidabad depicts a scene described in 1836 by Fanny Parks, the all-seeing memsahib whose *Wanderings of a Pilgrim in Search of the Picturesque* (London, 1850; reprinted Lahore, 1975) is one of the most enjoyable and informative source books on Anglo-Indian life. "The mor-panki, a kind of pleasure boat, with the long neck and head of a peacock, most richly gilt and painted, and the snake-boats, used on days of festival, are fairy-like, picturesque, fanciful, and very singular." (*Wanderings,* vol. II, p. 98)

We are grateful to Clifford Maggs and Giles Eyre for information about these albums. Eric Newby has written a diverting account of his more recent river excursion: *Slowly Down the Ganges* (London, 1966).

6. A MOUNTAIN RAT ON A HINDUSTANI ALMOND TREE

Signed by Shaykh Zayn-al-Din
Eastern India, Calcutta; dated 1778
H. 63.8 cm., W. 93.7 cm.
Lent by Mr. Edwin Binney, 3rd

Lady Mary, wife of Sir Elijah Impey, was one of the first Anglo-Indian patrons of natural history painting. Sixty-four paintings of this type from her collection are known. Many are signed by one of three artists: a Muslim, Shaykh Zayn-al-Din, and two Hindus, Bhawani Das and Ram Das, all "of Patna." They are dated from 1774 to 1782, the same years during which Sir Elijah was chief justice of the Supreme Court of Bengal.

The *Mountain Rat* is characteristic of the series in revealing the Mughal training of its painter. Unlike later studies of flora and fauna made for the British, which are more "scientific" and less Indian, it is more sensitively *felt* than *observed*, markedly ornamental and bold in design, and richly painted, with pigments carefully built up in layers rather than laid on in single washes. Moreover, the subject is grounded in a landscape rather than isolated as a specimen, and the page includes such extraneous items as a stump, an insect, and grassy tufts. At the same time, the artist has bowed to European science in offering a cross section of a growing almond.

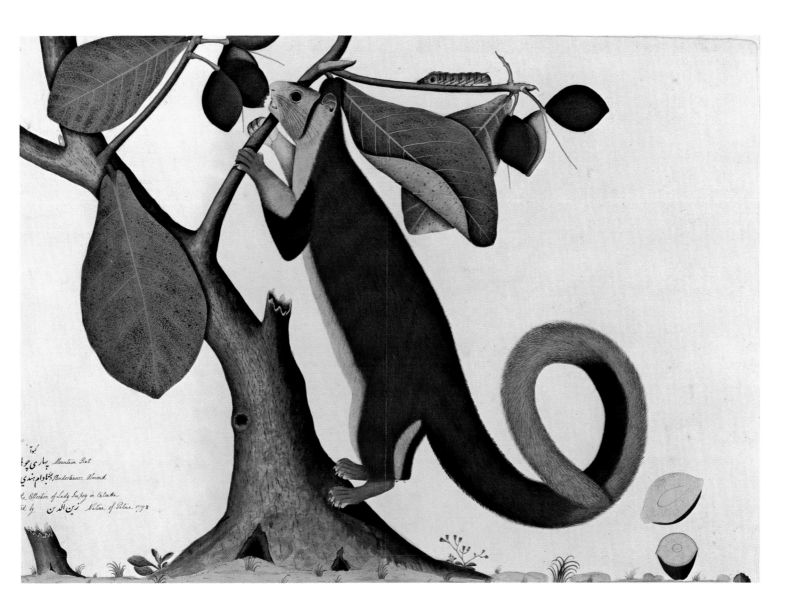

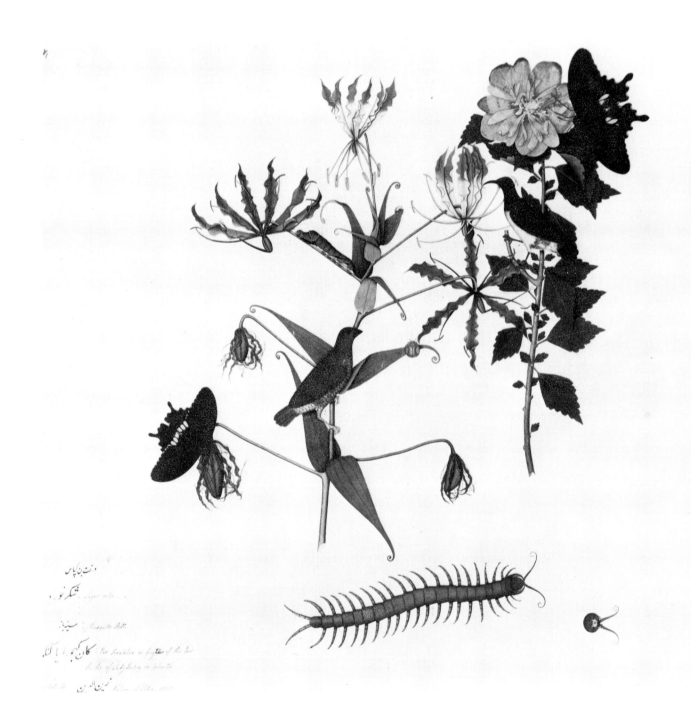

7. SPOTTED MUNIA OR SPICE FINCH; A
PURPLE-RUMPED SUNBIRD (MALE); A
GLORIOSA SUPERBA; AND A DOUBLE
ROSE OF SHARON (*HIBISCUS SYRIACUS*)

Signed: Zayn-al-Din
Eastern India, Calcutta; ca. 1780
H. 53.1 cm., W. 65.1 cm.
Private collection

Lady Impey assigned botanical subjects to her artists
more on visual than scientific grounds, preferring strik-
ingly attractive combinations of birds, flowers and insects,
in the manner of Dutch still-life pictures, to systematic ar-
rangements for a naturalist. Nevertheless, as has been
pointed out to us by Professor R. A. Howard, director of
the Arnold Arboretum of Harvard University, the speci-
mens in this picture are botanically accurate. Intriguingly,
the *gloriosa superba,* threatened by an encroaching cater-
pillar, was depicted in several stages of its development,
with precise rendering of colors, stamens, and
geniculation.

During the same years that Lady Impey, an enlight-
ened amateur, employed artists in Calcutta, other Indian
draftsmen worked in Bihar and Bengal for Dr. James
Kerr (1738-1782), Company surgeon on the Bengal Es-
tablishment. His artists, however, were limited to botani-
cal subjects, treated with scientific restraint. Their studies
are the earliest official natural history paintings in the col-
lection of the India Office Library.

See: Mildred Archer, *Natural History Drawings in the India Office Li-
brary* (London, 1962), pp. 6, 71, 83-84.

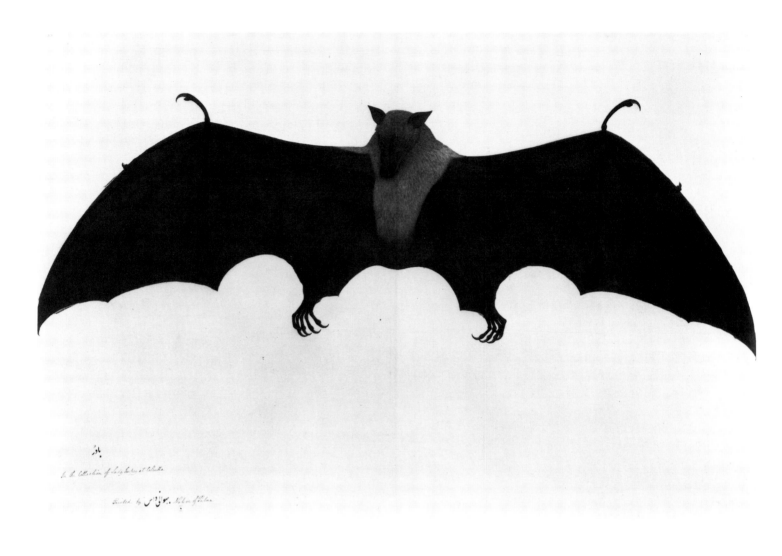

8. GIANT INDIAN FRUIT BAT, OR FLYING FOX

Signed: Bhawani Das of Patna
Eastern India, Calcutta; ca. 1780
H. 44.8 cm., W. 69.0 cm.
Private collection

Bhawani Das's *Bat,* starkly silhouetted against the white of the imported English paper, looks far too disturbing to be a strict fruitarian. Its eerie extra claws, useful for holding bananas or mangoes, evoke Gothic horror tales, and may have struck the same chord in Lady Impey that led Fanny Parks to collect her "'Bottle of Horrors,'…containing a cobra de capello, scorpions, lizzards, millepieds, centipieds, [and] grillus monstrous"—a few of India's small surprises (*Wanderings,* vol. I, p. 243).

Less suavely ornamental as a painter than his colleague Shaykh Zayn-al-Din, Bhawani Das compensated by deeper insights into the beings of his subjects. If outwardly ugly enough to affright Mephistopheles himself, to borrow another phrase from Mrs. Parks, this fruit bat's true nature seems sadly sweet, thoroughly timid, and pathetic.

9. CHEETAH

Signed: Shaykh Zayn-al-Din
Eastern India, Calcutta; ca. 1780
H. 63.5 cm., W. 94.0 cm.
Private collection

The fastest of animals, this long-legged, slimly built cat with a small round head can attain sixty-six miles per hour and maintain this speed for four hundred yards. As the cheetah lacks claw-sheaths, its cruelly sharp "weapons" are always bared. In a wild state, it hunted gazelle, antelope, smaller animals, and birds; domesticated as a hunter, it is taken blindfolded on a wagon to the field. Once released, the cheetah makes a few lightning-like bounds, and the hunt is usually over, the prey felled by powerful dewclaws and gripped at the throat by fierce jaws. Huntsmen then exchange the antelope or other slain animal for a cup of warm blood. (For a Rajput sketch of a cheetah in action see: Stuart Cary Welch, *Indian Drawings and Painted Sketches* [New York, 1976], no. 58.)

This is one of the few Impey pictures in which the subject is reduced in size to fit the paper. According to a penciled note, the animal measured five and one-half feet in length. Shaykh Zayn-al-Din, in true Mughal style, has concentrated on the stunning arrangement of spots, cleanly curving outlines, and variations of texture. The mask, however, is rendered in a manner more stylized than accurate.

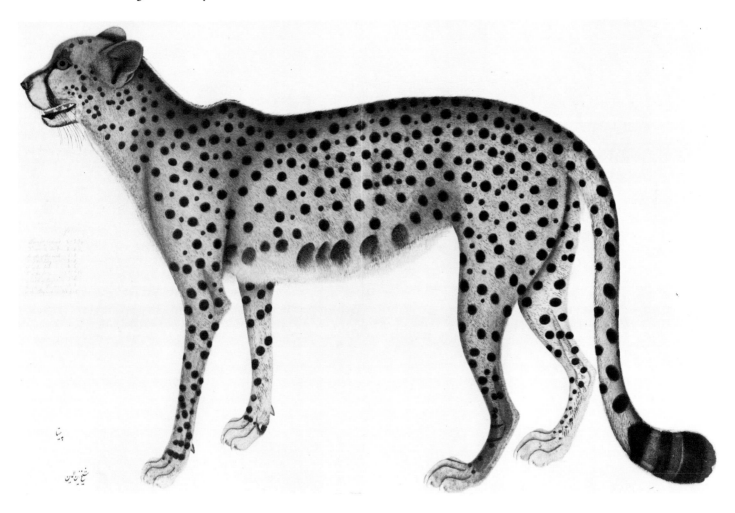

10. A BABOO DICTATING TO HIS MOONSHEE

Inscribed on scroll, "Calcutta, 1785"
Eastern India, Calcutta, 1785
H. 34.3 cm., W. 26.9 cm.
Private collection

According to *Hobson-Jobson, A Glossary of Colloquial Anglo-Indian Words, baboo* was a word used by Englishmen "with a slight savour of disparagement, as characterizing a superficially cultivated, but too often effeminate, Bengali" (p. 44). A *moonshee* is a writer or secretary. Here, the two are glimpsed at characteristic tasks, on the broadly arched terrace of an outdoor office, probably on an Englishman's estate. Seated on the omnipresent striped cotton matting (*durrie*, near a brass and teak money-box and his well-worn sandals, the *moonshee* scratches away at his accounts in open-mouthed concentration, bony hands and arms propped up on long bony legs. Behind him stands the slightly officious *baboo,* wearing a jaunty turban and foppishly trailing shawl. Through the arches, we see peasants' huts with the curved thatch roofs usual in Bengal.

By 1773, with the Mughal menace ended, Calcutta had become the virtual capital of British India. Safely and comfortably, Anglo-Indians could settle down to family living, almost as if in England. More and more women joined their husbands, and social activities flourished. With the visits of English landscape painters, such as Hodges and the Daniells (no. 5), the European style of painting spread into Indian ateliers. In this picture, perhaps the earliest dated example of its sort from Calcutta, the blurred outlines, atmospheric perspective, and thin washes of color show that the artist had studied English work.

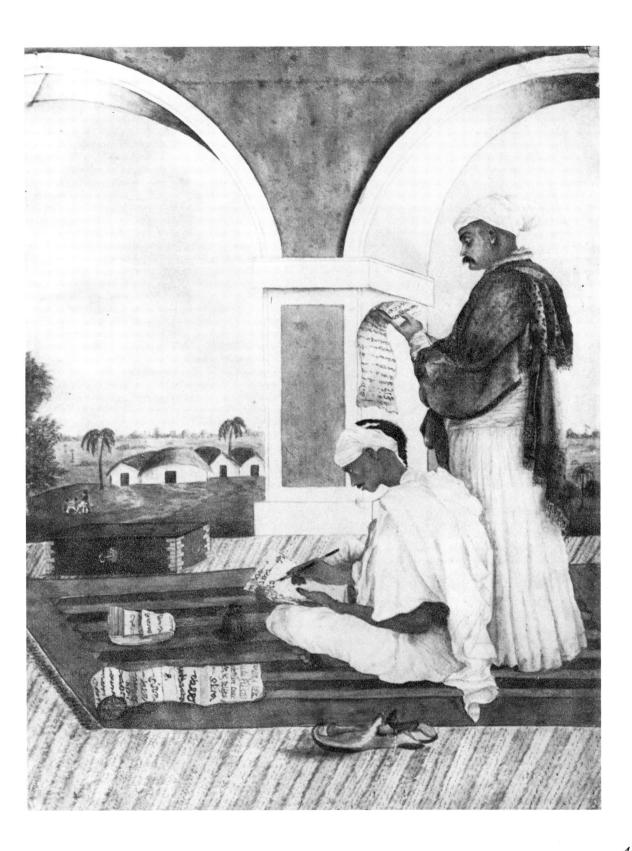

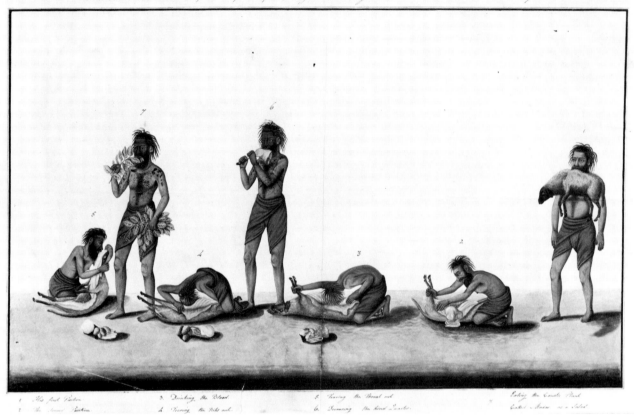

11. SUZA GEER BERAH GEER THE FAMOUS SHEEP EATER FROM SURONG NEAR SHAS GUNGE IN THE FURRAKABAD DISTRICT AT HIS BREAKFAST

Owner's signature at lower right: James Nath. Rind
Upper India, probably Farrukhabad; ca. 1785-90
H. 29.5 cm., W. 50.3 cm.
Private collection

Company servants, like today's foreigners in India, were astounded by what they saw; and if they could acquire pictures of their discoveries, they did so, just as we snap photographs. Some of India's oddest sights were, and are, human. Poverty fosters certain kinds of eccentricity; and desperation occasionally pushes it into public view. Suza Geer, a disturbingly exhibitionistic carnivore in a largely vegetarian land, was documented by a Mughal-trained artist for Major James Nathaniel Rind, an enthusiastic col-

lector of paintings who was in India from 1778 to 1804. He served in the 18th (and later 14th) Native Infantry, was employed on survey duty between 1785 and 1789, and became a brigade major in Calcutta after a furlough in 1801. He died in England in 1813.

The artist has shown Suza Geer progressively devouring a sheep, with each stage of the upsetting meal numbered and described, as though for a text book on odd gastronomy.

44

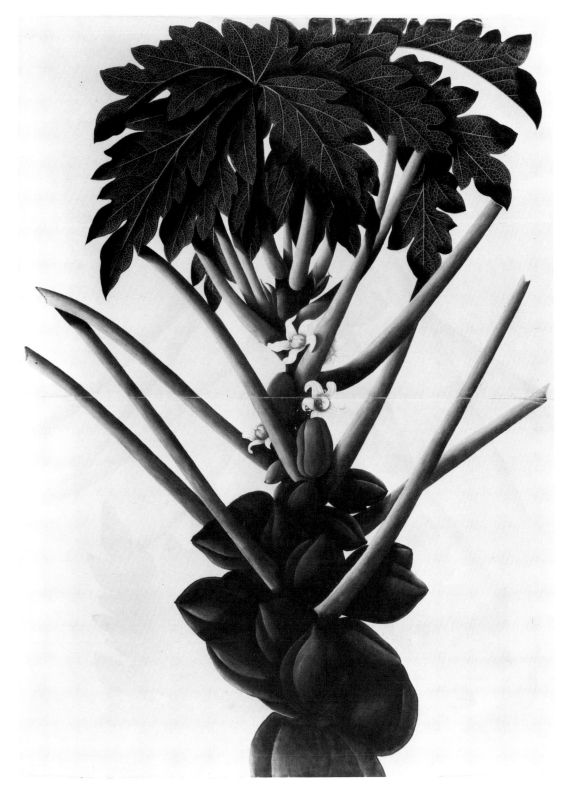

12. a

b.

12. THREE BOTANICAL STUDIES

From the collection of Major James Nathaniel Rind
Eastern India, Calcutta; ca. 1800

a. Female Papaya Tree (*Carica papaya*)
H. 75.5 cm., W. 54.5 cm.
·Private collection

b. Indian Jujube (*Ziziphus mauritiana Lam*)
H. 40.9 cm., W. 64.8 cm.
Private collection

c. A Botanical Fantasy, Based upon a *Heliconia Ginger* or a Grass Flower
H. 66.7 cm., W. 42.3 cm.
Lent by Mr. Michael Archer and Mrs. Margaret Lecomber

Although only a few minor biographical facts and dates illuminate the career of Major Rind, his small collection of Indian paintings, of which a good sampling is exhibited here (nos. 11-13), hint at his personality and prove that he chose them with originality and flair. The *Famous Sheep Eater* (no. 11), presumably acquired when he was on survey duty, along with several views and a copy of an Asokan inscription, is one of the most bizarre of Indian miniatures. His botanical studies and a noble *Cobra* (no. 13), doubtless collected when he was stationed in Calcutta after 1789, are also highly personal selections, with strong pictorial qualities.

c.

According to *Hobson-Jobson*, the papaya, or paw-paw, was brought to India from the Caribbean by the Portuguese. "The name," it informs us, "seems to be from America, like the insipid, not to say nasty, fruit it denotes" (p. 670). Perhaps Major Rind selected its picture because he realized, with us, that it is delicious with lemon juice. More likely, however, he responded to the powerful forms of its spreading stalks, drooping leaves, lumpy fruit, and delicate white blossoms. The upside-down mirror image, faintly visible on the page, was created over the years, while the picture was folded for storage.

The study of the *Indian Jujube* is as subtle in treatment as the papaya is bold. Each tiny shoot, spine, and immature bud is sensitively recorded, in Seurat-like dots of color, by an artist who sensed as well as saw the miracle of growth.

Major Rind's third botanical picture, on the other hand, while also sensitive, is stunningly aggressive. Simultaneously sleekly grooved and lanceolate, its bright yellow and rich green forms seem particularly Indian.

Professor R. A. Howard's observations on these pictures as botanical studies are especially interesting. He pointed out that the papaya's stem is too small and its leaves somewhat too divided. Nevertheless, it is botanically fairly accurately observed, as is the *Zizyphus*, with its conduplicate venation, paired stipular spines, and tawny pubescence. However, he described the third picture as an "artifact"—an assemblage of plant material based upon the theme of a *heliconia ginger* or a grass flower, containing bracts and membranaceous elements never associated in nature.

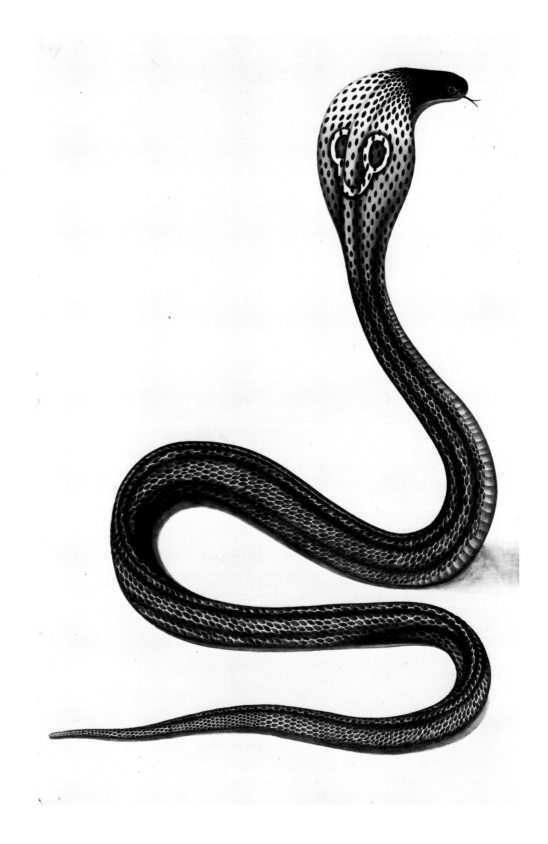

13. COBRA DE CAPELLO

From the collection of Major James Nathaniel Rind
Eastern India, Calcutta; ca. 1800
H. 65.5 cm., W. 45.2 cm.
Lent by Mr. Edwin Binney, 3rd

This fearful, stately, and venomous creature was approached from behind by the artist, with good cause. As king among snakes, the cobra figures extensively in Indian religion. Of all fauna, it is most revered by Buddhists and Hindus alike.

Hobson-Jobson, quotes an anecdote of 1672, concerning "a certain High German...commonly known as the Snake-Catcher [who] was summoned...to lay hold of a Cobra Capel...and...did, merely holding his hat before his eyes, and seizing it with his hand, without any damage." The same source contrasts a no-nonsense Englishman's approach in 1882: "In my walks abroad I generally carry a strong, supple walking cane....Armed with it, you may rout and slaughter the hottest-tempered cobra in Hindustan. Let it rear itself up and spread its spectacled head-gear and bluster as it will, but one rap on the side of its head will bring it to reason" (p. 224).

Like his botanical studies, this unusually vivid study must have been acquired by the brigade major after his return to Calcutta from survey duty. As usual, he chose well.

14. WHITE LOTUS (*Nelumbo Odorata*)

Eastern India, Sibpur (near Calcutta); ca. 1800
H. 65.5 cm., W. 45.2 cm.
Lent by the Fogg Art Museum, Harvard University, Cambridge, Massachusetts, Gift—Eric Schroeder

Although we look at such pictures as this lotus, with its glowingly modeled foliage, as works of art, the East India Company, by whose botanists they were commissioned, justified them as contributions to their economic survey. Botanic gardens were established by the Company in several places. The largest was at Sibpur on the Hooghly River, where "Shalimar", the country house and gardens of Lieutenant-Colonel Robert Kyd of the Bengal Infantry, an eager amateur botanist, was taken over officially before he died in 1793. There is no evidence, however, of Kyd's having commissioned botanical pictures.

Kyd was succeeded by Dr. William Roxburgh, who had directed the gardens at Samalkot in the Madras Presidency from 1789 to 1793. While there he had trained local artists to produce life-size drawings of the extensive collection of specimens. About five hundred duplicates were made and sent to the Company in London. The process was continued in Calcutta and by the time Roxburgh retired in 1813, 2,545 pictures had been painted in the south and in Calcutta. The originals are still kept at the Sibpur Herbarium, bound in thirty-five volumes, known as the *Roxburgh Icones*.

Studies such as this lotus were painted by Roxburgh's artists for private collectors.

See: Archer, *Natural History Drawings*.

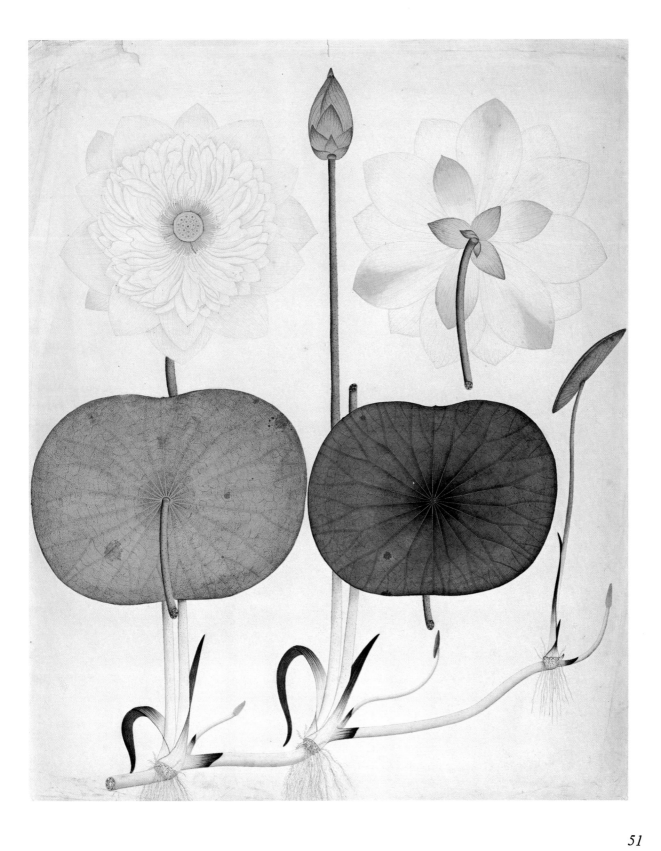

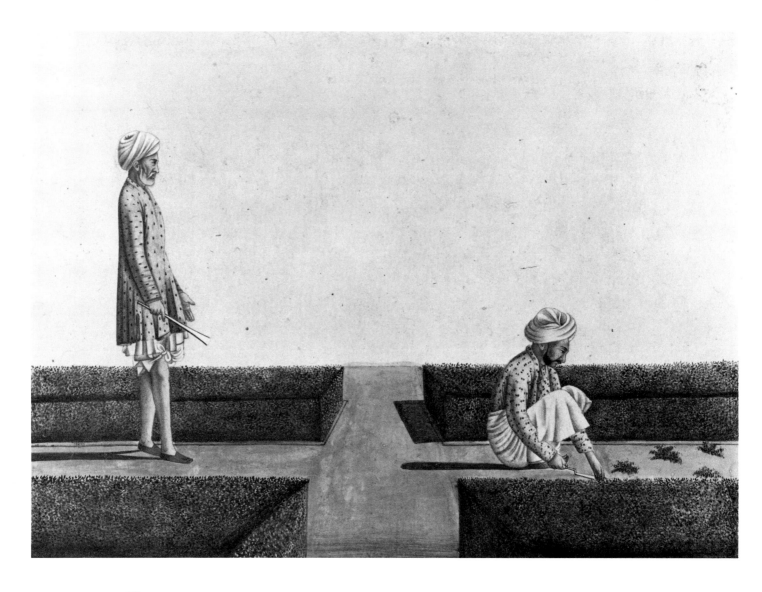

15. OCCUPATIONS

Eastern India, Murshidabad (?); ca. 1800 or earlier
a. Gardeners (*Malis*)
 H. 15.9 cm., W. 21.4 cm. (with borders)
b. Grainsellers (*Modis*)
 H. 15.9 cm., W. 21.4 cm.
Private collection

The English in India were curious about everything, particularly people. To satisfy this interest, as well as the English penchant for collecting, Indian artists painted sets of small pictures showing many categories of humanity. Just as tourists of today are assailed by hawkers waving postal cards, earlier travelers were approached by picture sellers with renderings of local views, famous personages ("Please, Sahib, just for looking! Mughal emperors, all painted by hand…so BEAUTIFUL! Very cheap!"), local castes, and occupations.

Although the quality of these two pictures precludes the likelihood of their having been hawked on a river wharf or at the door of a dak bungalow in Murshidabad, they were part of a series representing occupations familiar to anyone living in the towns or countryside of Ben-

gal. Their artist was far superior to the usual hacks who turned out such sets. His *Gardeners,* for instance, captures the restful solitude of late afternoon in a garden. Perhaps because he sketched the subject while seated on the ground, the usual working position of a traditional Indian painter, the two men loom against an almost infinite landscape, bounded by low hills on the distant horizon. We sense the vibrant heat still lingering over the immaculate hedges and pathways, temporarily sullied by the younger man's weeds. Behind him, an old Muslim, perhaps his father, stands with the dignity and authority of a judge, elegant as a courtier.

The highly skillful, Mughal-trained artist plays a game with symmetry in the second picture, whose composition suggests the merchants' scales.

16. HOOK-SWINGING

Eastern India, Murshidabad artist working at Calcutta; ca. 1800
H. 54.2 cm., W. 41.9 cm.
Lent by the Victoria and Albert Museum

Although the Abbé J. A. Dubois (1770-1848), a French Catholic priest, lived in the Deccan and Madras rather than Eastern India, his account of hook-swinging is one of the fullest and most explicit:

> Chidi-mari (known as *Charak-Puja* in Bengal) is another torture to which devotees submit themselves in honour of the goddess Mari-amma, one of the most evil-minded and bloodthirsty of all the deities of India. At many of the temples consecrated to this cruel goddess there is a sort of gibbet erected opposite the door. At the extremity of the crosspiece, or arm, a pulley is suspended, through which a cord passes with a hook at the end. The man who has made a vow to undergo this...penance places himself under the gibbet, and a priest beats the fleshy part of the back until it is quite benumbed. After that the hook is fixed into the flesh thus prepared, and in this way the unhappy wretch is raised in the air. While suspended he is careful not to show any sign of pain; indeed he continues to laugh, jest, and gesticulate like a buffoon in order to amuse the spectators, who applaud and shout with laughter. After swinging in the air for the prescribed time the victim is let down again, and, as soon as his wounds are dressed, he returns home in triumph. (J. A. Dubois, *Hindu Manners, Customs, and Ceremonies* [Oxford, 1953], pp. 597-598)

The stiff-legged but accurately detailed figures in this large and crisply painted picture lend it a suitably nightmarish mood.

Related pictures "of the sombre Murshidabad type," also painted in Calcutta, are in the India Office Library (see: Mildred Archer, *Company Drawings in the India Office Library* [London, 1972], nos. 46, 47).

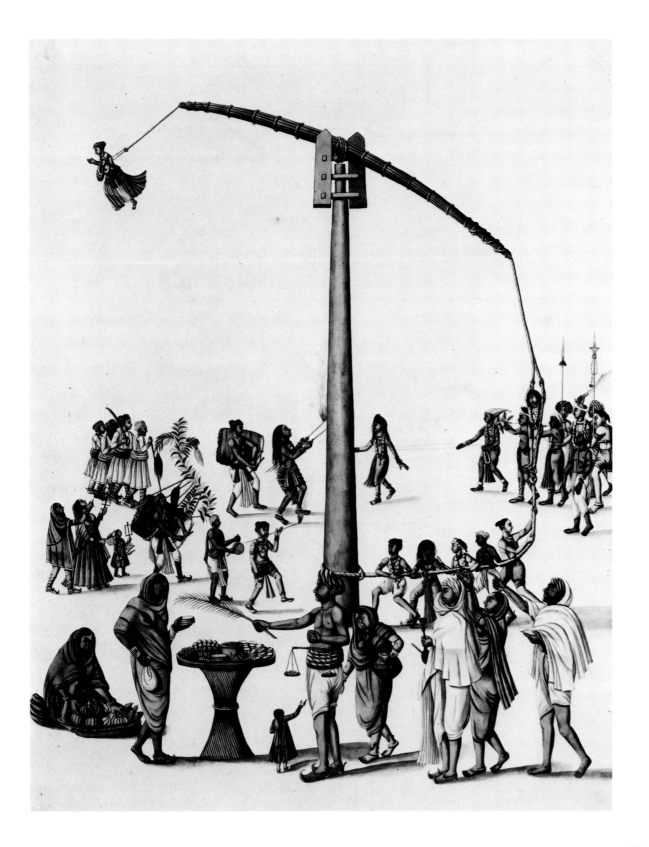

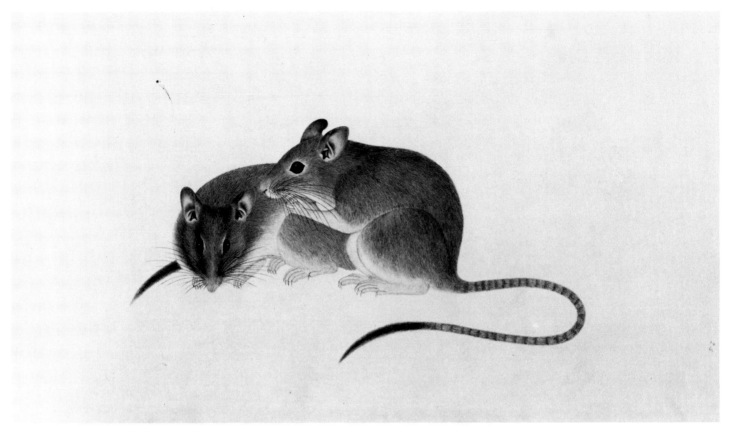

17. INDIAN RODENTS

Eastern India, Barrackpur (near Calcutta); ca. 1804-05

a. Two Indian Gerbils
 H. 26.7 cm., W. 46.7 cm.
 Lent by the India Office Library and Records, Collection of the Marquis of Wellesley
b. A Porcupine
 H. 28.7 cm., W. 47.7 cm.
 Lent by the India Office Library and Records

With the encouragement of the Marquis of Wellesley (governor-general 1796-1805), an Institute for Promoting the Natural History of India was established in 1804 at Barrackpur, near Calcutta, with a menagerie and aviary. At the urging of its supervisor, Dr. Francis Buchanan (1762-1829), staff-surgeon to the governor-general since 1803, 500 rupees were appropriated for the upkeep of the animals and birds, 300 rupees for collecting them, 100 rupees for artists, and 60 rupees for paints, brushes, and stationery. Unfortunately, the recording of specimens by this team of artists ended shortly after Wellesley's recall in 1805.

Lord Wellesley and Dr. Buchanan obviously delighted in the work of their native artists; and these two paintings from Wellesley's albums are versions of the official drawings made under Buchanan's supervision. The skittish gerbils seem almost to tremble as we inspect them, while the slower-moving porcupine poses stoically, confidently protected by his bamboo-forest of quills. Science and art have met.

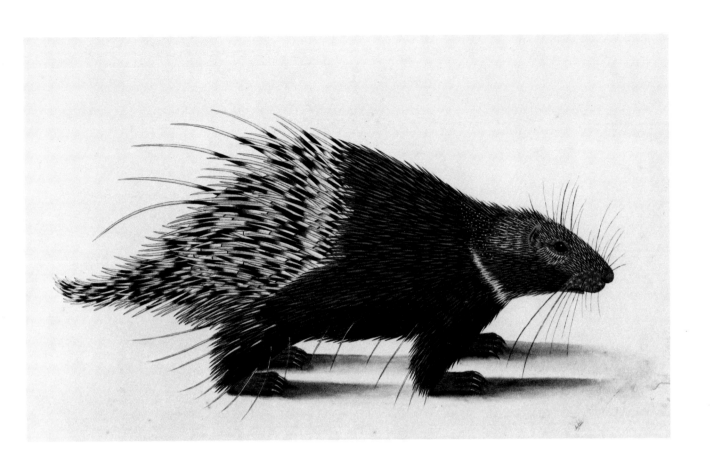

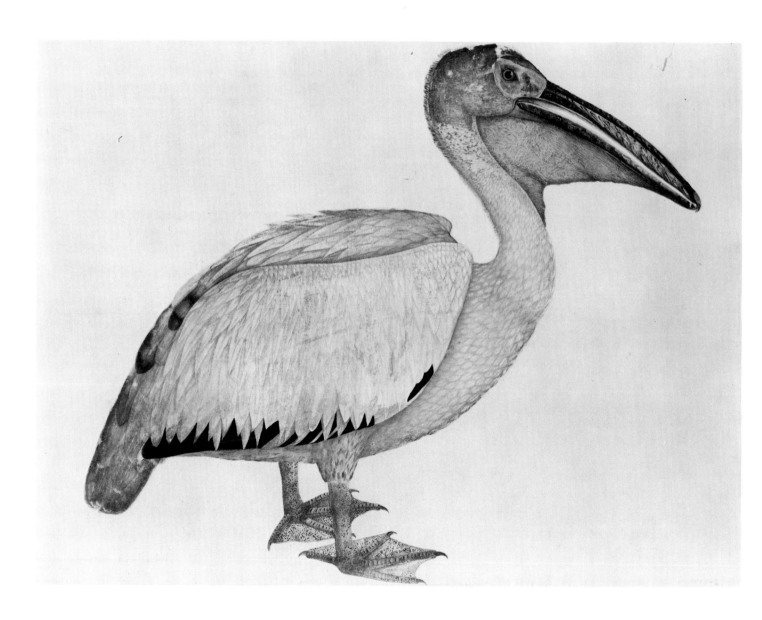

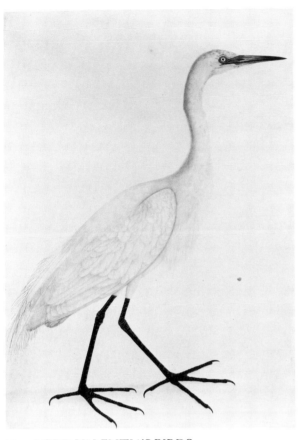
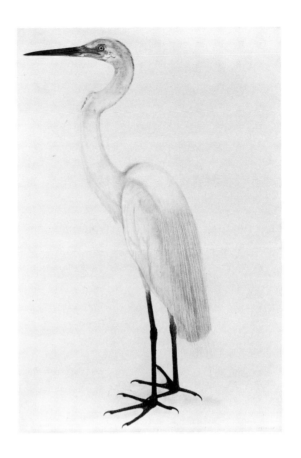

18. LORD VALENTIA'S BIRDS

Eastern India, Barrackpur (near Calcutta); ca. 1802
a. A Pelican (*Pelicanus Orientalis*)
 H. 45.5 cm., W. 63.5 cm.
b. Indian Egret (female ?)
 H. 66.3 cm., W. 47.1 cm.
c. Indian Egret
 H. 66.3 cm., W. 47.1 cm.
 Private collection

George Annesley, 10th Viscount Valentia (1769-1844), was another enthusiast of natural history paintings. An aristocratic, concerned, and observant travel writer, he stayed with Lord Wellesley when in Calcutta in 1803 and presented him with at least two paintings of birds (now in his collection at the India Office Library) which bear his Indian seal ("The Right Honourable Lord Bahadur Viscount Valentia"). Presumably, Lord Valentia had commissioned them for his host along with a series for himself during his visit.

Dr. Buchanan's artists had considerably refined their technique by the early nineteenth century. Not only were they acutely sensitive to the shapes and textures of birds, but they could suggest the glint of eyes and sheen of quills by varnishing such areas. They invite comparison with Mansur, Jahangir's renowned flora and fauna specialist. While Mansur's birds are considerably smaller in size and finer in scale, Lord Valentia's probe nature's secrets almost as deeply and are more accurate.

See: Welch, *Imperial Mughal Painting*.

a.

19. MR. ADAMS'S ALBUM

Eastern India and Burma; ca. 1826
a. An European Gentleman
b. A Painter Taking a Sketch of a Lady
c. Government House in Calcutta
d. A Hindoo School in Calcutta
e. A Hindoostanee Woman
f. A View of Chinsurah, the River Face
g. A Muhummedan Mosque
h. A Watchmaker
i. Bride and Bridegroom
j. European Gentleman Going a Airing on an Elephant
k. A Hunt in the Sunderbunds
H. 36.5 cm., W. 23.1 cm. (each)
Private collection

One of the most touching, informative, and comical documents of Calcutta and Burmese life is an album commissioned by a certain Mr. Adams, probably George Adams of the Bengal Civil Service.

It contains 417 folios, each with a watercolor or gouache. All can be attributed to the same artist, who must have spent several years painting them in the leather bound album, on English paper watermarked "J. Whatman 1826." Inasmuch as the first Anglo-Burmese War (1824-1826) was contemporaneous, the Burmese subjects must be among the earliest artistic documents from the British period in Burma.

a. A particularly nostalgic watercolor, folio 95, shows an English gentleman (Mr. Adams ?) seated in his bungalow with a young daughter dancing at his feet and a newly born infant in the arms of a Burmese *ayah* (nursemaid). A print of London Bridge, a pet dog, and a peep into the patron's study further set the mood, while *darzi* (tailor) sews baby clothes and the *kitmutgar* (table servant) strides in bearing cheroots and a smoking charcoal to light them.

The album's table of contents identifies folio 181 as

b. "A Painter Taking a Sketch of a Lady." The artist, perhaps a self-portrait, tiptoes round the room, with spare brushes rakishly tucked behind his ear, rendering the lady on a piece of artfully scrolling paper. The Beeby Sahib (august lady), squinting in burning sunlight, is a true personification of all that was considered gracious, cultured, and refined in old Calcutta. She wears a dress of low décolletage, with puffed sleeves and quantities of lace. A particularly scruffy

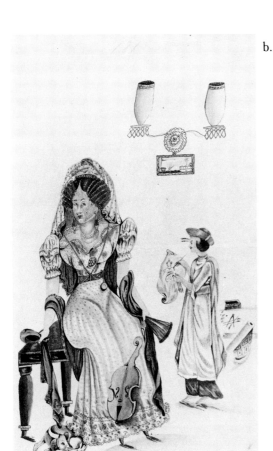

b.

c.

dog rests near her pointed toes, while a flying violin—her attribute?—hovers at knee height.

Many of the anonymous master's pictures evoke the pleasures we associate with Saul Steinberg. One such is "Government House in Calcutta," (folio 249) the Palladian edifice, based upon Kedleston Hall, built between 1799 and 1803 at such cost that it was partly responsible for Lord Wellesley's recall as governor-general (but see Chronology entry for 1799-1803 for Lord Valentia's opinion). Contemporary travelers also noted the adjutant birds atop its John Bullish lions.

Serious matters as well caught the eye of Mr. Adams's artist, whose many domestic scenes suggest that he was attached to the Adams household. "A Hindoo School in Calcutta" (folio 245) describes a varied assemblage of twelve small boys learning Bengali and English from an English teacher and his *moonshee*.

"A Hindoostanee Woman," (folio 397) however, introduces a sloe-eyed bewitcher from the more elevated realms of Calcutta's low life.

Mr. Adams took his artist with him on excursions up-river as well as to more distant places. "A View of Chinsurah, the River Face" (folio 412) depicts a town on the Hooghly, twenty-six miles from Calcutta, which was described about ten years later by Fanny Parks as "present [ing] a view of fine houses situated in good gardens, and interspersed with the dwellings of the natives." (*Wanderings,* vol. II, p. 100)

The Adams album contains whole repertoires of the usual Anglo-Indian subjects: portraits of historical personages, studies of flora and fauna, and occupations. But even these are treated with endearing originality. "A Muhammedan Mosque" (folio 147) is staged with trumpeting nudes, a Buraq (the Prophet's heavenly steed) fresh from the hairdresser, and two infinitesimal figures in the foreground, whose scale implies that the building is alarmingly vast.

c.

d.

e.

f.

g.

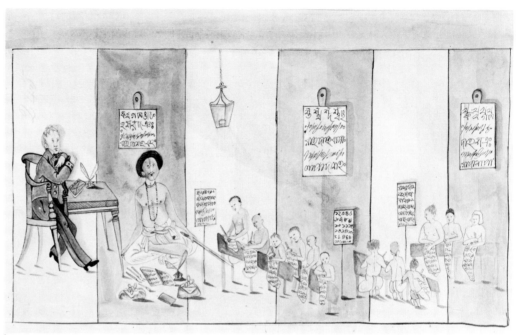

d.

h. Particularly appealing is "A Watchmaker" (folio 307) who resembles a happy mantis, working at a Sheraton table beneath a sign inscribed in wiggly pseudo-English.

Occasionally, the artist takes us into the houses of

i. his own people, as in "Bride and Bridegroom" (folio 274) showing a richly attired Bengali couple seated on a four-poster bed of the sort found today in the crumbling neoclassical mansions of Calcutta's Chitpur Road. But he returns us safely to the Englishman's

j. world in two out-of-door subjects: "European Gentlemen Going a Airing on an [angry-looking] Elephant" (folio 417) in which one of the tightly

k. trousered riders resembles a prune; and "A Hunt in the Sunderbunds" (folio 73). This last describes a triumph of British adjustment to India: a party of Europeans riding to hounds, one of them mounted on an elephant.

According to Mildred Archer, there were three Messrs. Adams in Calcutta during the period of this album: H. Adams, who was assistant to the harbourmaster from 1829 onwards; Sir John Adams, K.C.B., a military officer who served in the Bengal Presidency from 1780 to 1837; and the one of the group most likely to be ours, George Adams of the Bengal Civil Service, who arrived in India in 1828 and served in Calcutta until 1831, when he went to the Hamirpur Division as assistant undercommissioner of revenue.

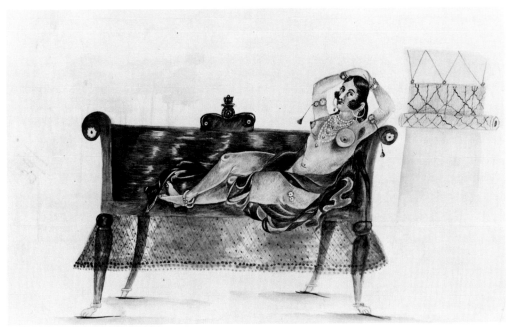

e.

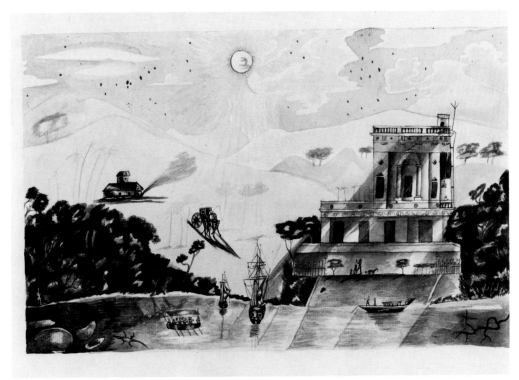

f.

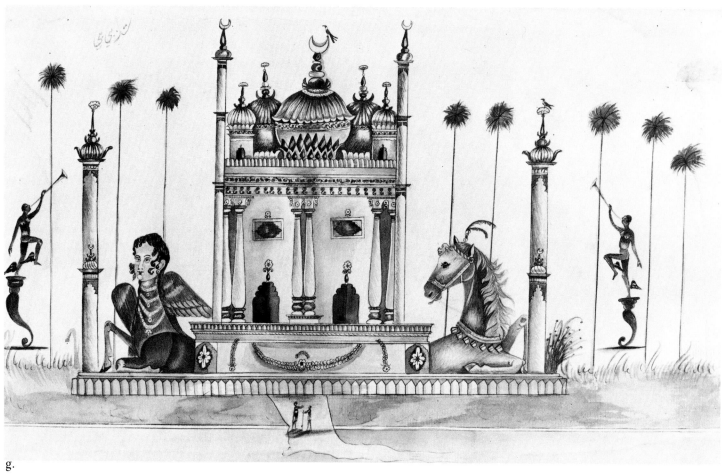

g.

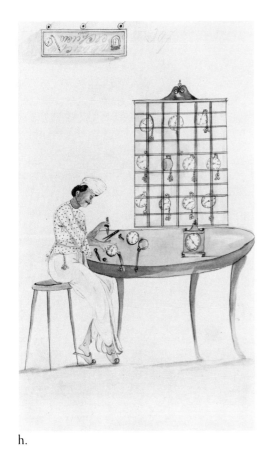

h.

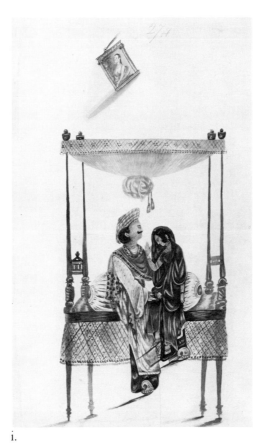

i.

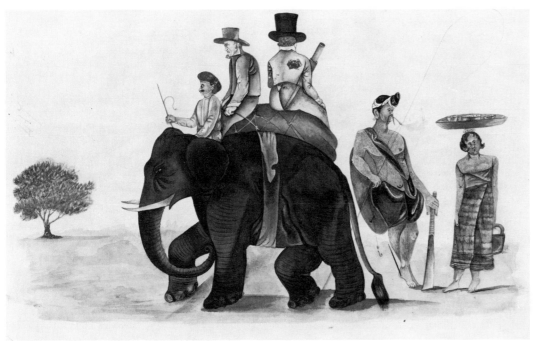

j.

k.

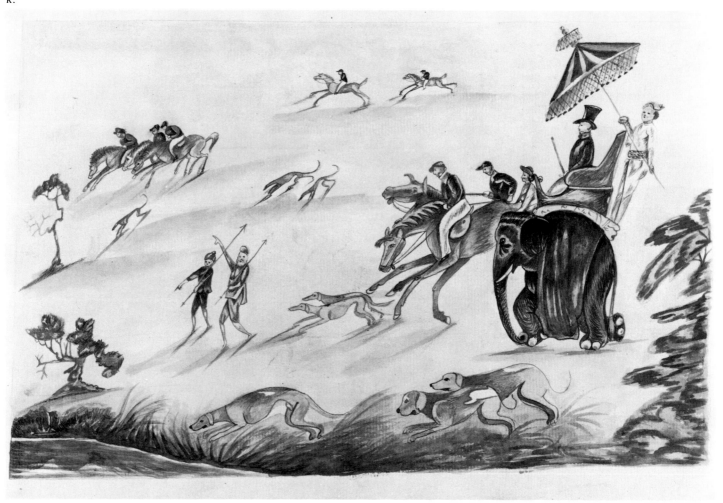

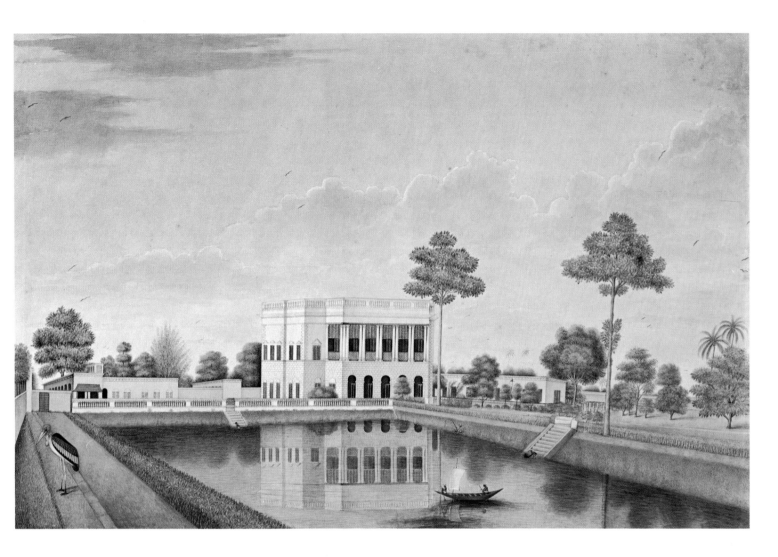

20. HOUSE AND GARDEN, CALCUTTA

Shaykh Muhammad Amir of Karraya
Eastern India, Calcutta; ca. 1845
H. 46.2 cm., W. 68.6 cm.
Lent by the India Office Library and Records

By the 1840's, English life in Calcutta was solidly stable, seemingly unshakable in its prosperity. Among the English, a tight pecking order, as strict as India's caste system, had emerged. At the top was the governor-general and others were stratified according to rank, with members of the civil service or army ranking highest. Beneath them came such lesser branches of officialdom as the police, and those in commerce. The latter were divisible in twain: the bankers and others "in finance," and the mere merchants,

who were "in trade" and branded as "box-wallahs," a word borrowed from their native equivalents, the lowliest of whom went from door to door selling boxfuls of ribbons, thread, and trinkets.

The owner of the splendid house depicted here must have been eminent, though the artist, thus far the only well-known name among Indian artists working for the British in Calcutta, was a true "box-wallah." For Shaykh Muhammad Amir of Karraya (a suburb of Calcutta) of-

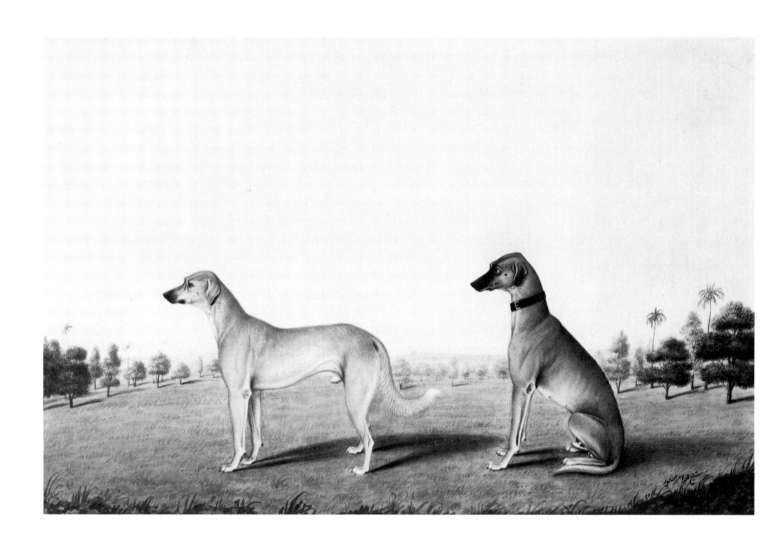

fered his services to all comers, hawking his talents in promising neighborhoods. Although we know of no formal portraits by him, his views of houses and gardens, of housepets, horses, and servants catch the mood of a period that must have been glorious for the blessed few.

This portrait of an airy, neoclassical mansion typifies his gently lyrical, accurately detailed, immaculately finished gouaches. Often touched by humor and whimsey, as evidenced here by the ungainly bird, his pictures also contain elements of sadness, as though he, if not his patrons, knew that the world he recorded would soon be disrupted.

21. TWO DOGS IN A LANDSCAPE

Signed by Shaykh Muhammad Amir of Karraya
Eastern India, Calcutta; ca. 1845
H. 29.6 cm., W. 45.0 cm.
Lent by the Victoria and Albert Museum

From the same set of pictures as the *House and Garden, Calcutta* and the *Tandem* (nos. 20, 22), this especially happy portrait of two beautifully cared-for hounds sparkles with life. The one on the left is about to wag his tail in greeting, while the less demonstrative one gazes ahead with devotion. Open fields, delightful to bound in, stretch into the far distance, with just enough trees for shade.

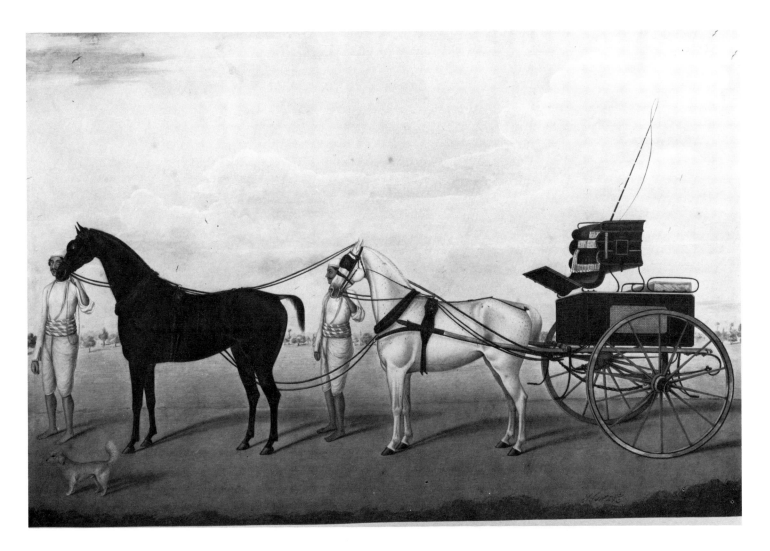

22. A TANDEM HARNESSED TO A HIGH-WHEELED GIG

Signed: Shaykh Muhammad Amir Musavvir (painter's name)
Sakin-i (resident of) Karraya
Eastern India, Calcutta; ca. 1845
H. 46.2 cm., W. 66.1 cm.
Lent by the India Office Library and Records

A household such as the one documented by Shaykh Muhammad Amir depended upon many servants. A decade earlier, Fanny Parks compiled "A List of Servants in a Private Family" (*Wanderings*, vol. I, pp. 209-210), which tells a great deal about upper middle-class Anglo-Indian life.

<div style="text-align:right">wages
rupees per
month</div>

1. A Khanasamah, or head man; a Musalman servant who purchases the provisions, makes the confectionary, and superintends the table	12
2. The abdar, or water-cooler; cools the water, ices the wines, and attends with them at table	8
3. The head khidmatgar; he takes charge of the plate-chest, and waits at table	7
4. A second khidmatgar, who waits at table	6
5. A Bawarch, or cook	12
6. Mate bawarchi	4
7. Mashalchi; dish-washer and torch-bearer	4
8. Dhobee, or washerman	8

9. Istree wala, washerman for ironing 8
10. A darzee, or tailor 8
11. A second tailor 6
12. An ayha, or lady's maid 10
13. An under woman 6
14. A doriya; a sweeper, who also attends to the dogs 4
15. Sirdar-bearer, an Hindoo servant, the head of the bearers, and the keeper of the sahib's wardrobe, the keys of which are always carried in his kamarband, the folds of cloth around his waist 8
16. The mate-bearer; assists as valet, and attends to the lamps 6
22. Six bearers to pull the pankhas (ceiling fans), and dust the furniture, etc. 24
23. A gwala, or cowherd 4
24. A bher-i-wala, or shepherd 5
25. A Murgh-i-wala, to take care of the fowls, wild-ducks, quail, rabbits, guinea-fowls, and pigeons 4
26. A malee, or gardener 5
27. A mate, do. 3
28. Another mate, or a cooly 2
29. A gram-grinder, generally a woman who grinds the chana for the horses 2

30. A coachman 10
38. Eight sa'ises, or grooms, at five rupees each, for eight horses 40
46. Eight grass-cutters, at three rupees each, for the above 24
47. A bihishti, or water-carrier 5
48. A mare bihishti 4
49. A Barha'i mistree, a carpenter 8
50. Another carpenter 7
52. Two coolies, to throw water on the tattis (*khus* grass, to cover windows in hot weather) 4
54. Two chaukidars, or watchmen 8
55. A durwan, or gate-keeper 4
57. Two chaprasis, or running footmen, to carry notes and be in attendance in the verandah 10
57. total rupees per month 290 or about 290 pounds per annum.

One must bear in mind, however, that this lists the servants of Mr. and Mrs. Parks, who ranked moderately high in the pecking order. During the hot season, a dozen or so extra servants were taken on to man the cooling system.

23. PONY RIDING

Signed: Shaykh Muhammad Amir of Karraya
Eastern India, Calcutta; ca. 1845
H. 39.4 cm., W. 52.1 cm.
Lent by The Marquis of Dufferin and Ava

Accompanied by the *khansamah* (head man), a *sa'ise* (groom), and a grass-cutter, and protected from the sun by a bonnet and large parasol, a European child goes riding in a Calcutta garden. Although Muhammad Amir's representations of people, mostly servants, usually avoid the familiarity of close scrutiny, in this case the sahib's son or daughter is totally concealed from his, and our, eyes. Such isolation not only symbolizes the position of the English in India before the Mutiny, but was also one of the Mutiny's causes.

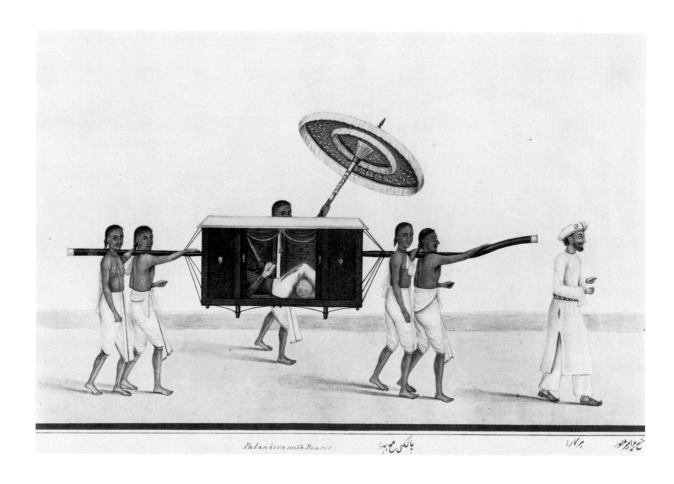

Palankeen with Bearer. پالکی مع بهرہ جر بار شیخ محمد امیر

24. PALANKEEN WITH BEARERS

Signed: Shaykh Muhammad Amir of Karraya
Eastern India, Calcutta; ca. 1835-40
H. 16.1 cm., W. 24.4 cm.
Lent by Mr. Edwin Binney, 3rd

This picture of an English gentleman as he might have
been seen on the streets of Calcutta, is from an album of
pictures by Muhammad Amir commissioned by a Cal-
cutta business man, Thomas Holroyd, Esq. of No. 5 Park
Street, Chowringhee. Although most such houses have
now been torn down or turned into gasoline stations, the
picture of his ghostly residence from this same album has
survived (see: Stuart Cary Welch, *A Flower from Every
Meadow* [New York, 1973], no. 73). Mr. Holroyd, "late
of Fergusson and Co.," having been in 1836 "an assignee
of Cruttenden and Co.," joined the Oriental Club of Lon-
don in 1839, to which he gave this album. It was sold in
the early 1960's.

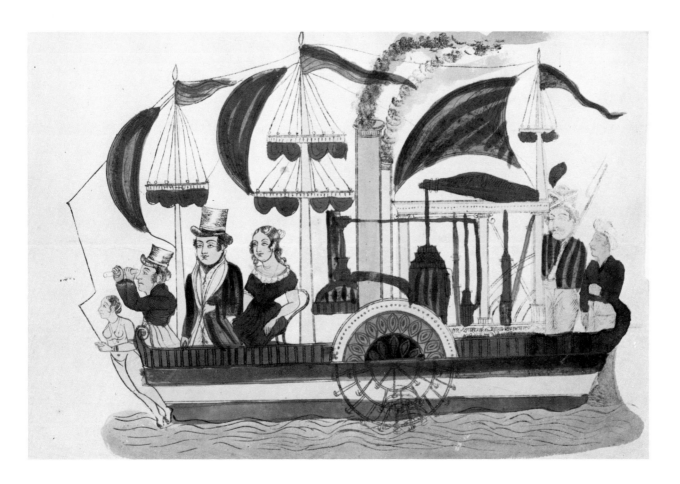

25. EUROPEAN COUPLE ABOARD A PADDLE-WHEEL BOAT

Inscribed (in the lithograph): Becheram Das
Pande, Kalighat, 1857
Eastern India, Calcutta, Kalighat; 1857
Lithograph
H. 28.3 cm., W. 41.7 cm.
Lent by the India Office Library and Records

With all its sails set, smokestack puffing, and paddle-wheel spinning, this unseaworthy vessel might well make the naked lady figurehead on the prow look apprehensive. Nonetheless, the European couple remain fearless—perfect examples of stiff upper lips in action.

Kalighat, on Tolly's Nulla in Calcutta, was the center of worship for the Goddess Kali, to whom Job Charnock, the English founder of Calcutta, is said to have sacrificed cocks in the late seventeenth century. Pilgrims gathered at this shrine to Kali long before the village of Kalikata grew into Calcutta. At least since the early nineteenth century, Kali's worshippers have bought cheaply produced pictures here as souvenirs. Although most of these are boldly brushed portrayals of the goddess and other religious themes, the demand for more topical subject matter was also met by the folkloristic ateliers, who added depictions of local heroes and villains, of notable deeds or atrocities, and of momentous events, such as the coming of the steam-boat. This example is of particular importance for several reasons. It is unusually appealing in subject; it is also rare in being signed, dated, and located; and it demonstrates how by 1857 lithographic printing was being used by the artists as a means of expediting their productions.

See: W. G. Archer, *Kalighat Paintings* (London, 1971); and Mildred Archer, *Indian Popular Painting in the India Office Library* (London, forthcoming).

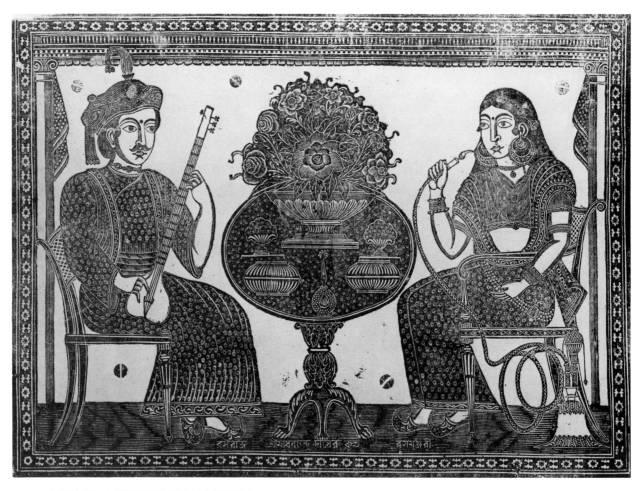

26. A BENGALI GENTLEMAN WITH
HIS LADY

Eastern India, Calcutta; last quarter of the 19th
century
Woodcut
H. 28.8 cm., W. 36.9 cm.
Lent by the Victoria and Albert Museum

While this dignified Bengali pair, seated mostly formally
on English-style chairs at a table decked with a Victorian
arrangement of flowers, would seem to represent marital
bliss, it does not. The *baboo*, strumming a sitar, is of the
genus sugar-daddy, and his lady friend a common
prostitute.

However tame it might seem to us, this woodcut was
intended to shock the traditionally minded Bengalis of
Calcutta and to entice the wickeder among them into
buying it. Such woodcuts are related to the better-known

paintings and drawings of Kalighat (no. 25), which often
illustrate equally depraved situations. In all religions, pil-
grimage centers seem to attract the worldly along with
the spiritual, perhaps because it is impossible to appreciate
either without the other.

The fascinating subject of nineteenth-century Indian woodcuts is
discussed by Mildred Archer in her forthcoming book, *Indian Popular
Painting in the India Office Library.*

27. BENEATH THE SHAMEEANA

Upper India, Patna; ca. 1815
H. 43.6 cm., W. 65.4 cm.
Lent by the India Office Library and Records

Near emptiness is often mysterious; and here the presence of three liveried servants standing at the edges of a courtyard, beneath a vast awning (*shameeana*), augments it. Something seems about to happen—perhaps a wedding, or a reception honoring a British resident.

This picture was acquired by W. G. and Mildred Archer in Patna in 1948 from Ishwari Prasad, a Patna artist descended from a long line of Patna artists. He supplied Mildred Archer with much reliable evidence, based on documents and recollections, which enabled her to write a fascinating account of this offshoot of the Mughal school that adjusted during the nineteenth century to new clients: the local gentry and merchants and the British. Although no artist's name can be linked to this haunting courtyard scene, still so marked by Mughal craftsmanship and flavor, it seems to have inspired Hulas Lal (1785?-1875?) to depict a very similar space, in about 1830, which he populated with spritely ladies celebrating the spring festival of Holi.

See: Mildred Archer, *Patna Painting* (London, 1947), pl. 8.

28. FIVE PET DOGS

Upper India, Patna; ca. 1815 (paper watermarked 1812)
H. 19.0 cm., W. 24.0 cm.
Lent by Mr. Michael Archer and Mrs. Margaret Lecomber

Unpretentious, lacking in virtuosity, and often somber in coloring, Patna pictures nonetheless appeal, sustained by their honesty and a certain innocent sweetness. Few artists have ever drawn doggier pets than these, who romp on, panting and barking, thanks to a humble Patna painter who seems to have enjoyed them as much as did their English master. To carry out his commission, the artist had to overcome the traditional bias against dogs, who were not accepted as "man's best friend" but rather branded as pariahs associated with filth and contamination.

The painterly handling of this sketch is partly due to the technique known as *kajli seahi,* which bypassed outlining in favor of brushwork and coloring.

This picture was acquired by W. G. Archer at Patna in 1948.

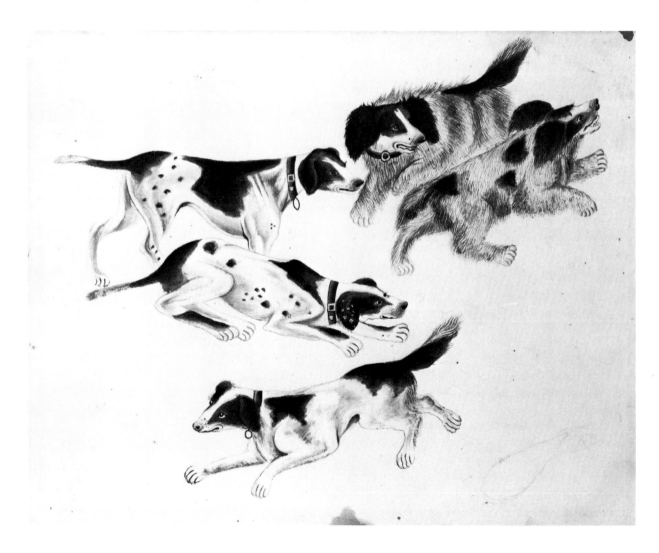

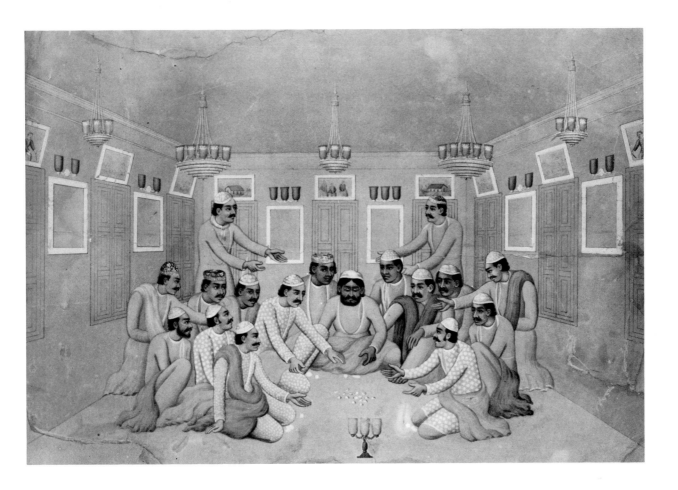

29. MEN GAMBLING AT THE DIWALI FESTIVAL

Attributable to Hulas Lal
Upper India, Patna; ca. 1830
H. 26.3 cm., W. 37.8 cm.
Lent by Mr. Michael Archer and Mrs. Margaret Lecomber

Diwali, the Festival of Lights, is celebrated by Hindus in early winter. Drinking and gambling—here using cowrie shells, the traditional forerunners of dice—are given religious sanction at this time and fully enjoyed.

Hulas Lal (1785?-1875?) painted the den of gamblers wearing winter clothes in a room hung with framed mirrors and pictures, European style. A member of the painter dynasty of Patna recorded by Mildred Archer in *Patna Painting,* he was a son of "Lall-jee," an artist of Banaras, whose work was described by Bishop Heber:

I saw several miniatures by Lall-jee, dead some years since, and by his son now alive, but of less renowned talent, which could have done credit to any European artist, being distinguished by great truth of colouring, as well as softness and delicacy. The portraits I saw were certainly not so good, but they were evidently the works of a man well acquainted with the principles of his art, and very extraordinary productions, considering that Lall-jee had probably no opportunity of so much as seeing one Italian picture. (Reginald Heber, *Through the Upper Provinces of India, Narrative of a Journey from Calcutta to Bombay, 1824-1825* [London, 1828], vol. I, p. 378)

This picture was acquired by W. G. Archer at Patna in 1948 from Shyam Binari Lal, a descendant of the artist.

See: Mildred and W. G. Archer, *Indian Painting for the British, 1770-1880* (Oxford, 1955), pp. 47-48.

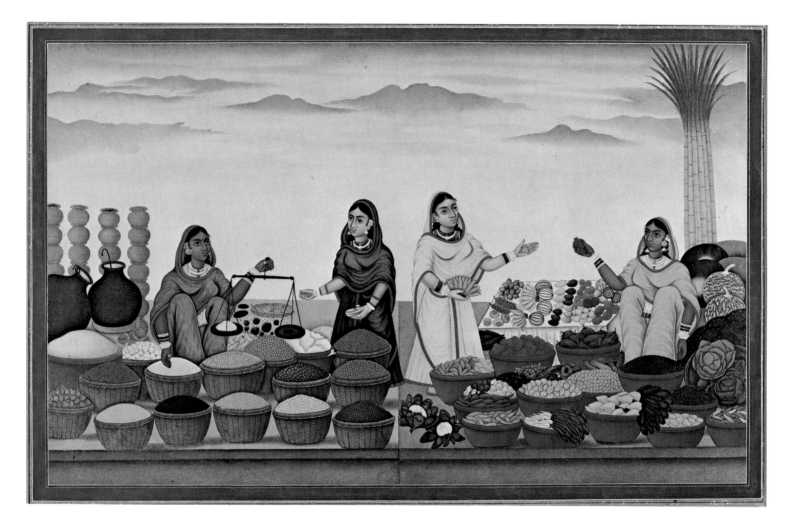

30. WOMEN SELLING FOOD GRAINS, VEGETABLES, AND FRUIT

By Siva Dayal Lal
Upper India, Patna; ca. 1870
H. 20.0 cm., W. 33.0 cm. (without borders)
Lent by the Victoria and Albert Museum

Of all his artistic dynasty, Siva Dayal Lal (1820?-1880?) was the most vibrant colorist. For ornamental grandeur, too, pictures such as this one have few equals in Patna painting. Monumental in its breadth of design, yet detailed in its portrayal of baskets, pots, and edibles, it could almost be the design for a wall painting. Each small area, such as the board of fruits and vegetables, is an artfully planned abstraction; and such shapes as the clouds, resembling distant mountains in a Chinese landscape painting,

are charged with a personal vision.

Conforming to the dispassion of the rest of the picture, the women are generalized, solemn, and slightly aloof—an effect due as much, we suspect, to the artist's personality as to the English patron's attitude towards Indians.

For more information about the artist, see: Archer, *Patna Painting.*

31. A GENTLEMAN'S HOUSE AT CHAPRA

Upper India, Chapra; ca. 1796
H. 37.2 cm., W. 52.6 cm.
Lent by the India Office Library and Records

The Palladian "marble palaces" built by Englishmen in Calcutta were duplicated in the *mofussil* ("the provinces"), as at Chapra, the headquarters of the Saran district north of the Ganges from Patna. The old saw rightly says that "the Englishman's house is his castle," and Indian artists were often employed to paint them. No other example we have seen is as movingly atmospheric as this one, with its sharply silhouetted bushes and flowers, recalling Juan Miro's early gardenscapes, and the implications of buzzing insect life and tropically violent growth rates of vegetation.

Exceptional, too, are the nearly invisible figures, crouched human mushrooms, tending and guarding the absent owner's chastely comfortable residence. Although he is not shown, and his name is not recorded, we sense a benign personality down the years from the lovingly protected young trees and the opened gates, with their quirkily picturesque Gothicism.

Mildred Archer, who discovered this picture, wrote that Chapra came under British administration in 1764, although the Dutch had already settled there as early as the mid-seventeenth century.

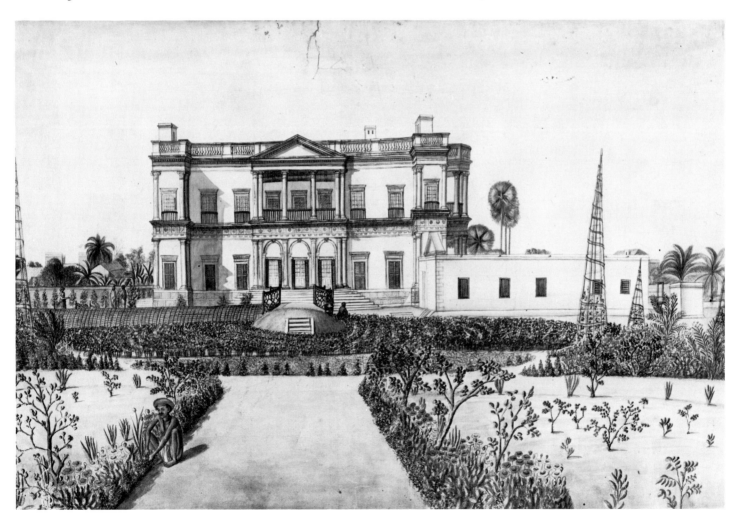

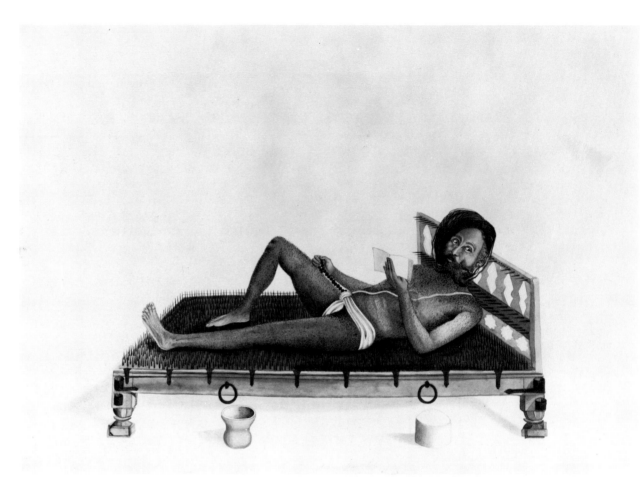

32. A PAIR OF FAKIRS

Upper India, Banaras; ca. 1790
a. Purana Puri, an *urdhabahus* (with arms upraised)
 H. 52.7 cm., W. 36.7 cm.
b. Another Ascetic, on his *kantaka-sayya* (thorn-
 couch)
 H. 33.6 cm., W. 52.7 cm.
 Private collection

Hindu holy men were, and are, among the most pictur-
esque sights in India. This bright-eyed pair was "drawn
from life" by a Mughal-trained artist for Jonathan Duncan
(1756-1811), who came to India in 1772, served as British
Resident at Banaras from 1788 to 1795, and later as gov-
ernor of Bombay, where he died in 1811. He is well
known to historians for his effective discouragement of fe-
male infanticide.

We quote in full a letter in his own hand describing
these portraits, which he must have commissioned while
in Banaras.

An account of two fakirs with
their portraits by Jonathan Duncan Esqr.
Purana Puri the first of these fakirs is certainly one
of the most extraordinary travellers of the present
age, and when it is recollected that his journeys
were performed on foot with his arms and hands in
fixed position above his head (an attitude con-
stituting the penance which he has chosen for him-
self), they cannot be considered without
astonishment. He is a native of Canuj; and with-
drawing from his father's house at nine years of age
he soon afterward became a faquir, and placed his
arms in the position which they have ever since re-
tained. From Allahabad he proceeded by Auranga-

bad, Poona, and Cochin to Bamissor, a celebrated place of devotion at the extremity of the Indian peninsula; whence he returned by the eastern coast of Jaggernat. Going again to Bamissor, he crossed over into Ceylon; and he mentions several places on that island, venerated by Hindus. Thence he went to Malacca, and returned by sea to Cochin; whence he travelled along the west coast, and continued in a northerly direction till he crossed the Attoc, and then turn'd easterly to Hardwar, where the Ganges enters the plains of Hindustan. From this place of devotion he again departed in a westerly direction, through the upper parts of the Punjab to Cabool, and thence to Bamian; where he mentions with admiration the number of statues that still exist, though the place itself has been long deserted by its inhabitants. He now proceeded to Asterabad, on the borders of the Caspian Sea; and to the "flaming mouth," being a spot in the neighbourhood of Bacu, whence fire issues. Here embarking on the Caspian he went to Astracan, and thence to Moscow. Here his course terminated in this direction, and returning to Astracan, he recrossed the Caspian, travelled to Isfahan, Shiraz, and Basora; whence proceeding to Muscat, he embarked for India. On his return from a second voyage to Arabia, he journeyed to Balkh, where he found some Hindus, to Bokhara, and to Samarcand, which he describes as a large city; and whence he arrived after a ten days' journey at Badokshan in Tartary; in the hills around which rubies are found. Here turning south he visited Casmir and Nepal; whence he proceeded into Thibet, to the respective seats of the Dalai and Tesu Lama, and prosecuted his journey northwards till he reached the Mana Saravora, a lake six days' journey in circumference, whence flow the Brahmaputra, Swiju, and Sutlij rivers. On his return, he was charged by the lama with dispatches for Mr. Hastings; who conferred a small village, in free tenure, on this remarkable pilgrim. [One wonders if he was not employed by Warren Hastings as an intelligence agent.]

The penance of the second Faquir is that of reclining on a bed of iron spikes. His travels were also very extensive; carried as we suppose, by his disciples.

So fond was he of Banaras, that while governor of Bombay, Jonathan Duncan wrote letters to Lord Welles-

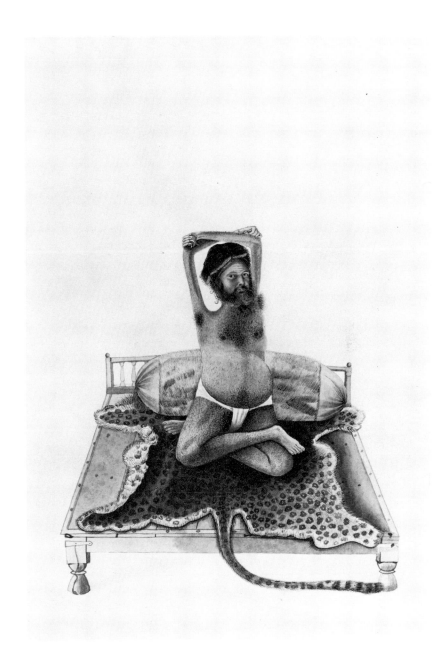

ley asking to be returned to his former post. He is said to have become a legend at Banaras, where the highest tribute an Englishman could be given by a local was to be called "Duncan Sahib's younger brother."

See: Edward Ingram, *Two Views of British India: The Private Correspondence of Mr. Dundas and Lord Wellesley* (Bath, n.d.); Philip Woodruff, *The Men Who Ruled India*, vol. 1: *The Founders* (New York, 1954), pp. 238-239; and John C. Oman, *The Mystics, Ascetics, and Saints of India (1903, reprinted Delhi, 1973).*

33. HEAVENLY PALACES AND GARDENS

Signed: The Work of Faiz-ullah
Upper India, Oudh, Faizabad; ca. 1765
H. 50.3 cm., W. 69.2 cm.
Private collection

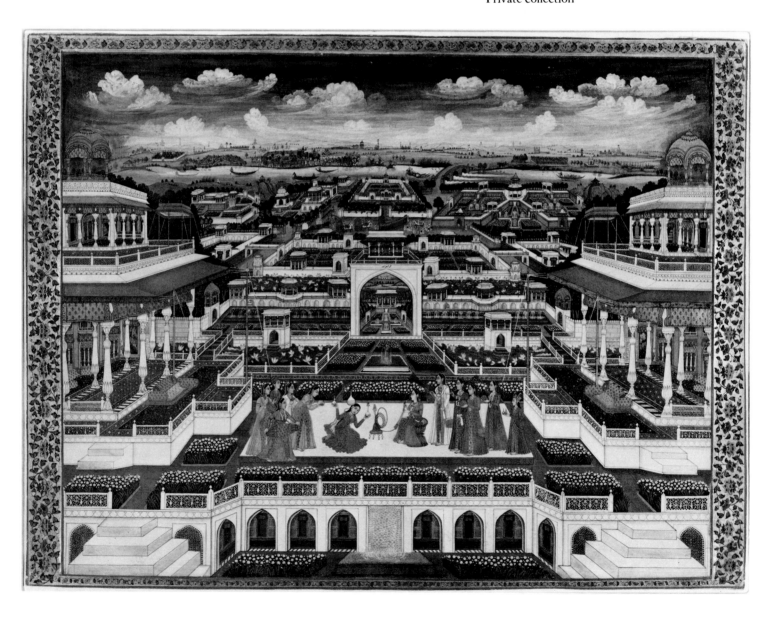

European "scientific" perspective struck Faiz-ullah, the artist of this picture, with the force of a custard pie. Befuddled by its principles, but thrilled with their effect, he peppered the composition with vanishing points and created a boundingly staccato view of a Mughal heaven on earth. In spite of its spatial chaos, we can prowl through the palace, across its marble terraces, up flights of stairs to private chambers and kiosks for secret trysts; or amble through infinite formal gardens, courtyards, and bowers. In the center of this packed design, thanks to the artist's carefree handling of space, an archway opens into a seeming tunnel of subterranean delights.

Although the people here are second to the architecture, they also conform to a late Mughal ideal, contributing to the rococo ambience. In the foreground, a skillful girl entertains the harem ladies by balancing a flask of wine or *attar* (perfume) on her right ear. Across the river, the menfolk spend the day at their occupations: hunting and watching animal combats.

This large and pleasingly vulgar picture was probably painted for the third Nawab Wazir of Oudh, Shuja-ud-daula (r. 1756-1775), at his capital, Faizabad. As the central government of the Mughals weakened, the governors of Oudh, Bengal, and Hyderabad gradually rivaled the central power. While continuing to do lip service to the emperor, they returned to him less and less of the revenues, and whenever possible they lured away his most talented poets, artists, and musicians. Oudh and Bengal, however, were fools' paradises, comparable to lusciously ripened mangoes, about to topple from the tree. Hungry and eager, the British waited, hands outstretched.

For other paintings by the same hand, see: Mildred Archer, "Gardens of Delight," *Apollo* (September, 1968), figs. 17 and 18.

34. A EUROPEAN GENTLEMAN WATCHING NAUTCH GIRLS

Signed: Mihr Chand son of Gunga Ram
Upper India, Oudh, Lucknow; ca. 1780
H. 29.0 cm., W. 39.6 cm.
Lent by Prince Sadruddin Aga Khan

Late eighteenth and nineteenth-century Oudh, with its capital at Lucknow, was an Indian mixture of today's Teheran, Monte Carlo, and Las Vegas, with just a touch of Glyndebourne for good measure. Although a series of Company officers and Residents (after 1773) tried to keep the Nawabs in hand, they seldom succeeded, for the vastly rich, imaginatively sensual, selfish, childish, yet often generous and charming Nawabs were untameable. An international cast of Westerners, magnetized by Lucknow's giddy reputation, flocked there during the late eighteenth century. Among them was General Claud Martin (1735-1800), a French *bon vivant* who combined business acumen with delusions (?) of grandeur and built "Constantia," one of the looniest palaces in India, which he left to be used as a boys' school, as it still is. Other residents included Colonel Antoine Polier (1741-1795; see also no. 36), a Swiss soldier of fortune with scholarly and artistic leanings, who left the Company's army in 1772, to serve the Nawabs of Oudh, and who was eventually murdered in France; and Colonel John Mordaunt, the zealous amateur of cockfighting, who brought his feathered condottieri all the way from England in the hope of defeating the Indian breed (no. 39).

The anonymous European in *nawabi* dress, enjoying the nautch (dance) while smoking a hookah and sitting on a Sheraton sofa, must have been an active member of Lucknow's international set. While his portrait may have been commissioned tongue-in-cheek, Mihr Chand, the best-known Lucknow Mughal artist, took it seriously and created one of his outstanding pictures, lavishing on it rich ornament, golden highlights, and dragonish skyrockets.

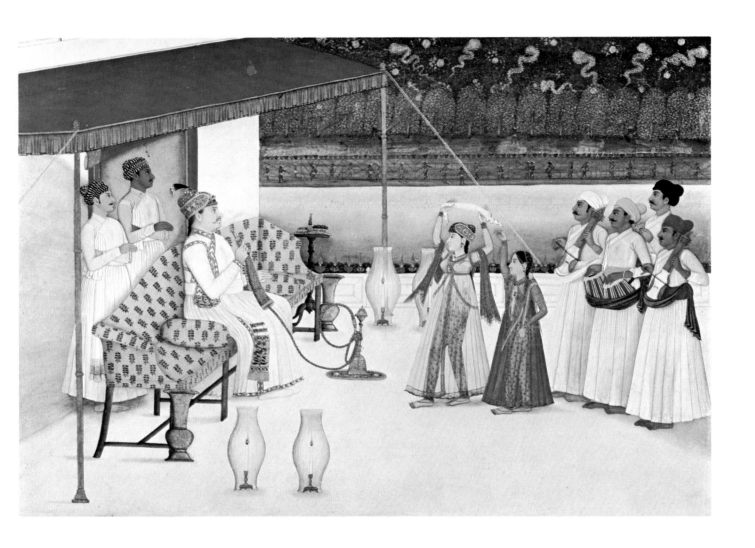

35. NAWAB SHUJA-UD-DAULA

Probably by Mihr Chand, after an oil painting by
Tilly Kettle
Upper India, Oudh, Lucknow; ca. 1780
H. 44.6 cm., W. 60.9 cm.
Private collection

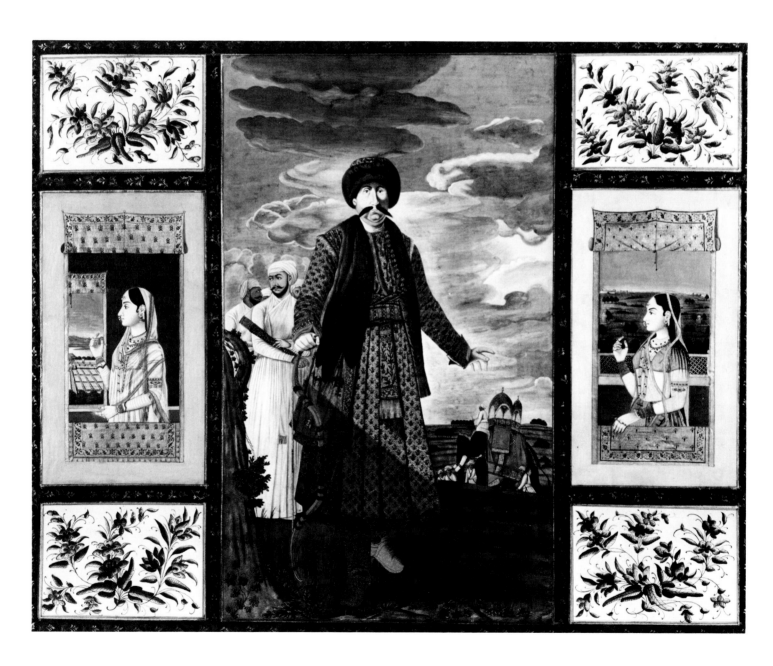

Shuja-ud-daula (r. 1731-1775), probably the most admirable of the Oudh rulers, proved his capacity by resisting the pressures of the Marathas, the Rohilla Afghans, and the British, a considerable accomplishment made feasible by Oudh's geographical position and wealth. He reorganized the armies along European lines, with the help of such mercenaries as Colonel Jean Baptiste Joseph Gentil. Along with flourishing ateliers of painting, he maintained such Urdu poets as Sauda, Mian Hasrat, and Ashraf Ali Khan. His capital was Faizabad, where he moved from Lucknow in 1765.

Physically powerful, he was noted for his might in drawing a huge bow, such as the one he holds here. His harem contained seven hundred wives, two of whom, in idealized form, stand in windows of this album page. The central portrait was copied from an oil painting by Tilly Kettle, the first English portraitist to have braved India. Born in 1735, the son of a house painter, he studied in Richmond and London. After a mildly successful few years working in Oxford and the Midlands, he went to India in 1768, first to Madras, where he painted Company servants and the Nawab of Arcot, in the Carnatic. In 1771, he moved to Calcutta; but by this time Shuja-ud-daula had learned of him and invited him to Faizabad, where he painted with great success in 1772. One of his portraits of the Nawab was given by the sitter to Colonel Gentil, who in turn presented it to Louis XVI. It still hangs at Versailles.

Before leaving Faizabad, Colonel Gentil had borrowed that portrait as well as three other Kettles to be copied by Indian miniaturists. Apparently, this was common practice, or soon became so, for the copy here was made for Colonel Polier (nos. 34 and 36). He presented it along with the rest of the album to Lady Coote, presumably the widow of Sir Eyre Coote (1726-1783), the brilliant and erratic Company soldier who amassed a great fortune, went home, and was elected to Parliament. After returning to India in 1777, he died as commander-in-chief against Haidar Ali in Mysore.

Although it is unsigned, the excellent quality of this copy links it to Mihr Chand, the Lucknow artist who included such work among his specialties.

See: Mildred Archer, "Tilly Kettle and the Court of Oudh," *Apollo* (February, 1972), pp. 96-106.

36. COLONEL ANTOINE LOUIS HENRI POLIER WATCHING A NAUTCH

After an oil painting by Tilly Kettle
Upper India, Faizabad or Lucknow; ca. 1780
H. 25.0 cm., W. 32.0 cm.
Lent by Mr. Michael Archer and Mrs. Margaret Lecomber

Colonel Polier (1741-1795) was born in Switzerland to a French Protestant family. In 1757, he followed his uncle's example by joining the East India Company, serving at Masulipatam and in Bihar. In 1761, he was transferred to Bengal and commissioned as a captain lieutenant of engineers. Promoted to major in 1767, he later became discouraged by a ruling that forbade foreign officers from rising beyond that rank and accepted the invitation of Shuja-ud-daula to go to Oudh as engineer. His career at Oudh, where he arrived in 1772, was a success, though marred by continuing unpleasantness with the Company, from which he resigned in 1775, but to which he was readmitted in 1782. Enriched by private trade, he also served as engineer and architect to Shuja-ud-daula's son, Asaf-ud-daula (r. 1775-1797). When the new Nawab moved to Lucknow from Faizabad, Polier settled in a large bungalow, where he kept his collections of Indian manuscripts and paintings. He joined the Asiatic Society of Bengal in 1784, five years before returning to Europe. There, he married in 1791 and settled in Avignon, where he was murdered by robbers two years later.

Mildred Archer has identified this finely painted gouache, by an excellent Mughal artist, as a copy after a lost oil painting by Tilly Kettle, dating from 1772, when both artist and sitter were in Faizabad. Polier wears native dress, perhaps to please the Nawab, who was not fond of Europeans. Mary Webster, who has seen the painting, points out that its statuesque solidity is typical of Kettle, as opposed to the more agitated figures in the work of Johann Zoffany, who painted Polier at Lucknow in 1786.

See: Archer, "Tilly Kettle," and Mary Webster, *Johann Zoffany 1733-1810* (London, 1976). The conversation piece portrait of Polier is No. 105 in this catalogue. See also: Antoine Louis Polier, *Shah Alam II And His Court*, ed. P. C. Gupta (Calcutta, 1947), and Mildred Archer, *India and British Portraiture: 1770-1825* (forthcoming).

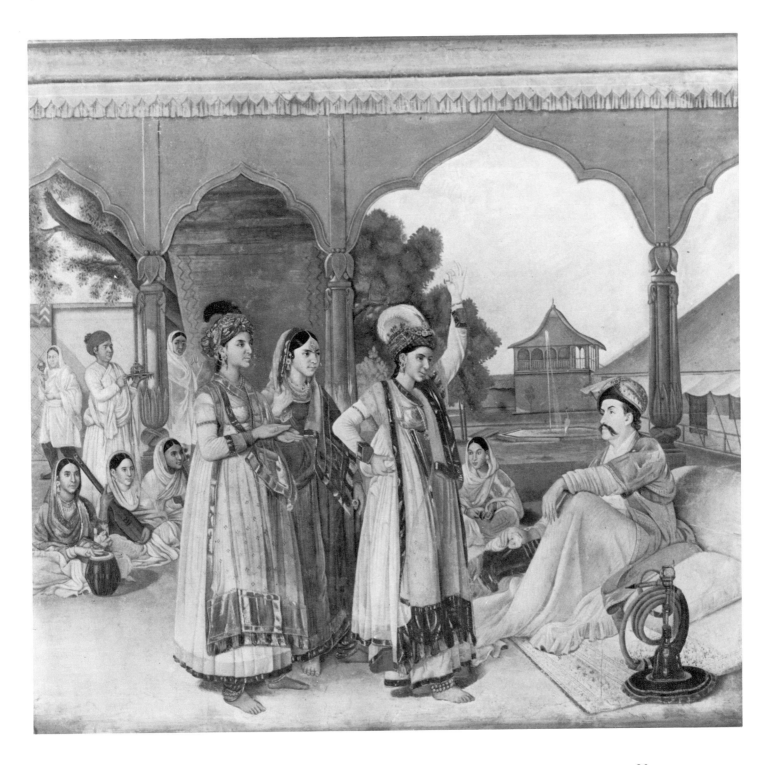

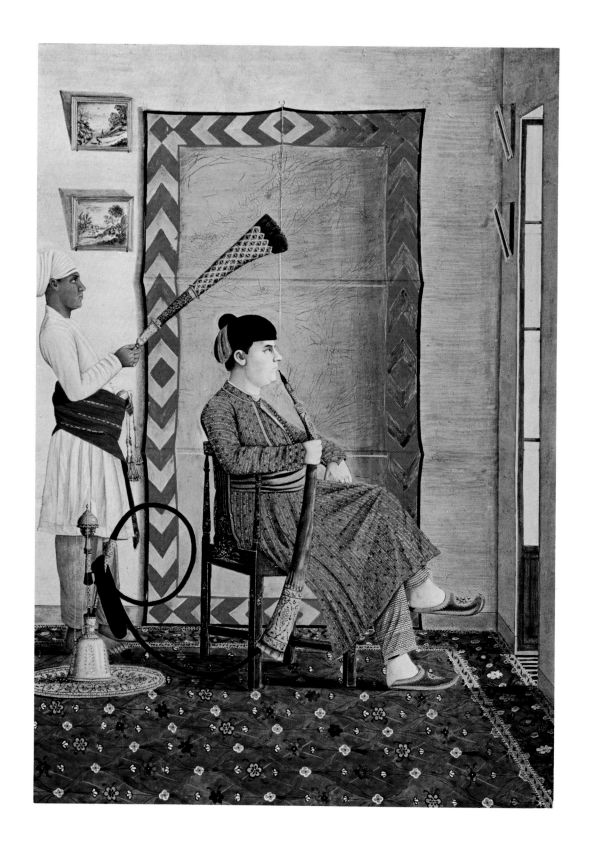

37. JOHN WOMBWELL

Upper India, Oudh, Lucknow; ca. 1785
H. 41.0 cm., W. 30.8 cm.
Lent by Prince Sadruddin Aga Khan

Another member of the European group at Lucknow was John Wombwell, the Company's accountant. Like his friend Colonel Polier, as whose guest he was portrayed in the 1786 Zoffany conversation piece, he enjoyed the comfort of Indian clothes, as here in this dramatically shadowed, tautly honest characterization. Seated on a black and gold chair in plump profile against a subdued blue-green and red textile he puffs his hookah and gazes through an open door into the morning light. Behind him, holding a peacock-feather fly whisk, stands a handsome young servant in a white turban and a coat with a voluminous sash. His pose and personality invite comparison to a strikingly similar servant in another Lucknow portrait of about the same date, showing a stout gentleman, possibly also English, seated on a terrace by the Gumti River. In every way that picture is markedly close to the Wombwell portrait, and we believe both are by the same excellent painter, one of the circle of Mihr Chand (see: E. Blochet, *Collection Jean Pozzi, Miniatures Persanes et Indo-Persanes* [n.p., 1930], pl. LIV. Yet another portrait by this artist, from the Bibliotheca Phillippica, was sold by Sotheby's on November 27, 1974, lot 727). We find it hard to believe that these paintings, although influenced by the work of Kettle, were actually copied from European originals.

38. IN THE STREETS OF LUCKNOW

Upper India, Oudh, Lucknow; 1790-1800
H. 32.7 cm., W. 46.2 cm.
Lent by the India Office Library and Records

We are oppressed by the wind and the hot sun, and by the tension. Two horsemen and their footmen interrupt the market's calm, unsettling us more than the merchants and porters, who are used to the commotion. For Lucknow was a bustling and important trading center as well as the market for Oudh's rich harvests. Notwithstanding the interlopers' bravado and panoply, our eyes are drawn to the hagglers and gossipers, to the bent old man across the road, and to the shops themselves. As is so often still the case in India, a walk in the streets hyper-stimulates. Textures, shapes, and colors are too picturesque; the clusters of people offer too many anecdotes; personalities are over-vivid. Life is a play acted only by "stars," and we cannot muster enough empathy, laughter, or pathos to meet their challenges.

Every face in the crowd has been seen as a portrait by the Mughal-trained, but European-influenced artist, who specialized in densely populated scenes of Lucknow, often interpreted with cynical wryness, masterfully and deliberately disturbing. Although his name is not known, his style was personal and original, reminding one that Oudh's Urdu poets were not alone in making important contributions at this time. His soured view of life should be ascribed, perhaps, to Oudh's loss of independence following the death of Shuja. His son, Nawab Asaf-ud-daula (r. 1775-1797), convinced by the British that their troops guaranteed security, devoted himself to a life of pleasure. He transferred his court from Faizabad to Lucknow, where he spent huge sums on palaces, mosques, and shrines, determined to make it more splendid than Hyderabad, the Nizam's capital in the Deccan. If one regards the late Mughal period in Oudh as a phase of decline, 1775 marks the beginning of the end.

See: Archer, *Company Drawings*, p. 159, no. 121i.

39. COLONEL MORDAUNT'S COCK MATCH

A copy after the oil painting by Johann Zoffany
Upper India, Oudh, Lucknow; ca. 1800
H. 46.0 cm., W. 66.2 cm.
Private collection

In 1784, on a visit to Lucknow, Warren Hastings witnessed a colorful match between Colonel Mordaunt's English cocks and the Indian ones of Nawab Asaf-ud-daula. The festive atmosphere moved him to invite from Calcutta the great painter of conversation pieces, Johann Zoffany. Zoffany accepted the governor-general's invitation and came to Lucknow, where he painted two versions of the subject. The first, for Hastings, now in an English private collection, was painted between 1784 and 1786; the second, a simplified version, with fewer figures, was made for the Nawab. It remained in Lucknow until the Mutiny of 1857, when it appears to have been destroyed. A mezzotint version of the first was printed in 1792.

Colonel John Mordaunt, the illegitimate son of the Earl of Peterborough, commanded the bodyguard of the Nawab, a fellow enthusiast of cockfighting. In Zoffany's masterpiece, he is shown elegantly dressed in white, somewhat resembling a ballet dancer between entrechats. The massive Nawab, having stepped from his *musnud* (throne of pillows), rushes towards him, in the heat of excitement.

All of the elite of Lucknow gathered for the Colonel's match. John Wombwell, thinner than in either his 1786 Zoffany portrait or in the slightly earlier Indian one we illustrate (no. 37), sits by the vacant throne, looking as uninvolved in the sport as only an accountant could. General Martin, in full uniform, perches on the throne platform, conversing with Mr. Trevor Wheler, who holds a rooster.

The present gouache can be considered an interpretation rather than a copy, based on the mezzotint of 1792 rather than on Hastings's original, which was sent to England in 1788, or on the Nawab's simplified version. We date it to about 1800 on the basis of the painting of faces, which retain elements of the eighteenth century. Its ruggedly striped *shameeana* (awning) and other painterly variations are consistent with the ways of Indian artists, who, like Indian musicians, invariably improvised on given themes.

See: Webster, *Johann Zoffany*. Mildred Archer, in "Tilly Kettle," refers to watercolor copies made from the Lucknow version in 1853. See also her forthcoming *India and British Portraiture: 1760-1825*.

40. MAKING FIRE WORKS

Upper India, Oudh, Lucknow; ca. 1815-20
H. 23.7 cm., W. 19.9 cm.
Private collection

The Mughals adored fireworks; and no celebration, how-
ever minor, was quite complete without them. Nor was
any effort too great in creating pyrotechnical effects. This
small painting, from a set illustrating occupations, shows a
patient craftsman covering an elephant-shaped armature
with combustible paste. One wonders if his creation of
countless hours caused many Lucknow noblemen to raise
their eyes from dinner for its triumphant flash.

At Lucknow during its century or so of "decline," the
pursuit of pleasure became a major goal. Courtesans,
dancing girls and boys, animal combats, pigeon-flying,
and story-telling were all cultivated to new heights (or
lows); and when such joys palled, the singing of dirges
lamenting the Shiah martyrs Husain and Hasan provided
an elevating antidote.

Gastronomic virtuosity was also explored. Abdul
Halim Sharar recounts that "Asman Qadar's cook, Shaikh
Husain 'Ali, had covered the tablecloth with hundreds of
delicacies and many varieties of comestibles. There were
*pulau, zarda, qaurma, kababs, biryani, chapatis, achars, pa-
rathas, shir mals*—in fact every kind of food. However,
when tasted they were all found to be sugar." (Abdul
Halim Sharar, *Lucknow: The Last Phase of an Oriental
Culture* [London, 1975], p. 157). Presumably, this culi-
nary jest was followed by something more nourishing.

Four paintings from this same series are in the India Office Library.
See: Archer, *Company Drawings*, p. 160, no. 123 i-iv, and frontispiece.

41. GHAZI-UD-DIN HAIDAR ENTERTAINS
LORD AND LADY MOIRA

Upper India, Oudh, Lucknow; ca. 1819
H. 34.6 cm., W. 48.1 cm.
Lent by the India Office Library and Records

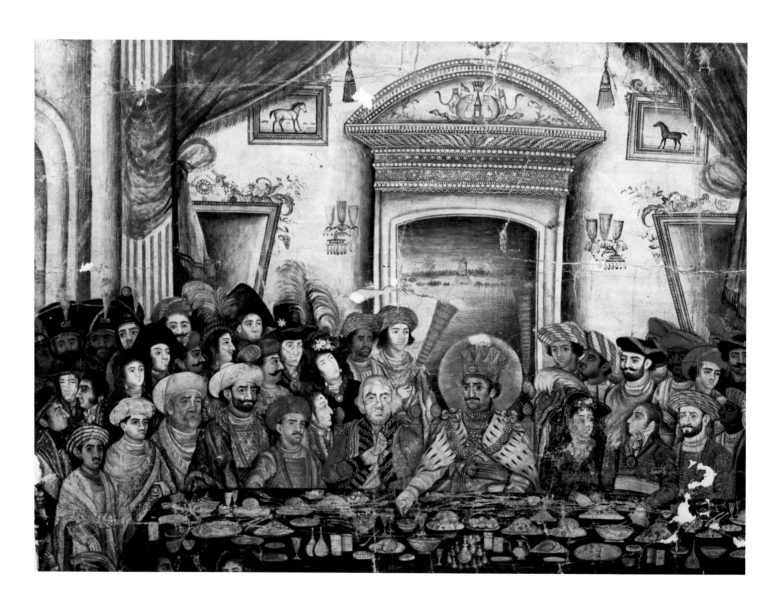

Being a mere Nawab Wazir seemed demeaning for Ghazi-ud-din Haidar (r. 1814-1827), who promised to lend huge sums to the Company. So thought Lord Moira, the governor-general from 1812 to 1823, when he suggested that "King" of Oudh might suit him better.

This elevation of rank took place in 1819. Perhaps the plot was being hatched already in 1814, when Lord and Lady Moira were feted by Ghazi-ud-din, the subject of this picture; but the kingly crown on the then-Nawab's head proves that the scene's depiction was commemorative. Nonetheless, the artist caught the mood and setting of the party, down to the majestically stern monarch's reaching into the welter of cups and dishes for the initial tidbit, the eating of which, like a pistol shot at a race meet,

began the feast. Through a doorway of the Anglo-Indian pleasure dome, we see the Gumti River, a refreshing escape from the oppressiveness of classical columns, swags, and crystal girandoles.

"Protected" by the presence in Oudh—at the Nawab's expense—of sixty thousand Company troops, Ghazi-ud-din was free to indulge his extravagant fancies. Like press photographers, his artists were at hand to document the revels, in gouache thickly piled to resemble oil paints.

A very similar painting is in the collection of the Victoria Memorial, Calcutta.

See: Archer, *Company Drawings*, pp. 159-160, no. 122.

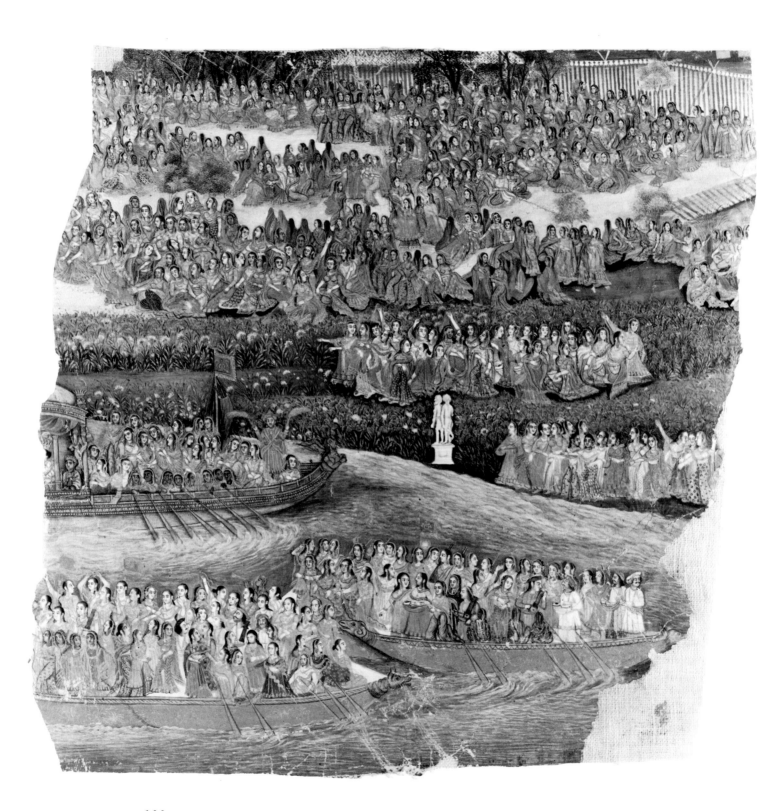

42. SOME OF THE KING'S WOMEN

Upper India, Oudh, Lucknow; ca. 1815
H. 33.0 cm., W. 32.0 cm.
Private collection

Ripped through the king's face, perhaps during the Mutiny, this fragment of a painting depicts a festival along the Gumti River. A red-orange army of women, each posed differently and a seeming portrait, greets Ghazi-ud-din, who is being rowed towards the bank by lady oarsmen. Other than the king, only a few participants are of the male sex—unless we count the dazzlingly white figures of the Italian garden sculpture.

Softly, flamboyantly sensual, like the Urdu poetry of Atish, Nasikh, and Saba, the later paintings of Lucknow require an open mind and innocent eyes to look beyond their superficialities. As can be seen here, their artists spared no pains; and if their structures are boneless as clouds or water, these underestimated masters must be acknowledged as among the more inventive and painterly of Indian miniaturists.

For translations of the poetry of this period, see: Ahmed Ali, *The Golden Tradition, an Anthology of Urdu Poetry* (New York and London, 1973).

Like an old caged bird, Shah Alam perches in his multi-columned throne, a pastiche replacement for Shah Jahan's. His pathetic, silent isolation contrasts with the carpet's arabesque tangle, sharp as barbed wire. The artist makes us sense the emperor's blindness by emphasizing his odd facial angle, closed eye, and his nervous fingering of rosary beads.

As a boy, 'Ali Gauhar, who became Emperor Shah Alam II (r. 1759-1806), saw the Persian conqueror Nadir Shah ride into Delhi. He had the misfortune to rule at a time when the Mughal Empire was crumbling; and however determinedly and cleverly he tried, he could not arrest it. Early in his career, realizing that the British were Mughal India's severest threat, he joined with Nawab Shuja-ud-daula of Oudh in an attempt to recover Bengal. After the emperor's defeat at Baksar in 1764, one of Warren Hastings's agents described him as being "tenacious of royalty as if it was attended with all the power and renown of Acbar and Aurangzeb." In exchange for the right to the revenues and rule of Bengal, the Company agreed to give him twenty-four lakhs of rupees annually. But he was to remain in Allahabad, where a Company general watched over him, and he was deprived of many prerogatives, such as the right to play the ceremonial *naubat* music.

In 1771, he returned to Delhi with the aid of the Marathas, who successfully repulsed the Sikhs, suppressed the Jats, and recovered Agra. But in 1782, his fortunes again deteriorated. His able chief minister died and one-third of the rural population fell victim to famine. Desperate, Shah Alam II invited the Maratha leader, Mahadaji Sindhia, to come to his aid in 1785. The new alliance was defeated in 1787 by the Rohilla Afghan Ghulam Qadir, who seized Delhi, eager for its legendary wealth. When he found none and the unfortunate emperor in all honesty denied its existence, the enraged Afghan blinded and mutilated him with his own knife. Later, the villain was caught by Sindhia. His tongue was torn out, his nose, ears, hands, and feet lopped off, and the remaining hulk was carried away for the emperor's delectation. The guards, however, found the load burdensome and hung him upside down on a tree where a black dog is said to have licked the dripping blood.

In 1803, during the second Maratha War, Lord Lake defeated the Marathas and advanced towards Delhi, setting up camp along the Jumna River. Shah Alam at once came to terms and sent his heir to invite the commander-in-chief to his presence.

Lord Lake was received in the Hall of Private Audience and was honored by being given Mughal titles: Sword of the State, Hero of the Land, and Lord of the Age. Before leaving Delhi, he appointed Colonel David Ochterlony (no. 46) British Resident at the Mughal court.

103

44. A MARKET STREET IN OLD DELHI

North India, Delhi; ca. 1810
H. 27.6 cm., W. 43.3 cm.
Private collection

Although the last direct descendant of the Mughal imperial house died without issue in Calcutta a few years ago, the Mughal mystique survived, centered in Old Delhi. The empire's (and city's) "twilight," the decline which may have begun when Emperor Aurangzeb (r. 1657-1707) moved his court to the Deccan in the seventeenth century, long outlasted Mughal imperial might. One could argue that the afterglow lingers to this day; for even now Mughal ways continue. Mughal songs are still sung; Shah Jahan's great mosque remains in use; and, as in the eighteenth century, one can visit shops in Chandni Chowk (Old Delhi's lively market street) to buy sweets of the old sorts or traditional spicy perfumes, poured from flasks stored in a beautiful coffer that has served the same firm since Mughal days.

Comparably timeless is the crowd of buyers and sellers and curiosity-seekers that seethes through the streets of another Old Delhi *chowk* in this picture. According to an inscription, it is "A painting of Shah Jahanabad [Delhi], showing the Sadullah Chowk; with the Delhi Gate, the Mosque of Nawab Bahadur, and opposite, in the distance, the Nimudhar Kila." Professor Cyrus Jhabvala, who helped decipher the inscription, suggests that it probably represents the now destroyed Faiz Bazar, which ran from the Delhi Gate of the Red Fort, past the Golden Mosque, to the Delhi Gate of the city.

The author is also grateful to Renana Jhabvala, Ismail Merchant, and Willard Wood for help in reading the inscription.

North India, Delhi; ca. 1811
H. 24.3 cm., W. 16.3 cm.
Lent by Mr. Edwin Binney, 3rd

During the Residency Period, the Mughal emperors, now known as the kings of Delhi, held sway over not much more than their own palace in the Red Fort. Stately but shabby puppets, they were among the sights of India for prestigious visitors to inspect and describe in letters home. Reginald Heber, the Lord Bishop of Calcutta, published his description of Akbar Shah II (r. 1806-1837) as seen in an imperial audience of 1824:

> He has a pale, thin, but handsome face, with an aquiline nose, and a long white beard. His complexion is little if at all darker than that of a European. His hands are very fair and delicate, and he had some valuable-looking rings on them....Akbar Shah has the appearance of a man of seventy-four or seventy-five; in this country that is a great age. He is said to be a very good-tempered, mild, old man, of moderate talents, but polished and pleasing manners. His favourite wife, the Begum, is a low-born, low-bred, and violent woman, who rules him completely, lays hold of all his money, and has often influenced him to very unwise conduct towards his children, and the British Government. She hates her eldest son [the future Bahadur Shah II, no. 52], who is, however, a respectable man of more talents than native princes usually show, and, happily for himself, has a predilection for those literary pursuits which are almost the only laudable or innocent objects of ambition in his power. (*Narrative of a Journey,* vol. II, p. 302)

The Begum's particular hatred for Prince Abu Zafar, the emperor's eldest son, who later ruled as Bahadur Shah II, relates to the episode depicted in this painting. For she had spared no efforts, including murder, to promote her own son's interests over his; and her son, Mirza Jahangir, who died of drink at thirty-one in 1831, is shown here, elegantly long-haired, riding behind his father. It seems likely that the dramatic moment recorded by the artist was the arrival of the mild Archibald Seton in 1811, bearing Lord Minto's refusal to recognize Mirza Jahangir as heir.

For the historical background, see: Percival Spear, *Twilight of the Mughals* (Cambridge, 1951), especially p. 42.

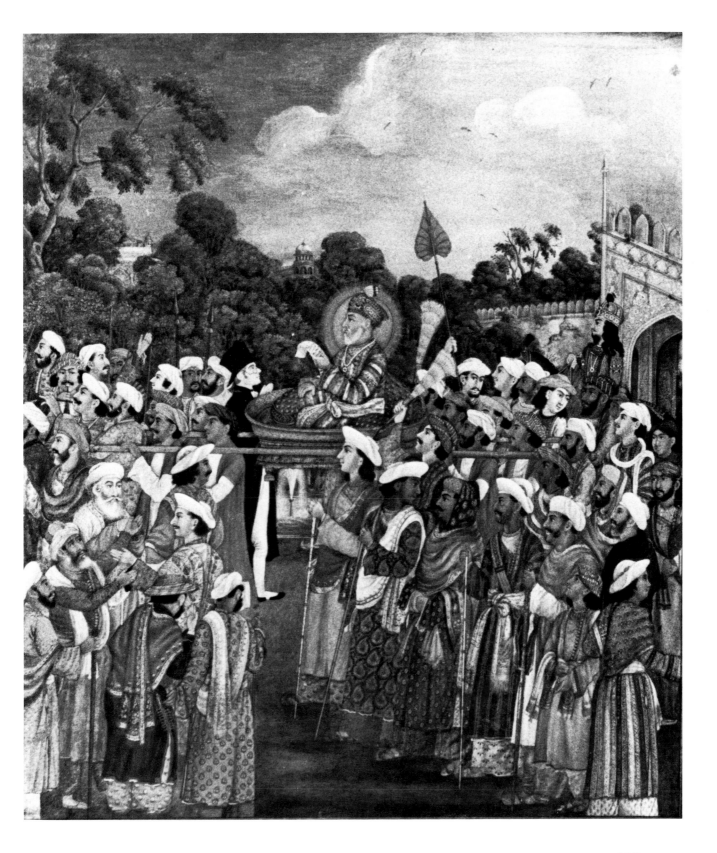

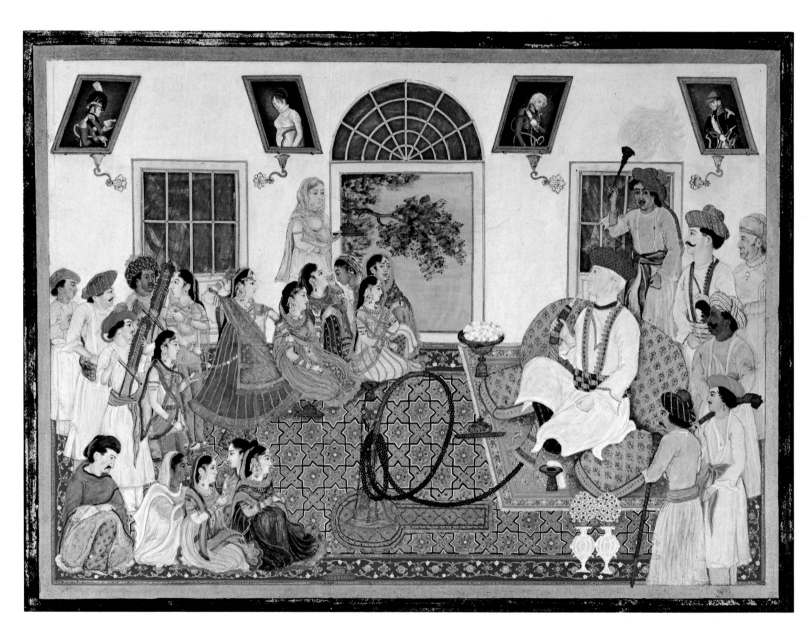

46. SIR DAVID OCHTERLONY WATCHING
A NAUTCH

North India, Delhi; ca. 1820
H. 22.4 cm., W. 32.1 cm.
Lent by the India Office Library and Records

108

In the early nineteenth century, Delhi was still a distant outpost of the Company's territories. To go there from Calcutta took months of hard travel, and those who went tended to be adventurous romantics, more prone to "going native" than their fellows in Calcutta or Madras.

David Ochterlony (1758-1825) was born to a loyalist family of Boston that moved to Canada in 1776. He left for India at the age of nineteen. His most notable appointment was in 1803, when Lord Lake made him the first British Resident in Delhi, a position tantamount to being the English emperor of northwest India. He was already forty-five years old; but he was a hardy campaigner, earthy, and adaptable. He was also opinionated and stubborn, which may explain why he was replaced by Archibald Seton and sent in 1807 to Allahabad as commander of forces. From there, two years later, he was ordered to the Sutlej River in the Punjab, to prevent the Sikh leader Ranjit Singh (nos. 54, 55) from crossing it. His firmness and military capability impressed Ranjit Singh, as well as the Company, and he remained in that area as a special agent to the governor-general in charge of Sikh affairs, with the powers of a prince. Although he disapproved of the action, he fought in the Gurkha wars in 1814 and 1815, so distinguishing himself that he was knighted; and he was soon sent to command a division in the Pindari campaign in Malwa, another rough-and-tumble chase suited to his temperament.

In 1818, at sixty, he returned to Delhi, establishing an excellent rapport with the Mughal court and occupying a pavilion in the Shalimar Gardens, where this portrait of the old warrior partying must have been painted.

By this time, Sir David seems to have preferred Indians to most of his fellow Englishmen. He is said to have kept thirteen elephants, one for each of his wives. But his removal as Resident to Delhi in 1807 still rankled; and he now became embroiled in a bitter collision with, of all people Colonel James Tod, author of *The Annals and Antiquities of Rajasthan,* who was equally sympathetic to Indian ways, though to those of Rajputs rather than Sikhs or Mughals. Both men were stubborn.

Tod's insistence upon British intervention in Rajput affairs was attacked by Ochterlony. Tod resigned and went home to England, where he wrote his classic book. He departed in 1822, the same year that Sir David suffered a "total prostration of the nervous system." Still quarrelsome, he argued for a show of force against the Jat ruler of Bharatpur, much against the official opinion. He was censured by the government and he resigned. In 1825, he died in Meerut of a broken heart. In the *maidan* (polo field and principal park) of Calcutta, a column fifty feet high was erected in his honor. It still stands.

One of the most appealing portrayals of an Englishman in India, this picture can be attributed on grounds of style to the same artist who painted Akbar Shah II receiving a far milder Resident, Mr. Archibald Seton (no. 45).

For another portrait of Ochterlony, supporting this identification, see: *Loan Exhibition of Antiquities, Coronation Durbar, 1911* (Calcutta, n.d.), C. 261, pl. LXIX, pp. 154-155.

47. A BHAND

North India, Delhi; ca. 1820
H. 9.9 cm., W. 14.3 cm. (whole sheet)
Private collection

A *bhand* was a group of raunchy buffoons, who were eager to entertain at marriages, or any other merry occasion. Here, they spoof all that was serious and sacrosanct to Hindus and Muslims alike: Lord Siva himself, shown in his hermaphroditic or *Ardhanari* form, combining his masculine self with that of his beloved, Parvati; the profound art of Kathak dancing; and Sufis, the mystically oriented Muslim holy men. In the right foreground, a clownish fellow "smokes" a hookah improvised from a twisted sash, while the pot-bellied cut-up at the left sports a turban tied around his slipper, an object of utter contamination.

This tiny picture is the work of an anonymous but brilliant painter who illustrated a particularly rich copy of the great Persian poet Sa'di's *Gulistan* (Rose Garden), now in a Teheran private collection. The manuscript is dated 1820, and its many finely painted and imaginative pictures abound in contemporary observation in addition to illustrating the poet's edgedly witty anecdotes. The artist's humorous style can also be associated with pictures made for Colonel James Skinner, a well-known Delhi figure in the early nineteenth century, half English, half Rajput, who would have found the *bhand* much to his taste. The leader of "Skinner's Horse," a troop that fought in the Maratha wars, "Old Secunder," as he was known in recollection of Alexander the Great, was a generous host, who often presented his guests with paintings of the evening's festivities. Conceivably, this was one of those pictures.

48. KNEELING ASCETIC

North India, Delhi; ca. 1825
Brush drawing, black line on paper
H. 17.2 cm., W. 13.0 cm.
Private collection

Sensitive observation and masterful draftsmanship characterize the best work of Mughal artists from the sixteenth century through the middle of the nineteenth. This dramatic, intimate study of a holy man confronts us with stunning directness. The self-effacing artist, making no attempts to impress with his virtuoso brushwork or "style," concentrated on the sitter's splayed, bony legs, saggingly creased stomach, and soulful eyes, which meet ours. A staff, unexpectedly adorned with ribbons, leans against his thigh, while he holds a *chilum* (clay pipe), no doubt for smoking hashish. Its late date notwithstanding, this sketch belongs in the company of the most serious and penetrating Mughal portraits, many of which depict comparably humble people.

See: Welch, *Imperial Mughal Painting.*

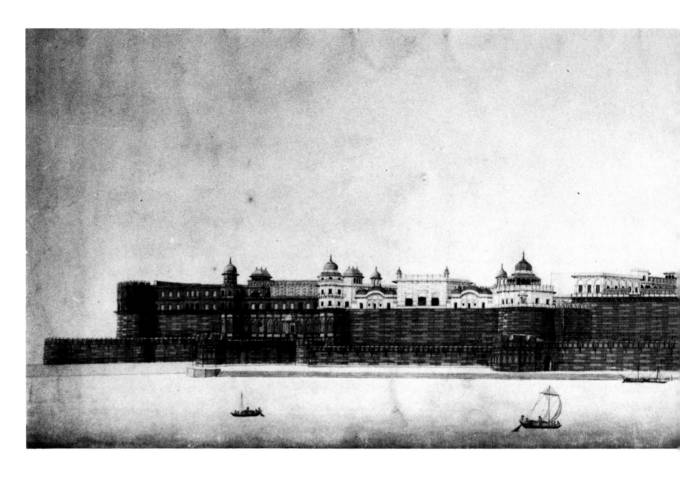

49. AGRA FORT FROM THE RIVER

North India, Delhi or Agra; ca. 1820
H. 30.1 cm., W. 95.5 cm.
Lent by the India Office Library and Records

Artists, explorers, and other adventurers (some of whom
served as Company surveyors), were among the first Eu-
ropeans to visit India's more remote monuments. William
Hodges's *Select Views* (1786) and Thomas and William
Daniell's *Oriental Scenery* (1795-1808), both of which in-
cluded prospects of many notable sites, increased trav-
elers' interest in visiting such places. They also sparked
enthusiasm among picture fanciers for architectural ren-
derings, which in turn inspired Indian artists to paint
them. This accurate panorama of one of the major Mu-
ghal fort complexes may even have been executed by an
English-trained Indian draftsman, who had worked on
survey duty. With dedication amounting to love, he re-
corded the seventy-foot high walls, running a length of

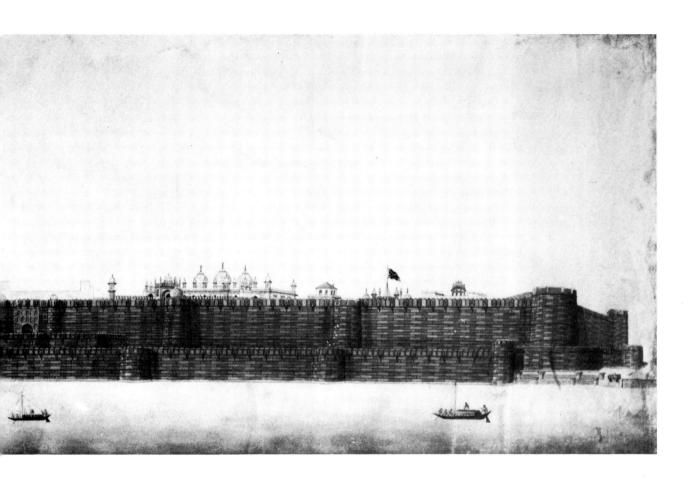

2,700 feet, of the Emperor Akbar's fortress on the right bank of the Jumna. One of its noble gateways was completed in 1566; but the Mughals had a way of tearing down and rebuilding, and most of the five hundred or so red sandstone houses within the walls were rebuilt by Shah Jahan (r. 1628-1657), who preferred white marble.

The English paper upon which the companion to this picture, a view of the Delhi Fort, was painted is watermarked 1816, and it is likely that both were completed shortly thereafter.

See: Archer, *Company Drawings*, pp. 179-180, no. 136 i.

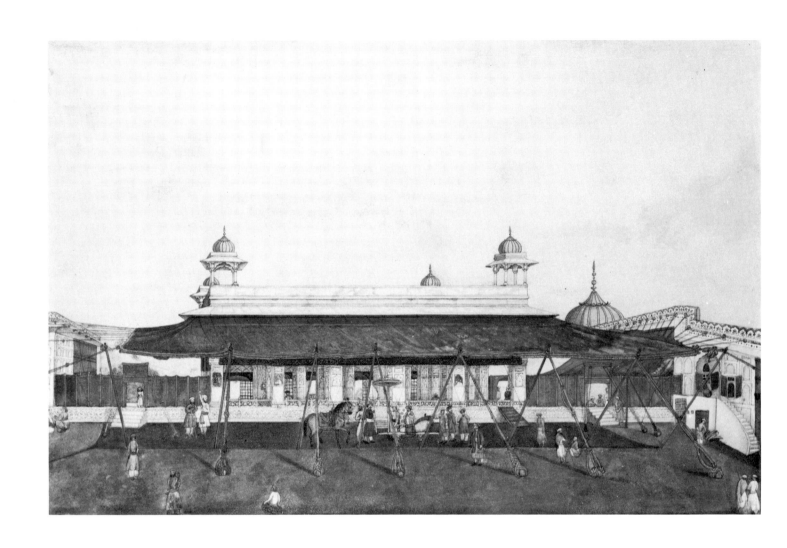

50. THE HALL OF PRIVATE AUDIENCE
(*DIWAN I KHASS*) IN THE RED FORT
OF DELHI

North India, Delhi or Agra; ca. 1820-25
H. 26.3 cm., W. 36.5 cm.
Lent by the India Office Library and Records

Shah Jahan's *Diwan i Khass*, a sumptuous palace in his
Delhi Red Fort complex begun in 1638, was the scene of
many Mughal triumphs and miseries. As painted here, it
retains such features as the gilt copper domes, marble bal-
ustrade, and central entrance way, all of which were re-
moved after the Mutiny. Bishop Heber came here, "to
this open pavilion of white marble, richly flanked by rose-
bushes and fountains, [with] some tapestry and striped

curtains hanging in festoons about it" (*Narrative of a Journey*, vol. II, p. 298); and so did Mrs. Meer Hassan 'Ali, an English lady who married a Muslim. She received a more intimate audience than the bishop and described it in her book, *Observations on the Mussulmauns of India* (1832, reprinted Karachi, 1974). She was led into the Begum's (queen's) *Mahul* (palace), behind the curtains to the right or left of the great hall. "I found on my entrance," she wrote,

> the King seated in the open air in an arm chair enjoying his hookha; the Queen's musnud [pile of cushions] was on the ground, close by....Being accustomed to Native society, I knew how to render the respect due from an humble individual to personages of their exalted rank....[I] left my shoes at the entrance and advanced towards them, my salaams were tendered, and then the usual offering of nuzzas [tribute of the lowly], first to the King and then to the Queen, who invited me to a seat on her own carpet—an honour I knew how to appreciate....

> The whole...visit was occupied in very interesting conversation; eager inquiries were made respecting England, the Government, the manners of the Court, the habits of the people, my own family affairs, [and] my husband's views on travelling. [The] conversation never flagged an instant....On taking leave his Majesty very cordially shook me by the hand, and the Queen embraced me with warmth....I was grieved to be obliged to accept the Queen's present of an embroidered scarf, because I knew her means were exceedingly limited compared with the demands on her bounty....A small ring, of trifling value, was then placed by the Queen on my finger, as she remarked, 'to remind me of the giver.'

Mrs. Meer Hassan 'Ali's sympathetic account, considerably at odds with those of other English visitors, including the bishop's, concludes by saying that "those who have been long intimate with [the King's] habits, in private, [say that] he leads a life of strict piety and temperance, equal to a durweish [religious mendicant] of his faith, whom he imitates in expending his income on others without indulging in a single luxury for himself....The Queen's manners are very amiable and condescending; she is reported to be as highly gifted with intellectual endowments as I can affirm she is with genuine politeness." (*Observations*, pp. 290-292)

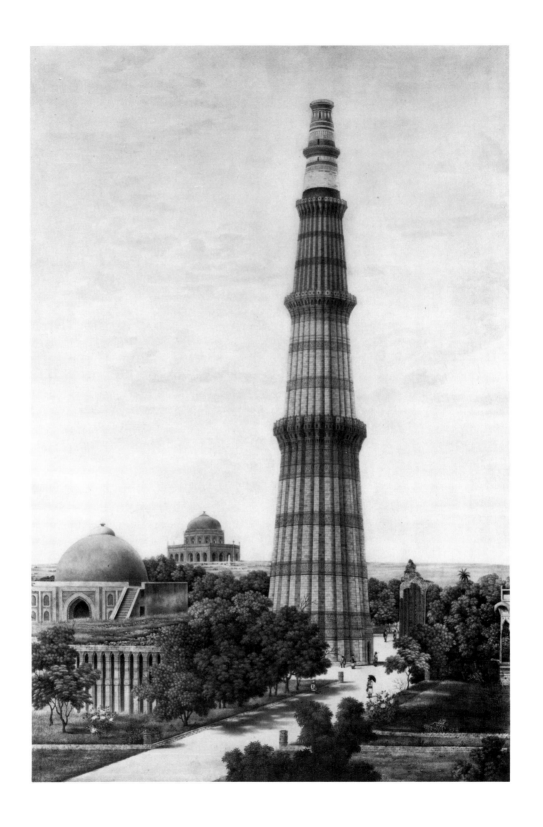

51. THE QUTB MINAR

Original border inscribed "Mohd. Yakoub" (Muhammad Yakub), perhaps the artist's name
North India, Delhi; ca. 1850
H. 65.4 cm., W. 87.8 cm.
Lent by The Marquis of Dufferin and Ava

"If you ask a native, 'who built the Kutoob?' his answer will generally be—'God built it; who else could have built it.'" (Parks, *Wanderings*, vol. II. p. 452)

In fact, this Tower of Victory was begun in A.D. 1199 by Qutub-ud-din Aibak as a minaret to a mosque proclaiming the prestige and authority of Islam. "He who holds Delhi holds India," he proclaimed; and his tower was the "Pivot of Justice," to "cast the Shadow of God over the East and over the West."

Over the centuries it has awed visitors, not least the British, for one of whom this large and detailed watercolor was painted. Its upper two stories had been rebuilt in the fourteenth century, and again damaged by earthquake in 1803. Colonel Robert Smith, a Company engineer and a very accomplished landscape painter, repaired the entire structure in the later 1820's, recreating the two most damaged stories. Although his "mushroom-shaped" finial evoked unpleasant criticism, his structural improvements have been sound.

This view must have been painted after 1847, when the offending "mushroom" was replaced by a soberer construction. In 1844, Sir Thomas Metcalfe, brother of Sir Charles, the Resident from 1811 to 1819 and 1825 to 1827, transformed the large tomb in the distance into a summer house, surrounded by well-tended gardens, which he names "Dil-Koosha" ("Delight of the Heart"). The Claud Martin of Delhi (no. 34), he lived there from 1813 until 1853, serving as agent and commissioner. A builder and collector like Martin, he designed a mansion on the banks of the Jumna where he assembled his inherited family furniture, his Napoleonic memorabilia, Persian and Indian manuscripts, and other curiosities. A fastidious gentleman, whose clothes were made in London, he devised a terrifyingly subtle method of reprimanding servants. He ordered a pair of white gloves "which were presented to him on a silver salver, and drawing these on with solemn dignity, he proceeded to pinch gently but firmly the ear of the culprit, and then let him go—a reprimand that was entirely efficacious." (Quoted by Spear, *Twilight of the Mughals*, p. 160)

His daughter Emily described him as having been about five feet eight inches tall "but well made," with gray hair balding at the top, blue eyes, a straight nose, and "beautifully small hands and feet." His face was pockmarked, he was not handsome, and his expression was often whimsical. But he was of a sociable nature. He often lent "Dil-Koosha" to newly wedded couples. It was sadly prophetic of dangerous times to come that this "perfect gentleman" was fatally involved in a palace intrigue. Apparently, he was believed to have conspired with three other Britishers to block the succession to the Mughal throne of Prince Jiwan Bakht, thereby enraging the prince's mother. All four men died ("of poisoning") in 1853.

See: Mildred Archer, "An Artist Engineer—Colonel Robert Smith in India (1805-1830)," *The Connoisseur* (February, 1972), pp. 78-88. Mrs. Archer's article includes an almost identical view, certainly by the same artist, fig. 6.

In 1842, H. E. Fane, nephew and aide to the Company's commander-in-chief, complained indignantly when his uncle lowered himself "to stand in the presence of a dirty, miserable old dog," namely Bahadur Shah II (r. 1837-1858), the last Mughal emperor. On this final great imperial Mughal portrait are inscribed some of his honorifics recalling another clever Englishman's comment that the Indian nobility "live on boiled rice and superb titles." We quote a few: "The Shadow of God," "Exalted King of Kings," "Refuge of Islam," and "Increasor of the Splendour of the Community of the Paraclete."

Big-eyed and disembodied as a saint in a Byzantine icon, Bahadur Shah II is shown with two sons and a servant before a rendering of Shah Jahan's splendidly majestic marble relief of the scales of Justice. An indigo carpet hangs behind him, over the openwork marble screen, to block chill winter drafts, symbolic perhaps of his long, troubled life. For Bahadur Shah was compelled to suppress his active nature and channel his considerable intelligence and abundant energy into literature and religion. Under the poetic name Zafar, he was the most talented versifier in a long line of admirably literary emperors. Instead of leading armies, he led spiritual followers and directed poets, who gathered by candlelight at *Musha'eras* to recite Persian and Urdu *ghazals*. In his Delhi, a late but extraordinary school of poets flowered, including such men as Ghalib, Zauq, and Momin Khan. Thwarted, like the emperor, in anglicized Delhi, their only freedom lay in literature. It is no wonder that in this portrait the lions supporting the throne are scrawny and feeble as alley cats, and Bahadur Shah's halo has turned from the usual gold to hauntingly anemic pale blues.

After decades as an imperial lion caged in an English zoo, where he was constantly tormented by the removal of more and more privileges, Bahadur reluctantly agreed, at eight-two, to risk everything by accepting the nominal leadership of the "rebels" during the Mutiny of 1857 (see Chronology). As everyone knows, his gamble failed. The gory struggle ended with most of his sons shot; but as the English had agreed to spare his life, he was merely exiled, after a humiliating trial. Accompanied by his wife and youngest son and a few servants, the last Mughal emperor was taken to Rangoon, in Burma, where he wrote sad poetry until his death in 1862. To quote verses ascribed to him, "On seeing me, no eye lights up, no heart near me finds solace; serving no use or purpose, I am but a handful of dust."

For the literature of this period, see: Annemarie Schimmel, *Classical Urdu Literature from the Beginning to Iqbal* (Wiesbaden, 1975). For a photograph of Bahadur Shah II on his deathbed, see: Clark Worswick and Ainslie Embree, *The Last Empire* (Millerton, New York, 1976), pl. 76.

52. THE LAST MUGHAL EMPEROR, BAHADUR SHAH II WITH TWO SONS

North India, Delhi; dated May 1838
H. 32.0 cm., W. 38.0 cm.
Private collection

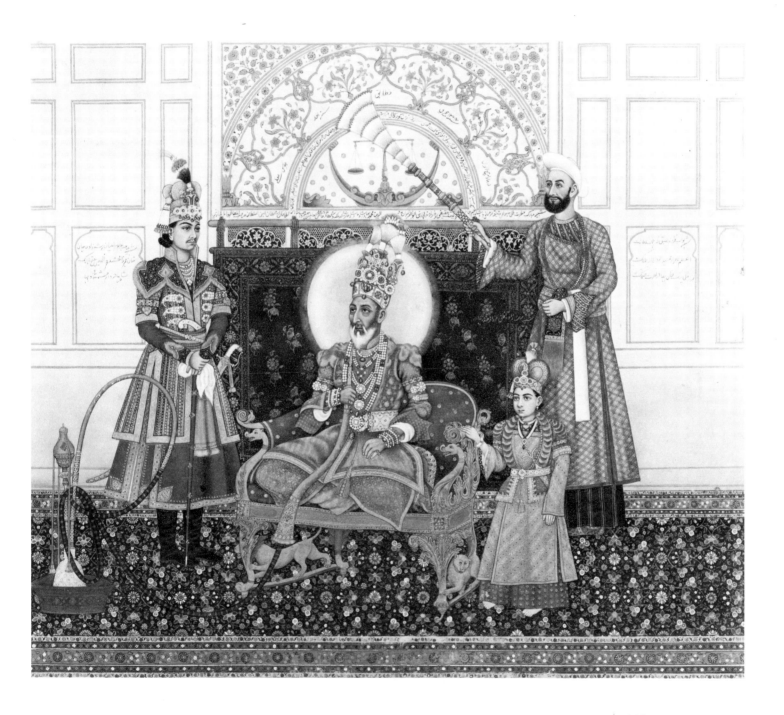

53. NAWAB MUZAFFAR-UD-DAULA NASIR AL MULK MIRZA SAIF-UD-DIN HAIDAR KHAN BAHADUR SAIF JANG

North India, Delhi; dated 1852
H. 36.5 cm., W. 25.0 cm. (including border)
Private collection

The admirably civilized Indian society of pre-Mutiny Delhi is personified by this nobleman, who had come with his brother from Lucknow in 1852. With their immediate families, the two (according to their friend, the poet Ghalib, from whose letters we quote) shared

> halls and palaces, all adjoining one another.... [When the Nawab left Delhi at the time of the Mutiny,] these great palaces, left without a soul to attend them, were utterly looted and laid waste, though some of the less valuable, heavier things...the drapings of the large halls and pavilions and canopies and carpets, had been left as they were....Suddenly one night...these things caught fire....Stone and timber, doors and walls, were all consumed by fire....I could see everything in the light of the leaping flames, and feel the heat on my face....Songs sung in a neighbour's house are, as it were, gifts which it sends; how then should not a fire in a neighbour's house send gifts of ashes?

> When the English forces entered Delhi [in the aftermath of the Mutiny], Muzaffar-ud-daula, with a number of others, went to Alwar, where the Raja was his friend. But he was taken prisoner there and brought to Gurgaon, where the British officers, without any trial or investigation or inquiry, shot him, along with a number of others.

In a letter to the Nawab's nephew, Ghalib wrote that his death "ranks with the tragedy of Holy Karbala" (the martyrdom of Husain and Hassan, remembered in the Muharram festival, no. 69).

In this portrait, painted five years before the Mutiny, the Nawab sits on a Victorian chair in his ill-fated palace, enjoying his hookah, while holding a manuscript. Like Sir Thomas Metcalfe, he was "a perfect gentleman."

See: Ralph Russell and Kurshidul Islam, *Ghalib, Life and Letters* (Cambridge, Mass., 1969).

An Indian proverb maintains that "one-eyed men have an extra vein," meaning that they are more knowing. Such a man was Ranjit Singh ("The Lion of the Punjab," r. 1780-1839), who survived a bout of smallpox in early childhood with a maimed face and a single eye. But these handicaps scarcely mattered to this charismatic, wildly effective leader, destined to unite the Punjab. His brilliant career began in 1779, when he became head of a Sikh *misl,* a small clan within the religious group that broke with Hinduism under Nanak (1469-1539), their first guru, and gradually became militant. Twenty years later, in 1799, Ranjit Singh had occupied Lahore, a fact which was legitimized by the Muslim ruler Shah Zaman. By 1801, he had defeated the Bhangis, Sikhdom's most powerful *misl;* in 1802 he took its holiest city, Amritsar; and by 1806 he held Ludhiana. But the British blocked him to the east and to the south; and in the treaty of Amritsar of 1809, Lord Metcalfe succeeded in holding him east of the Sutlej River. Until his death in 1839, Ranjit Singh dominated the Punjab. With the talent of an Akbar, he controlled a colorful and energetic court, despite nightly quaffs of his favorite drink, a concoction of corn liquor, opium, musk, and the juice of raw meat, "liquid fire," according to Miss Emily Eden, "of which no European can touch a drop."

An earthy sensualist, he kept the Shalimar Gardens supplied with pleasing girls and boys; but despite his wild antics, he remembered to be tolerant of Muslims, and he was wise enough never to fight the British.

The Punjab Hills had long been a major center of Rajput painting, but Ranjit Singh himself was not known as a significant patron of painting, although this picture proves that talented artists worked at Lahore by the end of his reign. According to the British traveler G. T. Vigne, once when Ranjit Singh agreed to sit to a likeness, he made fun of the artist. Conceivably, his pock-ravaged face soured his views on portraiture, a primary subject of Indian miniature painting.

In this portrayal of his Lahore horse, on English paper watermarked 1839, the squint-eyed *syce* (groom) confirms rumors that the one-eyed ruler preferred servants who were likewise afflicted, or had the delicacy not to flaunt their superior vision.

See: W. G. Archer, *Paintings of the Sikhs* (London, 1966); and W. G. Archer, *Indian Paintings from the Punjab Hills* (London, New York, and Delhi, 1973). See also: F.S. Aijazuddin, *Pahari Paintings and Sikh Portraits* (London, New York, Karachi, and Delhi, 1977).

54. RANJIT SINGH'S HORSE, WITH A
ONE-EYED SYCE

Inscribed on back: "The famous Lahore horse of
Maharaja Ranjit Singh"
North India, Lahore; ca. 1840
H. 18.3 cm., W. 23.3 cm.
Private collection

55. GENERAL JEAN FRANÇOIS ALLARD AND
 HIS FAMILY

North India, Lahore; 1838
H. 20.6 cm., W. 26.9 cm.
Private collection

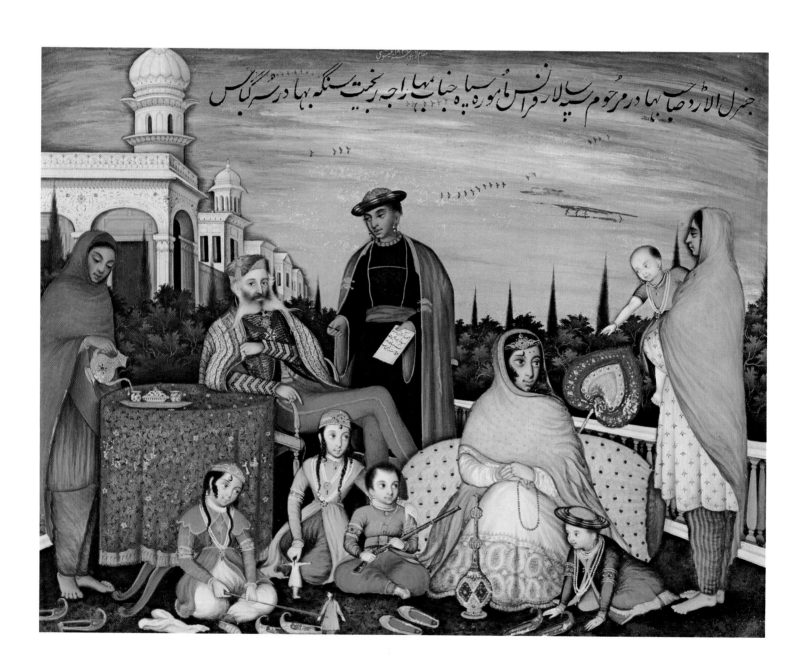

The garrulous, but truthful, Fanny Parks met General Allard in December, 1836. He had "just returned from France [and seemed] the most picturesque person imaginable; his long, forked beard, divided in the centre, hangs down on either side of his face; at dinner time he passes one end of his beard over one ear, and the other end over the other ear." (*Wanderings*, vol. II, p. 103) Trivia, yes; but vivifyingly descriptive of the general, who was born in St. Tropez in 1785 and enlisted at eighteen in Napoleon's 23rd Dragoons of the Line. He served in Italy until 1806, when he was promoted to sergeant-major of Joseph Bonaparte's bodyguard. From there he rose to become quartermaster of a dragoon regiment in Spain, where he served until 1814. Wounded, he was promoted to a lieutenancy in the Imperial Dragoons of the Guard, after which he became a captain in the 7th Hussars. He joined Napoleon during the One Hundred Days, and was a captain of the Cuirassiers at Waterloo. (His changes of uniform alone prove exhausting.) After the emperor's downfall, he was considered so ardent a Bonapartist that he received no pension. Still eager for a military career, he went to Egypt, then to Teheran, and finally to Kandahar—all without success.

On March 23, 1822, he arrived at Lahore, where he pursuaded Ranjit Singh to hire him at ten gold mohurs per diem to train two regiments, one of dragoons, the other of lancers. When his men proved themselves by crossing the river and battling with the Afghans, Ranjit Singh enlarged Allard's troops to four regiments, totaling 3,000 men. In addition he was soon assigned 2,000 of artillery. He amassed considerable wealth and lived in luxury. Distinguished visitors came to meet him, such as the peripatetic French botanist, Victor Jacquemont, who admired Allard for his literary knowledge and taste.

Never forgetful of France, Allard's troops, the "Francese Campo," flew Lafayette's flag, and he invariably wore the Legion of Honor as well as a decoration he had designed for Ranjit Singh. In 1833, saddened by the loss of a daughter and by the collapse of Palmer's Bank in Calcutta, where all his savings had been kept, he asked The Lion of the Punjab for permission to visit France. Ranjit Singh's enthusiasm for Allard and his cavalry was fickle. On this occasion he agreed, but would only settle the amount owed Allard in shawls—30,000 rupees worth. Nonetheless, Allard left via Calcutta with his Kashmiri wife and his children. Eighteen months later, he returned, alone, and again via Calcutta, where Fanny Parks met him. He died of heart failure in January, 1839, leaving his wife and children in France an estate of 25,000 rupees.

This painting of the general and his wife, children, and servants at tea in front of their great house at Anarkali, a suburb of Lahore, was painted there in 1838. Mildred and W. G. Archer possess a photograph given to them by F. S. Aijazuddin of an almost identical oil painting now in the St. Tropez museum which was made by Allard's nephew when the family were all together there in 1834-1836. Allard appears to have taken back to India with him a smaller version of this oil painting because W. Barr (a young lieutenant of the Bengal Horse Artillery who was accompanying Colonel Wade on his mission of Afghanistan) noted in his memoirs that in February, 1839, he visited Allard's house and saw a picture "of the General and his family, taken by a French artist when he returned home some three or four years ago...and though not finished, being only the design from which a larger drawing was made, the group is well arranged, and the pretty faces of his Cashmerian wife and his children, who were dressed in the costume of their mother's country, drew forth the admiration of us all." It would seem that in 1838, after Allard's return to Lahore, an Indian artist made this copy in miniature of the picture seen by Barr. How moving! Sadly this copy from the European painting must have been inspired by loneliness. Barr described Allard as a "handsome and benevolent man, possessing much firmness of character, tempered with mildness." The portrait celebrates not only the general's beloved family, but also his two great leaders, for hanging round his neck is Ranjit Singh's Bright Star of the Punjab above the Legion of Honor bestowed by Napoleon Bonaparte.

The painting bears three inscriptions: in gold, at the top "Painted at Lahore, 1838 A.D."; on the sky, in black ink (posthumous), "General Allard Sahib Bahadur, formerly a commander of France, assigned to the army of Maharaja Ranjit Singh, may he rest in peace"; and on an application being handed by a clerk to Allard for signature, "To the most generous Maharaja Ranjit Singh Bahadur in the Province of the Punjab."

See: H. L. O. Garrett and C. Grey, *European Adventurers of Northern India, 1785-1849* (Lahore, 1929); W. Barr, *Journal of a March from Delhi to Peshawur and from Thence to Cabul, Including Travels in the Punjab* (London, 1844); Archer, *Paintings of the Sikhs;* and Aijazuddin, *Pahari Paintings.*

I am grateful to Willard Wood, David Chaffetz, Aboulala Soudavar, Anton Heinen, and F. S. Aijazuddin for translating the inscription.

Ranjit Singh's death was followed by a period of anarchy. His son and heir, Kharak Singh, was dim-witted, and he died in 1840. Sher Singh, reputed to be another son, was murdered in 1843. Hira Singh then put Dalip Singh on the Sikh throne. But in 1844 he felt threatened by Bhai Vir Singh, a holy man of military propensities who occupied a village on the right bank of the Sutlej with an armed retinue of 1,500 men and stables of horses and elephants. Aggravatingly, to Hira Singh, he was greatly revered by the Sikh peasantry, and he regularly held court, at which Sikh affairs were discussed. Many disaffected chiefs had joined him at his monastery, and it was hinted that the British might support him against Hira Singh. Unfortunately, from the regent's point of view, few sympathized with his stand against "the god-inspired man." He tried negotiating with Bhai Vir directly, without result. And when he learned that Attar Singh Sindhanwalia had become allied with the Bhai and on British advice had crossed the river, Hira Singh summoned the other Sikh leaders and denounced the British divide-and-conquer policy. On May 5, eleven infantry battalions, fifty guns, and 4,000 cavalry were mustered out of Lahore. Guards were stationed along the river bank to prevent Attar Singh's escape, and a deputation was sent to Bhai Vir Singh requesting that he retire from the conflict. During these discussions, Attar Singh became angry and threatening. He was promptly gunned down, and within a few minutes, Bhai Vir had also been killed, along with many of his followers. Others drowned in the Sutlej while trying to escape.

When the triumphant army returned to Lahore, it was saluted by cannon from the citadel on Hira Singh's command. But at the cantonment, the heroes were taunted as *gurumars*, murderers of a guru; and when cholera broke out in their ranks, it was interpreted as Bhai Vir's curse. Hira Singh and his colleagues were held responsible. In appeasement, they offered liberal gifts to the troops, and promised to erect a shrine to the martyred guru over his ashes and provide lands to maintain it. The episode contributed to the first Sikh war of 1845 and 1846, and ultimately to the annexation of the Punjab by the Company in 1849.

The full inscription on this picture reads: "Bhai Veer Singh a highly renowned and charitable man in the time of Raja Heera Singh and afterwards killed in the civil war of Sikhs." A companion picture, showing Ranjit Singh's widow and infant son, Dalip Singh, is in a London collection. Both can be ascribed to a Guler or Kangra artist who moved to Lahore or Amritsar and adjusted his style to suit the new British patrons. Vivid chemical pigments, such as the aniline greens of the trees, were imported from England.

See: Sita Ram Kohli, *Sunset of the Sikh Empire* (New Delhi, 1967), pp. 77-80.

North India, Lahore; ca. 1850-60
H. 37.2 cm., W. 54.9 cm. (without border)
Private collection

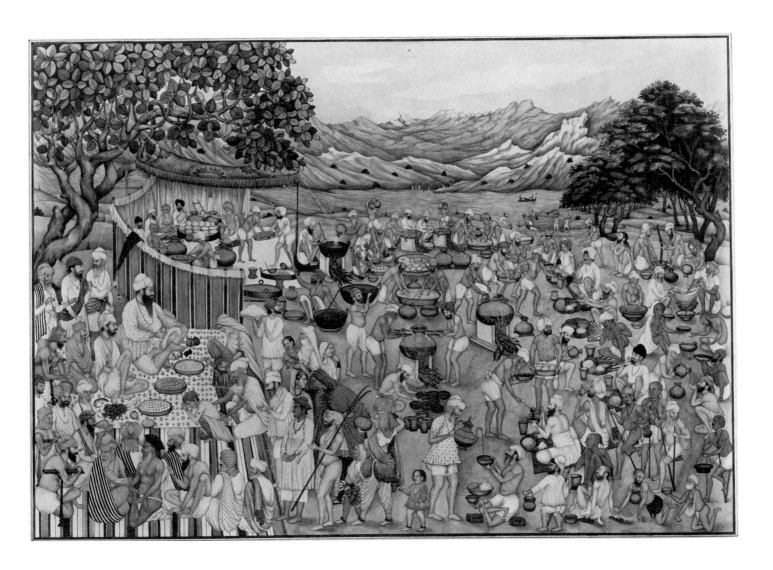

Seikh Akalies on the March. (Fanatical Soldiers)

After the annexation of the Punjab in 1849, the English moved there in ever increasing numbers; and just as they had wanted views and sets of pictures of tribes and castes from other areas, now they provided a market for comparable Punjabi subjects. This demoniac group, painted with exceptional gusto, is from such a set, and exemplifies the Indian genius for categorizing and institutionalizing everything under the sun. A quotation dating from 1832 given in *Hobson-Jobson* (p. 9) describes *akalis* almost as well as the picture: "We received a message from the acali who had set fire to the village.... These fanatics of the Seik creed acknowledge no superior, and the ruler of the country can only moderate their frenzy by intrigues and bribery. They go about everywhere with naked swords, and lavish their abuse on the nobles as well as the peaceable subjects.... They have on several occasions attempted the life of Runjeet Singh."

As shown here, these bellicose ascetics wore short trousers and steel bracelets and grew their hair and beards long, as was usual with Sikhs; but their tattered blue robes and razor-edged *chakras*, (terrifying weapons that were spun through the air, here sported on their turbans) were specialties.

See no. 72, which is from the same album.

Like the Punjab, Rajputana was very much in the "out back" until well after its princely states had allied with "the paramount government." And until the British left India in 1947, these states retained some degree of independence. Most of them (such as Mewar, Bundi, Kotah, Marwar, and Kishangarh) were ruled by Hindu princes (Rajas) who had been feudatories of the Mughals prior to the British period. They were Rajputs, belonging to the second or warrior caste, bred to defend the Brahmins (priests) and to govern the business and agricultural castes. Fighting, ruling, hunting, and making love were their characteristic activities.

They were also patrons of painting, both religious and secular; and each Rajput state maintained its own ateliers of artists. Portraits, hunting scenes, and the like—as opposed to religious subjects—usually reflected Mughal influence. Through the Mughals, who were in closer and earlier contact with Europeans, the Rajputs acquired a limited understanding of Western art. But it was not until the 1820's or later that the Company style effected Rajput painting.

Prior to that time, a few European prints filtered into Rajputana, and one occasionally finds them, mounted on Rajput borders, intermixed with portraits of Rajas or images of Radha and Krishna. Occasionally, too, as here, a Rajput artist used one of these European imports as a model. This Versailles gone berserk, inspired by the sort of French eighteenth-century print one still sees in French hotel bedrooms, was created at Kishangarh. It is probably by Nihal Chand, the most experimental artist of his school, whose oeuvre includes a number of such exoticisms. Fascinated by the cross-hatching and freely stroked lines of the engraver's tool, he has imitated them with loving care. Among the *allées* and distant French villages, complete with church spires, he has drawn what appear to be Rajasthani wells; and we should not be surprised to sight Radha and Krishna strolling through the crazy-quilt of trees, as though in their heaven, Brindaban.

For other Kishangarh paintings see: E. Dickinson and K. Khandalavala, *Kishangarah Painting* (New Delhi, 1959); Welch, *A Flower from Every Meadow*, nos. 27-29; and W. G. Archer and Edwin Binney, 3rd, *Rajput Miniatures from the Collection of Edwin Binney, 3rd* (Portland, Ore., 1968).

58. (FRENCH) VISTAS AT KISHANGARH

North India, Rajasthan, Kishangarh; ca. 1750
H. 19.5 cm., W. 28.5 cm. (whole sheet)
Private collection

132

59. THE CHIAROSCURO LADY FROM EUROPE

North India, Rajasthan, Bundi; ca. 1765
H. 45.5 cm., W. 36.5 cm.
Lent by The Marquis of Dufferin and Ava

With lives of their own, art motifs spread over the world, to be borrowed whole or transformed, according to artists' changing needs. Many of the ideas in this grisaille painting can be traced to Michelangelo Merisi (1573-1610), known as Caravaggio, the Italian painter who explored such effects as light cast from a single candle. Georges de la Tour (1593-1652) of France soon became the leading exponent of candle-lit figures and still life, subjects which traveled in printed form to a workshop at Bundi, in Rajasthan, during the mid-eighteenth century. There, an anonymous artist took what he wanted from the source and imbued his lady at her toilette with imponderables. We sympathize with his bewilderment at something so foreign. He must have questioned the meaning of her queer ritual and worried about the contents of all those little vials, seemly offerings to a *farangi* (European) god. Apparently, he also wondered whether the squiggles on her dress were ornamental patterns or creepy creatures from the deep. But, like most Indians of his time, he was quite certain about European women's flagrant sexuality; and he concentrated upon this lady's generous curvaciousness. Through his life-giving brush, even the somberest of saints, weary from her travels, could have been transmuted into a joyous courtesan.

60. EMPEROR AKBAR'S TOMB AT SIKANDRA

North India, Rajasthan, perhaps painted at Jaipur;
late 18th century
H. 54.5 cm., W. 37.9 cm. (with border)
Private collection

This traditional view of a Mughal monument, inscribed in both English and Persian, may have been painted for an Indian patron. It contrasts informatively with those certainly commissioned by the British, who demanded accuracy of proportion as well as perspective (nos. 49, 50). The painter of this picture created his ideograph of Akbar's tomb according to projections, employed by "primitive" artists the world over, in which facades, walls, trees, figures, and minarets are seen head-on, in their most characteristic views while the gardens, courtyards, and watercourses are shown as though viewed by a flying bird. This ancient approach offers certain advantages: it enables us simultaneously to see from the sides and from above, and to gain a much fuller idea of each element in the structure. It also produces a highly appealing picture, with no violation of the surface's two dimensional harmony, and in this case transforms Akbar's tomb into a sort of mandala, the Buddhist and Hindu psychocosmogram. On the other hand, it tells us very little either about relative proportions—the gardeners are tall as trees—or of the "feel" of surfaces. It presents the idea instead of the appearance, the spirit rather than the substance.

The tomb of Akbar (r. 1556-1605) was built by order of his son Jahangir (r. 1605-1627) between 1605 and 1613. As usual in Muslim tombs, the body is buried in the earth, directly beneath the cenotaph—in this case a superbly ornamented and inscribed marble monument at the center of a cloistered marble court on the highest level of the principal red sandstone building.

मलीसन

61. EPHEMERA FROM KOTAH

North India, Rajasthan, Kotah; ca. 1845-80
a. Village-scape in English style, ca. 1845
 H. 14.5 cm., W. 9.8 cm. (whole sheet)
b. Colonel G. B. Malleson, ca. 1850
 H. 10.2 cm., W. 6.9 cm. (whole sheet)
c. Chatero Duhajan, a Muslim dandy from Agra,
 ca. 1870
 H. 20.8 cm., W. 17.5 cm. (whole sheet)
d. The Night Train to Kotah, ca. 1873
 H. 24.8 cm., W. 40.0 cm. (whole sheet)
 Private collection

Although Kotah was not among the more ancient Rajput states, its princes were renowned for military prowess, and its school of painting was the most draftsmanly in Rajasthan. Of the Hara clan, Kotah had split from Bundi in the seventeenth century, and many of its sons fought and died for the Mughal cause in the Deccani campaigns a few decades later. In 1817, Kotah was the first Rajasthani state to enter an alliance with the Company.

While fighting in the Deccan during the late seventeenth century, the Kotah Rao hired brilliant artists of Persian antecedents, who brought their energetic calligraphic tradition and radiant colors to Rajasthan. There, inspired by vigorous new patrons, these artists prospered and devised imaginative new compositions depicting hunts and other Rajput activities, which were passed on and added to by their descendants until the school finally died during the late nineteenth century.

a. Sharp-eyed masters of brushwork, Kotah artists constantly drew from nature, and adjusted rapidly to the European manner, as in this succinct and accurate view, reminiscent of Constable's watercolors.

b. Colonel Malleson's likeness, inscribed with his name, must have been sketched during the reign of Maharao Ram Singh II (1827-1865), who was held responsible when the auxiliary forces he maintained at Kotah for the Company rebelled in 1857 and murdered the political agent and his two sons. To quote the colonel, "Inasmuch as he made no attempt to put down the revolt or to aid the British officer, as a mark of the displeasure of Government, his salute was reduced by four guns (from seventeen)." (George B. Malleson, *An Historical Sketch of the Native States of India* [London, 1875], p. 75)

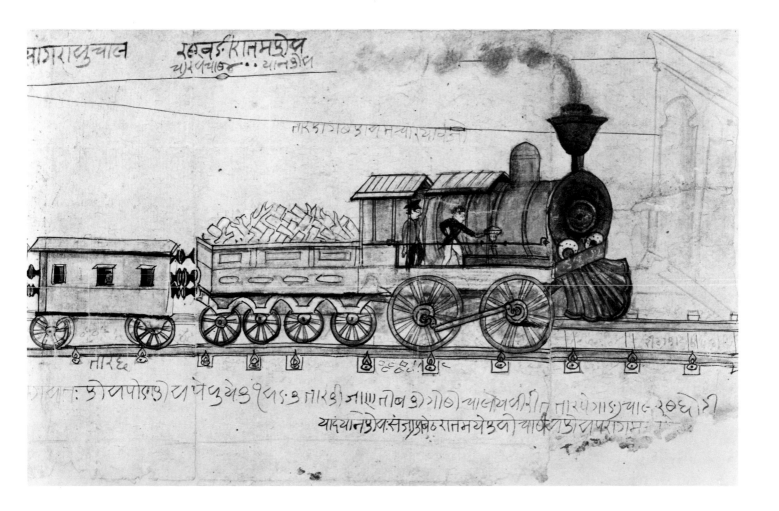

c. This foppish gentleman from Agra, perhaps a musician, caught the attention of one of the artists employed by Maharao Chattar Singh (r. 1865-1889), the last significant Kotah patron. He wears an Inverness cape, copied no doubt from a sporting Britisher's.

d. The Rajputana State Railway first puffed its way between Delhi and Bombay in 1873, which must be the approximate date of this drawing, inscribed "night train." The artist interpreted its hurtling, snorting wonders as a new kind of beast, more horrendous than all the lions and tigers in Kotah's jungles; and he may have sensed that this steely imperial creature was one the Maharao could never add to his trophy room.

For a Kotah gouache in European style of a horse, see: Welch, *Indian Drawings*, no. 56.

For Kotah painting in general, see: W. G. Archer, *Indian Painting in Bundi and Kotah* (London, 1959); Milo Cleveland Beach, *Rajput Painting at Bundi and Kota* (Ascona, 1974); and Archer and Binney, *Rajput Miniatures*.

62. VICTORIA MAHARANI WITH THE PRINCESS ROYAL

Inscribed in Devanagari script
North India, Rajasthan; ca. 1845
H. 26.0 cm., W. 20.5 cm.
Private collection

Unless otherwise directed, Indian artists usually painted inner views not outer, preferring abstract ideas to matter-of-fact "truthfulness." Had Queen Victoria (r. 1819-1901) seen this portrayal, the décolletage in which causes her eldest child, the Princess Royal, to avert her glance in dismay, British Indian history might have run a different course. When the artist confected it, he veered between things temporal and spiritual, his eyes roaming to and fro among an assortment of stimulating sources. One, presumably, was a print of the actual queen as a young matron, sharing her royal ermine with Princess Victoria Adelaide Mary Louise ("Pussy"), who later married Frederic III, King of Prussia. The second may well have been a Madonna and Child, and another a generalized portrayal of a European belonging to the "class of *danseuses* and courtezans—expert alike in dance, music, and all the artifices of love," to quote the late N. C. Mehta, who reproduced a late Mughal bosom-companion to this miniature in his *Studies in Indian Painting* (Bombay, 1926), pl. 36. Borrowing here and there, the artist transformed the queen's features, straightening her slightly aquiline nose, and endowing her with a widow's peak. Characteristically Indian in his fondness for gracefully curling shapes, he spun ears into "seashells," and twisted and pulled royal eyes into tremulously drooping "foliage."

141

63. CAPARISONED BULL

North India, Rajasthan, Nathadwara; ca. 1860
H. 32.3 cm., W. 41.5 cm. (with borders)
Private collection

Supercharged by aniline dyes from England, this richly colored portrait of a bull is unquestionably the gaudiest picture here. That its electric blue-green, raging yellow, crimson, and gold trim stop short of offensiveness is due to the artist's joyously unselfconscious use of the new pigments. In his innocence, he could do no wrong.

He sensed, perhaps, that mighty animals can carry mighty colors. And this Brahmin bull is such, an impressive descendant of those carved into stone seals in the third millennium B.C. and unearthed at Mohenjo-Daro. Since ancient times, these animals have been harnessed to plows and have supplied much of the power for Indian agriculture. Justly, Hindus have accorded them important roles in religion. Nandi the bull is Lord Siva's chief courtier, the guardian of all quadrupeds. Here, however, we see the bull adorned for a procession at the Vaishnavite shrine of Nathadwara, sacred to Shri Nathji, a form of Krishna. Near this shrine, in the town that has grown in its shadow, bullock carts are raced like Roman chariots. Conceivably, this splendid animal triumphed in such a contest and proudly sports the finery of the winner.

But bulls are also revered at Nathadwara for their role in bringing the sacred image of Shri Nathji from Mathura during the seventeenth century, when the Rana of Mewar defied the Mughal emperor, Aurangzeb (r. 1657-1707), by offering it sanctuary. After the stone image had crossed into Mewar, but before it reached the capital, Udaipur, Shri Nathji refused to go further. Extra bullocks were brought for more power, but without success; and after elephants also had failed to pull the holy wagon, the priests acknowledged that Shri Nathji had reached his chosen destination.

Soon after the arrival of the image, artists came to assist the *mahant* (head priest) by painting cotton back-cloths (*pechwai*) for it. They also began to portray Shri Nathji and his priests in smaller form, as other subjects to sell to pilgrims, for one of whom this picture was doubtless made. Even at such orthodox centers as Nathadwara, it appears, the "improved" technology of aniline dyes was welcomed in the service of God.

See: Robert Skelton, *Rajasthani Temple Hangings of the Krishna Cult* (New York, 1973).

64. MAHARAJA RAM SINGH II OF JAIPUR

North India, Rajasthan, Jaipur; ca. 1870
H. 10.5 cm., W. 11.7 cm. (with border)
Private collection

Ram Singh II of Jaipur (r. 1835-1880) was one of the first princes of Rajasthan to be brought up under the watchful eye of a Company Resident, a circumstance brought on by two generations of court drama. His grandfather, Jagat Singh (r. 1803-1819), was considered by the British to have been "the most dissolute prince of his race...[whose] life did not disclose one redeeming virtue amidst a cluster of effeminate vices." Although he was supposed to have died without issue, a son, Jai Singh III (r. 1819-1835), was born four months after his death. During his reign "corruption and mis-government" was so rife that a Company officer was appointed to reside in Jaipur. In spite of the officer's presence, the intrigues at court worsened. In 1834, Company troops were called in, which sparked scenes worthy of the last act of a Marlowe tragedy. Maharaja Jai Singh was murdered at the behest of Jotharam, his wife's lover, who had supplanted the Company's political nominee. When the Resident tried to reform the administration and assume the guardianship of the infant Ram Singh, Jotharam hired *goondas* (ruffians) to kill him. The plot was less than successful. Although another corpse, that of Mr. Blake, a lesser official, was added to the litter, the *goondas* were caught and executed, and Jotharam was imprisoned for life.

In the wake of these atrocities, Ram Singh grew up in an atmosphere split between East and West. On the one hand, he prayed to Lord Siva, as here, and supervised daily sacrifices of goats (substitutes for the human beings of earlier times); and on the other, to quote a semi-official publication of 1876, he showed his "superiority to prejudice, and his inclinations to like Europeans and their ways." The report continues, "[He] *has learnt to dance* [italicized in original], and was wont to acquit himself unexceptionably as Lady Mayo's partner at the vice-regal balls at Simla," a deed which might be considered a Victorian expression of Rajput chivalry.

See: Malleson, *An Historical Sketch of the Native States of India*, pp. 37-38; Samuel Bourne and Charles Shepherd, *Royal Photographic Album of Scenes and Personages Connected with the Progress of H. R. H. The Prince of Wales* (Calcutta, Bombay, and Simla, 1876), p. 45; Thomas H. Hendley, *The Rulers of India and the Chiefs of Rajputana* (London, 1897), pl. 15; James Ivory, *Autobiography of a Princess* (New York, 1975), pp. 6-7; and Worswick and Embree, *The Last Empire*.

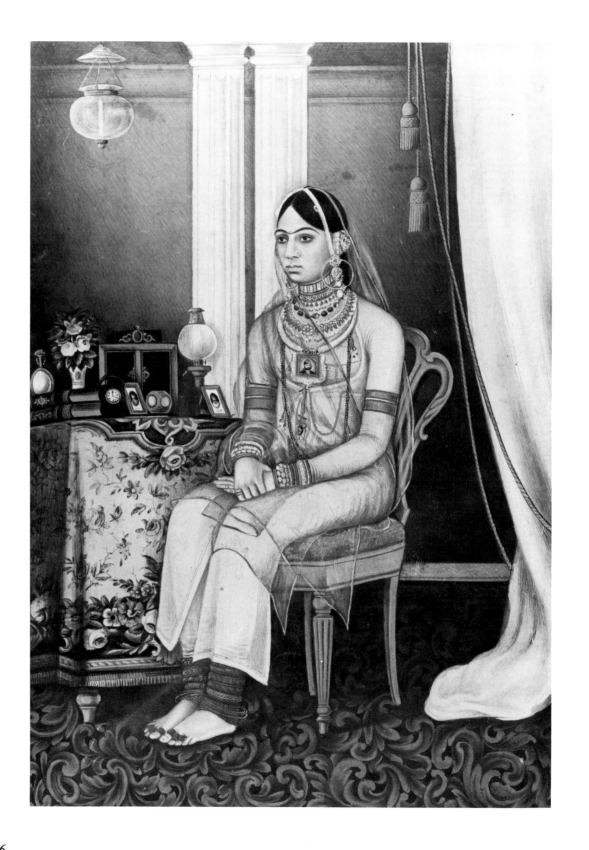

65. A MUSLIM COURTESAN

Signed: The Work of Gopilal the Painter
North India, Rajasthan; ca. 1875
H. 20.1 cm., W. 14.1 cm. (without borders)
Private collection

Indian courtesans, as compared to such painted fictions from the West as the *Chiaroscuro Lady* (no. 59) tended to be well-covered and genteel, at least in public. This one is positively prim, sitting on an unaccustomed Victorian chair for her likeness. Unsmiling, eyes fixed straight ahead, she wears a portrait of her patron the Maharaja, a custom passed on by the Mughals, who sported likenesses of the emperor or princes on turbans or necklaces as an indication of their closeness to august personages. Glass and lacquered ivory bangles adorn her ankles and arms; and she wears rings on her toes as well as fingers. Traditional torques, necklaces, pendulous earrings, and nose ornaments—royal equivalents of the simpler ones worn by Rajasthani village girls—belie the European clock, framed ivory portraits, books, aniline carpeting, and betasseled draperies. The old-fashioned trappings were truer to her way of life. Few, if any, Rajasthani women of 1875 shared the men's educations or their exposure to Western trends. And this girl, probably of very simple background, raised to share limited areas of a prince's life, must have been awed by every moment spent outside the *zenana* (harem) walls. Nonetheless, if she was sufficiently appealing, quick, and ambitious, her influence might have carried all the way to London or Paris, the outer limits of her prince's new playground.

66. MAHARAJA JASWANT SINGH OF MARWAR

Attributable to Narsingh Chitara (Narsingh the Painter)
North India, Jaipur; ca. 1880
H. 33.5 cm., W. 25.5 cm.
Lent by Messrs. John Robert Alderman and Mark Zebrowski

In 1875, Edward, Prince of Wales, steamed to India aboard the royal yacht *Serapis,* a converted troopship, to meet and receive the homage of his mother's, and eventually his own, subjects. Dutifully, often enthusiastically, he inspected India; but the hospitable, warm-hearted Sikh and Rajput princes, combining traditional panoply with squirely, almost English out-of-doorsiness, pleased him most. The age of the hunting-shooting-and-spending Maharajas had begun! Noblemen who formerly lived like feudal lords in remote forts of Rajasthan or the Punjab Hills, now braved all manner of contamination by traveling and cultivating Western ways; and in exchange, their curled "tiger" mustaches became the vogue in the West.

Maharaja Jaswant Singh of Marwar (r. 1873-1895), however, denied new-fangled ways, preferring to hunt wild beasts in his own jungles and to wear the family emeralds at home. He was fortunate in having a brother, Pratab Singh, who was delighted to go to London and meet the queen. While there, his wide-at-the-hip, tight-at-the-ankle breeches set a new style for horsemen—to be known as jodhpurs, after the capital of his state. Pratab

Singh became the personification of Maharaja-like sportsmanship and sometimes comical grandeur. But his brother, the actual ruler, clung to old values; and when he died in 1895, his favorite wife, Raiji, is said to have defied imperial authority by joining him atop the funeral pyre.

Following the royal visit, in 1877, Lord Lytton (viceroy from 1876 to 1880) concluded that the government of India should seek support from at least one level of society, and proposed that it be the aristocracy.

During the final quarter of the century, India's traditional artists were fighting last ditch stands against the camera. Many gave up paints and brushes to become photographers, after a transitional period of either copying photographs, as here, or painting directly on top of them. Such was their skill that it is often challenging to be sure whether or not some paintings are fundamentally what they seem.

See: Vitold de Golish, *Splendeurs et Crépuscules des Maharajas* (Paris, 1963); and Worswick and Embree, *The Last Empire,* p. 117.

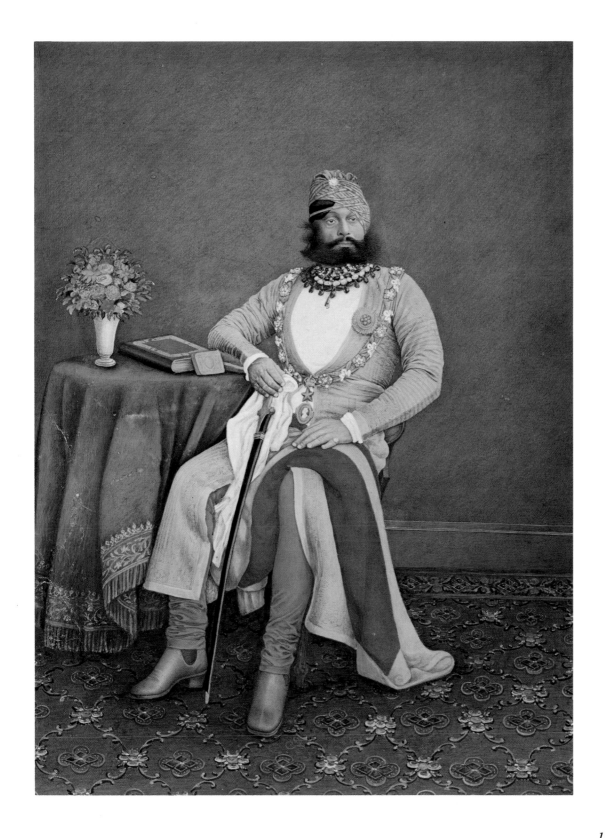

67. INDO-VICTORIAN FURNITURE
DESIGN

Upper India, Banaras; ca. 1880
H. 25.0 cm., W. 19.5 cm. (each sheet)
Private collection

Although Indians traditionally sat cross-legged on the
floor or on *chowkis* (platforms), they suffered the occa-
sional discomfort of chairs and sofas when it became
necessary to receive European guests. With the arrival of
increasing numbers of prestigious Englishmen, Western
furniture became essential in more Indian households, al-
though it was usually confined to otherwise useless rooms
visited by foreign sahibs, where it was accompanied by
equally unnecessary furbelows and knickknacks.

At first, Calcutta and Bombay merchants thrived by
importing these luxuries; but very soon, Indian craftsmen
began to duplicate, and even improve upon, the foreign
originals. Native designers and craftsmen learned to twist
extreme Victorian curves yet further, into outrageous
tropical jungles, ideal for the drawing rooms of Maha-
rajas, Nawabs, and rich merchants. And with character-
istic Indian imagination, as shown in these drawings for
prospective buyers, they stocked the flora with enough
fauna to satisfy the most eager huntsmen. To light on
such furniture, it appears, one first had to chase it across
the room!

68. TWO SORTS OF WORSHIP

Middle India, Deccan, Hyderabad; last quarter of the 18th century
a. Hindu Ladies at Prayer before a Lingam
H. 44.9 cm., W. 57.1 cm.
Lent by The Marquis of Dufferin and Ava
b. Two Mullahs
H. 29.2 cm., W. 42.5 cm.
Private collection

These large, richly painted pictures once formed part of a set illustrating religious practices in the Deccan. Elegant and courtly, the Hindu girls praying before a lingam, symbolic of Lord Siva, are but a step removed from the indigenous styles of Hyderabad or Kurnool during the later eighteenth century. More specifically helpful in establishing a provenance is the architecture behind the mullahs, which is typical of the tombs and mosques at Golconda, the Qutb Shahi capital near Hyderabad. Nonetheless, while both pictures are firmly rooted in a traditional style, their landscapes and such details as the saint-like face of the white-bearded Muslim, whose upward glance and expression evoke the late baroque, were modeled after European prints.

Like Oudh, Hyderabad was a Muslim state that became independent of the Mughals at the time of the empire's decline in the eighteenth century. Prior to 1798,

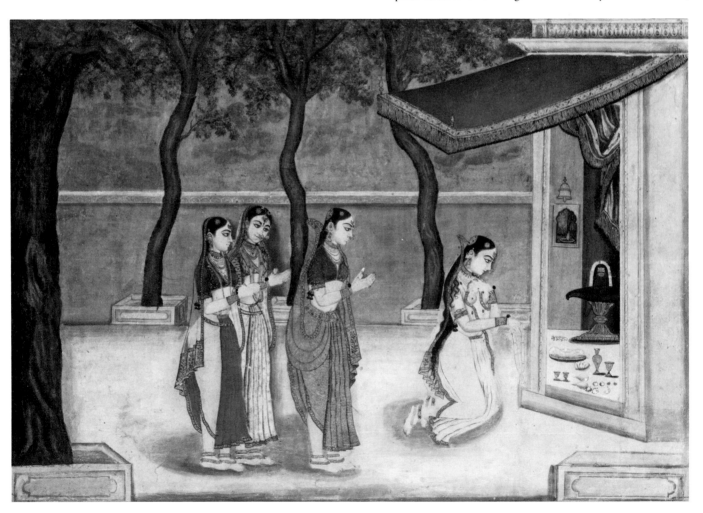

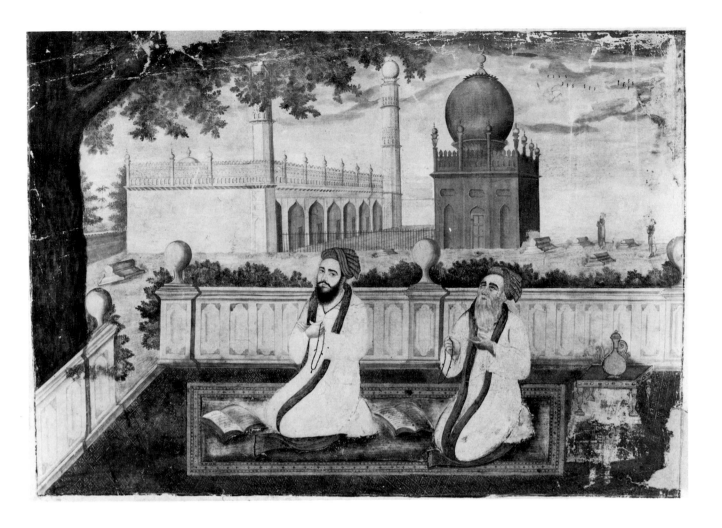

when Lord Wellesley forced an alliance upon Nizam 'Ali Khan (r. 1762-1802), requiring that he maintain 6,000 Company troops at his expense, Hyderabad was often a pawn in the hands of the Marathas and of the French. The first British Resident was Captain James Achilles Kirkpatrick (1797-1805), who was given the title *Hushmat Jung* ("Glorious in Battle") by the Nizam. A colorful gentleman, he married a Muslim girl, and their English descendants recall with pride that she abided by the strictest isolation of *purdah* in a splendid neoclassical mansion. Inasmuch as tradition forbade her ever leaving it, the compassionate captain commissioned a minuscule model of the house for her to admire in an inner garden. Both house and model still exist, as part of a college for women.

It would be tempting to suppose that the girls at prayer and the mullahs were painted for Captain Kirkpatrick or someone in his circle, though it is conceivable that their ornamentally Gallic restraint and tastefulness result from French patronage. Before Lord Wellesley's treaty of 1798 compelled the Nizam to banish them from his state, many French officers and business people lived in Hyderabad.

"Taste" was endemic to Hyderabad, which inherited from Golconda a major Muslim artistic tradition, rivaling the Mughals. Its last ruler, Sultan Abu'l Hasan (r. 1672-1687), who yielded his kingdom to the emperor Aurangzeb, was known as Tana Shah, "The King of Taste." As compared to the flamboyance and louche wordliness of Oudh (nos. 33-42), Hyderabad was refined, reserved, and gentle. While the Lucknow Nawabs flaunted their enjoyment of the full life in gaudy public rooms, the Nizams, seldom more innocent, maintained discretion behind white facades of classic purity.

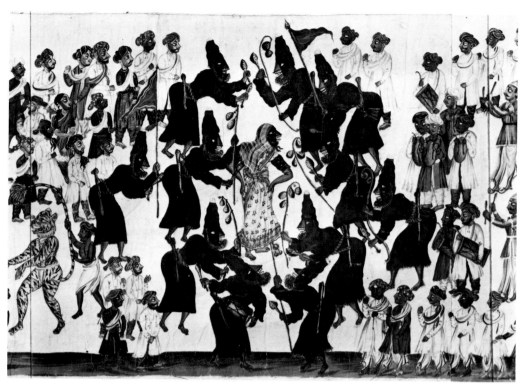

69. A RELIGIOUS PROCESSION
(MUHARRAM)

Deccan, Hyderabad or Arcot; ca. 1840
H. 16.2 cm., W. 565.5 cm.
Private collection

India's sights and sounds are often baffling. This scroll, with its strange procession of floats, people dressed as animals and demons, giant effigies, European glass lamps and English chairs, wild men, and aristocrats riding in carriages is in fact an accurate description of the annual commemoration of the martyrdom of two Muslim saints.

Husain and Hasan, the Prophet's grandsons, by his daughter and son-in-law, 'Ali, are held sacred by the Shiah sect, which is particularly strong in Hyderabad and Arcot. The ten day festival begins with the sighting of the new moon. Dirges (*marsiya*) are sung; towers (*ta'ziyah*) are erected, in the form of the mausoleum placed over Husain's remains after his death in the battle of Kerbala; and standards with symbols, such as the double sword given by the Prophet to 'Ali, are carried through the streets.

detail

In the Deccan and South India, tragedy, religious extremism, and buffoonery often mix, as in the procession depicted here. Men and boys join hands, singing dirges, and some are dressed like Hindu ascetics or tigers. Standard bearers rush through the crowds, upsetting old men, women, and children, causing mixed amusement and rage. Usually decorous citizens frequently take on the roles of fakirs. A few, known as the *benawa,* revel in temporary poverty; while others, the *azad,* or unrestrained, sporting Persian wool caps, behave as though in a Roman Saturnalia.

During the Muharram festival, revered institutions and people are satirized. The *hakim,* or doctor, is ridiculed by a man handing out ludicrous pills; and even the local ruler is spoofed unmercifully. Less specific characterizations include the *bharang*, or foolish chatterer, who clowns about, kicking his posterior with his heels; the *bagla,* dressed as a large bird; the *sharabi,* or drunkard; and the *Ghaliz Shah,* a foully attired King of Filth.

For an excellent and full account of a Muharram procession like the one depicted here see: Ja'far Sharif and G. A. Herklots, *Islam in India,* ed. William Crooke (1832, reprinted Delhi, 1972).

Sree Shahoo Maharaj Chutterputty
The adopted Son of the late Mah-
rayah Purtab Singh of Sattard.

श्रीराष्ट्र महाराजक्षत्रपतीश्रीप्रतापसीहेमहारा जयाचीक्षमीक्षका
मीपीतंक चीतलेयाचीत सवीर संख्यानसातारा

70. SHAHOOR MAHARAJ CHUTTERPIDDY OF SATARA

Middle India, Maharashtra; mid-19th century
H. 24.8 cm., W. 29.3 cm.
Private collection

This small child, his eyes blackened with kohl, delicate and elegant as a white butterfly, was descended from the noblest Maratha house. The soldierly Marathas, Hindus from Maharashtra, gained renown when Sivaji (1627-1680), beginning as a robber chief, entangled the Mughals with guerrilla tactics that spread like crabgrass. On his death, he was succeeded by his son, Sambhaji, who was tortured to death by the Mughals in 1698. His brother, Raja Ram, inherited the Maratha leadership; and his widow, Tara Bhai, ruled at Satara in Maharashtra. In due course, the Peshwas, ministers of the Satara house, assumed all ruling powers, while nominally remaining feudatories of the Raja. Although the Peshwas themselves soon yielded active leadership to ambitious followers (the Bhonslas of Nagpur; the Gaekwars of Baroda; the Holkars of Indore; and the Sindhias of Gwalior), collectively the Marathas seized and controlled much of North India. Inasmuch as they dominated both the Mughals and the Rajputs during the years of the British rise to power, it could be claimed that India was taken from them, not from the better-known Mughal emperors.

In 1818, Sir John Malcolm accepted the crucial Maratha surrender. According to the terms of the settlement, the Peshwa was pensioned off at Bednur, on the Ganges.

(His adopted son, Nana Sahib inherited his bitterness and was one of the leaders in the Mutiny of 1857.) The Peshwa's lands became part of the Bombay Presidency; and Pratab Singh, the nominal head of the Marathas, descended from the house of Sivaji, was restored to the principality of Satara.

After twenty years of puppet rule, under a British Resident, Pratab Singh's independence of spirit galled the British government. He was charged with sedition and deposed in favor of his younger brother, Appa Sahib, who is portrayed here, seated in the left foreground. Pratab Singh was forcibly settled in Banaras, where he died in 1847, leaving only the adopted son shown in this portrait. A year later, on the death of his successor, the state of Satara was annexed by the British.

The white, gray, and gold palette aptly portrays a fragile child trapped in the brutal world of petty politics. In this masterful evocation of dreamlike oblivion, only the humble bearer, holding his highness's sword and a peacock-feather whisk, looks ahead in dispair.

See: Govind Sakharam Sardesai, *New History of the Marathas* (Bombay, 1946-48), vol. III, pp. 510-513.

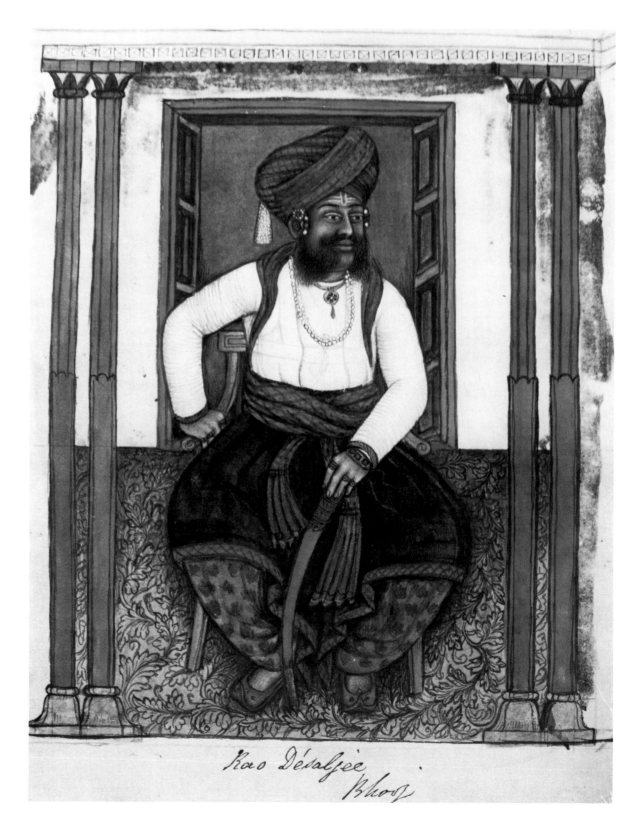

Rao Désaljée
Bhooj

71. HENRY PITMAN'S ALBUM

Western India, Cutch; mid-19th century

a. Rao Desaljee, Bhooj (Rao Desalji II of Cutch,
 r. 1819-1860)
 H. 20.3 cm., W. 16.5 cm.

b. A Mahratta Bheestie or watercarrier supplying a
 sepoy
 H. 20.3 cm., W. 16.0 cm.

c. Hindoo confectioner's shop
 H. 19.7 cm., W. 16.0 cm.

d. Leather tanners
 H. 16.0 cm., W. 20.3 cm.

e. A Nautch or dancing girl
 H. 20.3 cm., W. 16.5 cm.

f. Weaving
 H. 16.5 cm., W. 20.3 cm.

g. Cotton cleaning
 H. 20.3 cm., W. 16.5 cm.
 Lent by Peter and Evelyn Kraus

Although Surat was the first English settlement in India, and Bombay soon followed, the Bombay Presidency did not come into its own until the final defeat of the Marathas in 1818, after which it grew more rapidly as a commercial center. Lacking significant traditions of painting such as were available in most other Company areas, Western India offered no ready-trained artists for the English to hire. Mildred Archer points out that when Sir Charles Malet was British Resident in Poona (1786-1796), he brought there from Bombay the British painter James Wales and his assistant Robert Mabon, and helped find commissions for them from the Peshwa and his ministers. Malet also trained a Brahmin from Cambay to make drawings of local costumes and castes, which are now in the collection of Mr. and Mrs. Paul Mellon.

With the increasing English population in Western India, there was more demand for such pictures; and because there was no cadre of Mughal or Rajput-trained artists, those who supplied this need often approached painting with appealing freshness, comparable perhaps to that of such European "primitives" as the Douanier Rousseau.

The artist of the Pitman album had emerged by midcentury from this groping new school of painting, in which earthiness and honesty more than compensate for lack of academic polish. The album opens with a portrait of Rao Desalji of Cutch (r. 1819-1860), who received a Company Resident at his capital, Bhuj, in his accession year. He is shown seated on an English style chair, pleasantly smiling, with roundly modeled trunk and arms, impressively monumental (71a).

The anonymous artist, perhaps from Bhuj, captured fleeting gestures and makes us feel them. His Rao's hands really grip the chair, and his sepoy (71b) leans thirstily for a drink of water, careful, like all orthodox Hindus, to avoid the contamination of touching the container with his lips. All of this artist's pictures are comparably *felt* as well as *thought* out. Sharing them with swarms of flies, we can almost taste the sweets of the confectioner (71c); and such details as the weaver balancing a brush on his turban (71f) are convincingly observed. The cotton cleaner (71g), whose grooved old face emerges from cloudbanks of fluff, virtually twangs and whirrs off the page!

I am grateful to Peter and Evelyn Kraus and to Mr. T. Thomas of the India Office Library and Records for information about Henry Pitman, who was born on January 4, 1818, and married Maria Sharp in 1853. She died without issue in 1870, and he married again in 1873, two years after retiring and nine years before he died. He was a member of the Royal College of Surgeons, of which he became a fellow in 1865.

The fullest account of Company painting in Western India is found in Mildred Archer's *Company Drawings*, pp. 236-249.

Album inscribed on spine "Indian Sketches" bound in full morocco, gold tooled flyleaf inscribed "Henry Pitman, Deputy Inspector General of Hospitals, 1871." Album: H. 29.0 cm., W. 43.0 cm.

b.

d.

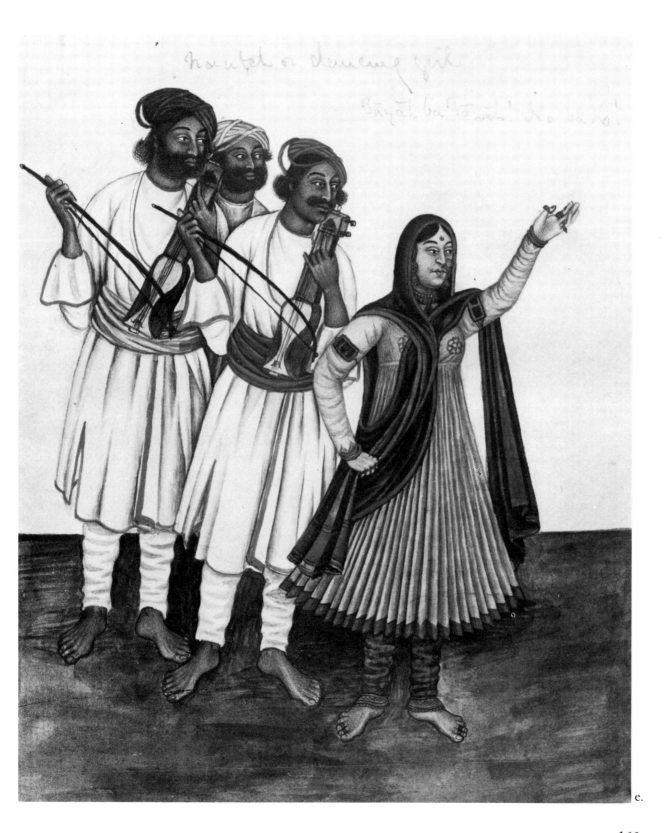

Nautch or dancing girl

Bājāh bajāwī ho bārī

Cotton cleaning

72. A HURKURAH (DAK RUNNER)
DELIVERING A LETTER TO SHRAFFS
(BANKERS) OF NOURIE HINDUOS

Western India, Sind or North India, Lahore;
ca. 1850-60
H. 19.0 cm., W. 23.7 cm.
Private collection

A Hurkurah (dak runner) delivering a letter to Shraffs (Bankers) of Nourie Hinduos.

Painted on smoother, imported paper, and somewhat less rustic in style and finish than the Pitman pictures, this bounteous display of fat pillows, fatter ledgers, and an even fatter, dimpled belly retains great appeal.

Long before this picture was inscribed, many indigenous words were in common use among the British in India. Here, *dak* (originally meaning "transport by relays of men or horses," *Hobson-Jobson,* p. 299) became a very common Anglo-Indian word, applied to the messengers' stations or posts, now known as *dak* bungalows or government rest houses. Many of these words, including bungalow—originally a thatched hut in Bengal—gained acceptance in England and America. Others are *dinghy* (a Bengali skiff); *veranda* (from the Persian or Sanskrit or both, meaning "an opened pillared gallery round a house," *Hobson-Jobson,* p. 964); and *buggy* (a "two-wheeled gig with a hood," *Hobson-Jobson,* p. 123). A very large number of seemingly English words originated in India.

The Nouries, or Noories, are from a village of that name in Sind, on the banks of the Fulalee, fifteen miles below Hyderabad (see: Walter Hamilton, *A Geographical, Statistical, and Historical Description of Hindostan* [London, 1820], vol. I, p. 570). Hamilton was one among many English scholars who gathered and published vast amounts of information about India's people and places, invariably with the help of native informants or *pundits* ("learned men from the Sanskrit," *Hobson-Jobson,* p. 740). It should be pointed out, however, that words also traveled in the opposite direction. *Damful,* often heard in Hindi, is from the English phrase, "damn fool."

See Bibliography for a few other publications on India's tribes and castes by British scholars of the nineteenth century.

Although this picture seems to be from the same album as no. 57, the subject and style are so characteristic of Sind that we chose to print it here.

73. ODD GOINGS-ON IN MADRAS

South India, Madras; ca. 1783
H. 25.3 cm., W. 18.5 cm.
Lent by Mr. Edwin Binney, 3rd

Most English traditions were taken to India, including the political cartoon, a favorite eighteenth-century expression raised to an art form by Thomas Rowlandson and James Gillray. This spritely painting, which might at first seem to represent colonials being silly at a costume ball—or, to an unwesternized Indian, some form of worship involving Hanuman, the monkey god—is in fact an Indian copy of an English caricature.

Mildred Archer has identified the personages and situation. The leering gentleman dressed as a bear is Sir John Burgoyne, commandant of the 23rd Light Dragoons, known in American history as "Gentleman Johnny." Lord Macartney, governor and president of Fort St. George, Madras (1781-1785) is a green monkey approaching the commander-in-chief at Madras (1782-1783), General Stuart, who lost his leg at the battle of Polore in 1781. Admiral Hughes, who left Madras in 1783, is seated behind General Stuart, with his friend Mrs. Helena Oakeley, whose husband Sir Charles became governor of Madras (1792-1794). The other lady is Mrs. Sydenham, wife of William Sydenham of the Madras Artillery. Another picture from the same series, otherwise devoted to Indian occupations, caricatures the scandalous behavior of Admiral Hughes and Mrs. Oakeley.

See: Archer, *Company Drawings*, pp. 16-17, no. 1 i-iii. The other caricature was presented to the India Office Library by Mr. Edwin Binney, 3rd.

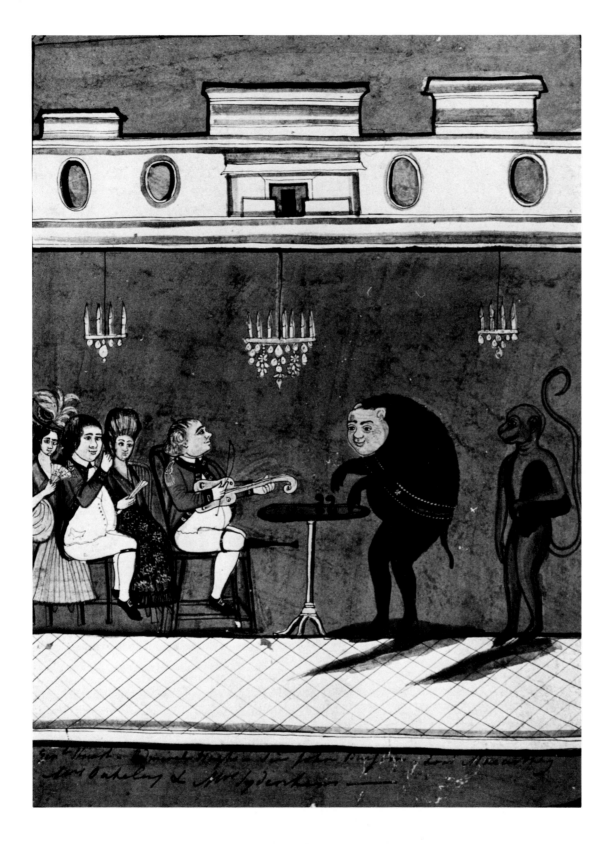

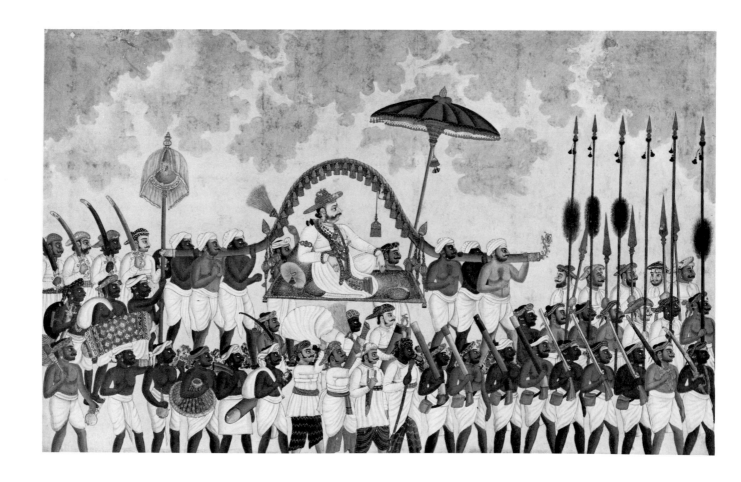

74. SARABHOJI, THE RAJA OF TANJORE IN PROCESSION

South India, Tanjore; ca. 1800
H. 42.0 cm., W. 66.0 cm.
Lent by the Fogg Art Museum,
Harvard University
Cambridge, Massachusetts, Purchase—
Alpheus Hyatt Fund

During the late eighteenth century, when many English officers were stationed in Tanjore during the Mysore wars, they wanted pictures of local interest to take home. These were provided by the Moochy caste, who shared in the artistic traditions still maintained by the ruling Maratha dynasty. Large numbers of sets showing couples working at characteristic occupations were painted, usually against the same light blue and gray cloudy skies shown here. Revealing a penchant for bright yellows, pink, and rose-violet, these hark back to the ateliers of Deccani refugees set up in Tanjore, according to oral tradition, during the late seventeenth century, when the Mughal seizure of Golconda forced many artists to find new patrons.

Raja Sarabhoji (r. 1798-1832) learned much of Europeans and their arts as a youth when he studied with Danish tutors. After the British had established a garrison at Tanjore in 1776, he presented sets of paintings made under his supervision to English guests. Conceivably, this processional portrait was such an offering. In it, we see the Raja wearing his Maratha style turban, borne in a palanquin by bearers, accompanied by his guard and attendants. They carry his bolster, sword, fly-whisk, rosewater bottle, and other pleasurable attributes of royalty.

For painting at Tanjore, see: Archer, *Company Drawings*, pp. 21-36.

75. MAN CANING AN ENGLISH-STYLE CHAIR

South India, Malabar Coast; ca. 1820
H. 19.0 cm., W. 22.7 cm. (whole sheet)
Lent by the Victoria and Albert Museum

Wherever the Company's servants gathered in quantity, "Company" paintings were made by local artists to supply their artistic needs. A minor but appealing school of this sort grew up along the Malabar coast, which was ceded to the Company by the terms of the treaty of Seringapatam in 1792. As usual, the pictures painted here not only take the local people and their occupations as subjects, but also reflect the mood of the people and place. Malabar pictures, such as this one, are peculiarly refined, almost gentle in spirit, painted with the same precision notable in the area's crafts. The sure, hair-thin outlines and subtle modeling of this painting are comparable to Malabar boats. The intricate basket-work which the wife of the craftsman carries on her head proves that his task was assigned on good grounds.

See: Archer, *Company Drawings*, pp. 55-58.

76. A PILE-CARPET LOOM AT HUNSUR

Inscribed: "Plan and elevation of a Carpet loom
with five men at work. Grazing Farm. Hoonsoor,
1st November, 1850"
South India, Mysore; 1850
H. 44.9 cm., W. 62.8 cm.
Lent by the India Office Library and Records

Grazing Farm

Aesthetically exciting pictures were occasionally painted by humbly unpretentious painters, hired in the name of commerce rather than art. This delightful and informative study of busy weavers and their smiling supervisor is by an artist trained in the tradition of religious manuscript illustration, as can be seen from the supervisor's profile face, with its curvilinear formulae known from such sources. The painter's eye for effectively bold pattern, clean, crisp color, and firm, wiry outline was easily and most appealingly "translated" into the artistic language required by his new patrons. In all likelihood, he was also employed to draw and color the designs on paper which were followed by the weavers.

According to Mildred Archer, "The Amrit Mahal cattle-breeding station was at Hunsur....Until 1864 it had a large tannery, blanket manufactory, and timber yard maintained by the Madras Commissariat." She suspects that this drawing was sent to the East India Company together with a specimen carpet for the museum.

See: Archer, *Company Drawings*, p. 58, no. 37.

77. ETTANETTAN TAMPURAN, THE TAMURI RAJA (OR ZAMORIN OF CALICUT)

South India, Malabar Coast, Calicut; ca. 1845
H. 46.6 cm., W. 28.0 cm.
Private collection

Traditional Indian portraits were usually posed according to caste. Brahmins, looking spiritual, wore simple clothing; ferociously aristocratic princes dressed magnificently and were frequently shown enthroned or in battle; while contented merchants, rich in their counting houses, oozed prosperity. Members of the fourth, or agricultural, caste were seldom portrayed; and when they were, likenesses tended to lack individuality. This picture of Ettanettan Tampuran (r. 1828-1845) is clearly of the second sort, though in most ways its anonymous artist broke with convention. Paradoxes and oddities abound: the prince's shabby stubble is singularly inelegant; and his thin arms are ill-suited to the bloated torso and lap, raising the apparition of a pregnant bishop. His furrowed brow and tensed lips bespeak anxiety, not royalty.

While the Raja's harrowed face holds center stage, the rest of the painting seethes with life. The crisp, pie-crust throne—a concoction of shiny finials, pillows, and bolsters—seems joined to the sitter, his Siamese twin. Apart from him are his luminous burnt-orange robes, like theatrical curtains, concealing in their puffs and wrinkles a world of quaintly rodent-like grotesques.

Francis Bacon's tormented souls and Goya's bitingly satirized Spanish nobility appear to blend in this late Indian portrait, by an anonymous, but original artist whose knowledge of European portraiture was probably limited to a few English prints, high Victorian photographs, and hack oil paintings. In spite of his ignorance (or because of it), he succeeded intuitively in creating a poignant image of fading aristocracy that brings to mind Satyajit Ray's comparable portrayal in his magnificent film, "The Music Room."

Calicut and its ruling house are ancient. Long frequented by Arab traders, it was the first Indian city visited by Vasco da Gama, in 1498, and it soon became a major Portuguese trading center, specializing in cotton cloth known in the West as calico. In 1515, the reigning Tamuri Raja sent a dispatch engraved in gold to Europe. Five years later, while traveling in the Lowlands, Albrecht Dürer acquired exotic items imported thence by Portugese merchants: two ivory saltcellars, feathers, wooden weapons, and a fish-skin shield.

Early in the nineteenth century, Walter Hamilton wrote interestingly about the ruler, pointing out that he is known to Europeans as the Zamorin, but "by his own tribe, and the other natives, he is styled the Tamuri Raja." He added that "All the males of the family of the Zamorin are called Tamburans, and the females Tamburettes...[and that] the oldest man of the family by the female line is the Tamuri Raja...[who] pretends to be of higher rank than the Brahmins, and to be only inferior to the invisible gods, which pretensions are acknowledged by his subjects, but held absurd and abominable by the Brahmins, who treat him as a Sudra [of the agricultural caste]....In 1767 when Hyder ('Ali) invaded Malabar, the Cochin Raja quietly submitted to pay tribute, while the pride of the Zamorin refused any kind of submission, and after an unavailing resistance, being made prisoner, set fire to the house in which he was confined, and was burned with it." (Hamilton, *A Geographical, Statistical, and Historical Description of Hindostan,* vol. II, pp. 294-295)

The Raja's self martyrdom was an act of *traga*, putting oneself or some member of one's family to torture or death in order to bring vengeance on the oppressor (see *Hobson-Jobson*, p. 937). Sadly, the once powerful Tamuri Rajas never regained their power. In 1792, they ceded most of their lands to the Company, retaining only a small but fertile estate, from which they exported cardamom, pepper, and sandalwood.

See: Hartnoll & Eyre, Ltd., *Important "Company" Paintings* (brochure), (London, October, 1977) and K. V. Krishna Ayyar, *The Zamorins of Calicut,* (Calicut, 1938).

78. BANYAN TREE WITH TANK AND
PALANQUIN

Provenance unknown; ca. 1840
H. 33.2 cm., W. 65.1 cm.
Private collection

Landscape was the least Indian of subjects, seldom more than incidental in Mughal or Rajput pictures, and even scarcer in Hindu and Jain religious illustrations. Nonetheless, as can be seen in such secondary passages, Indian artists possessed deep feeling for trees, vistas, and clouds; and when English patronage exposed them to pictures of views, the response was immediate and occasionally led to painting on a very high level. With its smoky haze, eerie lighting reminiscent of pictures by the German romantic, Caspar David Friedrich, and arrestingly spaced verticals, this landscape could hardly be more moving.

But while its quality is recognizable, the place depicted is not. Giles Eyre, who discovered it, may well be correct in suggesting that it "could perhaps be a naive version of an unknown work by Richard Barron. It has his same sense of brooding mystery, and there is something about the figures which reminds us of his humped Toda villagers from the Nilgiri Hills." Another friend, Pramod Chandra, proposes that these wooded hills are closer to those of Satara, in the Maratha area, beyond the Western Ghats. Moreover, he points out, the architecture of the Hindu temple in the distance is characteristic of southern Maharashtra.

See: Giles Eyre, *Company Paintings, 19th Century* (London, 1974). For Barron, see: Richard Barron, *Views in India, Chiefly among the Neelgherry Hills* (London, 1837).

Chronology

European contacts with India go back to the ancient Greeks, breaking down with the fall of Rome. Sporadic travelers, such as Marco Polo, who visited India on return from China to Venice between 1292 and 1295, contributed to the legend of her riches and wondrousness; but whatever trading took place was through go-betweens.

1498 Vasco da Gama, Portuguese explorer, is first European to reach India by sea. Seeking Christians and spices, he thought Hindu temples were Christian shrines. Inspired by his success, Portuguese soon sent traders who dominated South Asian seas for a century, with Cochin (1502) in south India, Goa (1510), Malacca (1511), and Ormuz (1515) as centers. Their aim: to defeat Muslim traders, to control spice trade, and thereby spread Christianity. They created a maritime empire based on cannon-power and fortified ports.

1526 Babur, a prince of Fergana descended from Timur and Chinghiz Khan, invades India, defeats Muslim Sultan of Delhi, and establishes Mughal Empire in Hindustan. He dies in 1530, and is succeeded by his son, Humayun (r. 1530-1556), who is exiled to Persia, then regains Mughal Empire before dying in 1556.

1556-1605 Akbar the Great, third Mughal emperor, expands and stabilizes imperial power, conciliates Rajputs and welcomes missionaries and merchants. Vital art patron; his artists at times paint Christian subjects (see fig. 1).

1583-1591 Ralph Fitch, Englishman, reaches India by overland route.

1588 English defeat Spanish Armada, a great stimulus to maritime enterprise.

1595-1602 Portuguese successes inspire Dutch to establish trading centers in East Indies. Dutch United East India Company founded in 1602.

1599 Inspired by Portuguese example, East India Company founded in London. First voyage, however, to Sumatra for trade in spices, silk, gems, camphor, and indigo. Pepper imported in such quantities that market glutted. Queen Elizabeth grants charter in 1600 to "the Governor and company of merchants of London trading into the East Indies."

1605 Jahangir, "World Seizer" (r. 1605-1627), succeeds his father, Akbar, as Mughal emperor.

1611 East India Company, discouraged by Dutch and Portuguese control of East Indies, opens factory in India at Masulipatam to deal in cottons and other fabrics.

1612 Surat, near Bombay, becomes Indian headquarters for the East India Company.

1615-1618 Sir Thomas Roe's embassy from James I to Emperor Jahangir cements relations between English and Mughals. The emperor admires Roe's English portrait miniatures, which he orders to be copied by his own artists. Impressed by English defeat of Portuguese ships (off Surat in 1615 and, in 1621, following siege of Portuguese Ormuz by Persians and English), he grants English trading privileges in exchange for East India Company becoming naval auxiliary of Mughals, to keep seas clear of Portuguese so that Muslim pilgrims can sail to holy city of Mecca.

1618-1687 Headquarters of Company at Surat, on west coast, with factories in south at Masulipatam and in Madras (1641). Trade with Bengal established at Hooghly in 1640, dealing in sugar, saltpeter, and raw silk.

1623 English massacred by Dutch at Amboyna Island, East Indies. After this, English concentrated on India.

1627 Jahangir succeeded by Shah Jahan (r. 1627-1657) as Mughal emperor. Because Portuguese had not helped him as prince against his father, and because he finds their missionary zeal offensive, he drives them from Hooghly, in Bengal. English replace them; and establish factory there in 1650.

1640 English granted site of Madras; build Fort St. George.

1641-1663 Dutch gradually overpower Portuguese, who lose control of Malacca, much of Ceylon, and Cochin. Portuguese area of influence reduced to Goa, Diu, and Dāmao.

1657 Aurangzeb (r. 1657-1707) succeeds father, Shah Jahan, after bitter fratricidal struggle. He over-expands empire to greatest size, but weakens it by alienating Hindus, thus inciting rebellions. Erosion of Mughal power begins, making way clear for others, including English.

1661 Bombay acquired by King Charles II as part of dowry of his Portuguese wife, Catherine of Braganza. In 1687 it replaces Surat as headquarters of Western India trade.

1671 Elihu Yale (1649-1721) joins Company as a "writer," or clerk. Born in Boston, while serving Company he puts savings into private ventures, buying spices in Java to sell in London. Before long, he owns four ships. Becomes governor of Madras; marries children into English aristocracy. In 1714 and 1718 he gives books and goods to the Collegiate School in Saybrook, Connecticut, which is chartered as Yale College in 1745. Dies a

very rich man in England, an inspiring example of success in India.

1671 French Compagnie des Indes Orientales, founded in 1664, attempts by force to establish factories on Malabar Coast (on west side of India). Fails; but French settle Pondicherry, near Madras, held by English for two years, later by French until 1950.

1685-1688 Company antagonizes Aurangzeb by attempt to take Chittagong. Emperor seizes Surat, expels Englishmen from his domain. East India Company abandons Hooghly and moves to Calcutta.

1687 Madras first among English settlements to be chartered as a Municipal Corporation, with a mayor's court. Unlike Bombay, which was threatened by Marathas, and Calcutta, in the heart of the richest Mughal province, Madras was secure.

1691 Job Charnock, a rugged Englishman who sacrificed cocks to the Hindu goddess Kali, founds Calcutta, named after village (Kalikata). Charnock took hard line against Mughals, who menaced the English in spite of presents such as "boxes with clockwork, . . . good pieces of ambergrease, European fusees, and small field pieces."

Charnock, who died in 1693, typified his generation of Englishmen in India, who intermarried with locals, ate Indian as well as European food, consuming huge midday meals, accompanied by much wine and arrack, a powerful native liquor. Shooting, gambling, kite flying, firing cannons, and brawling were among their boisterous entertainments. If they survived the tropical fluxes and fevers, many of these rugged pioneers succumbed to overindulgence.

1696 Fort William built at Calcutta rather than Hooghly, site of the former factory, when English allowed to return to area following Sir Josiah Child's war against Mughals of 1688.

1698 Mughals, showing signs of weakness, allow the English to fortify Calcutta and to collect taxes and administer justice in three nearby villages. In 1701, the English governor of Calcutta is strong enough to stop the sailing of all Mughal ships.

Late 17th century At the end of seventeenth century, French, Danes, and the Imperial Ostend Company emulated English and Dutch examples by establishing companies to trade in India, but none could rival the former in India or the latter in the East Indies.

ca. 1700 During the early eighteenth century, the lot of the Englishman in India gained in security and comfort. Hamilton wrote, "Most gentlemen and ladies in Bengal live both splendidly and pleasantly, the forenoons being dedicated to business and after dinner to rest, and in the evening to recreate themselves in chaises or palankeens in the fields, or to gardens, or by water in their budgeroes, which is a convenient boat that goes swiftly by the force of oars."

1709 Thomas Pitt (1653-1726), known as "Diamond Pitt," grandfather of William, returns to England rich as a nabob (from Nawab, a Mughal title). Others eager to emulate him.

1717 Company granted possession of five villages round Madras by the Mughal emperor Farrukhsiyar (r. 1713-1719).

1719-1748 During the reign of Muhammad Shah ("Rangila," the Pleasure-Loving), Mughal power and prestige fail. In 1722, his Wazir, Asaf Jah, retires to his province in the Deccan and founds the dynasty of the Nizams.

In 1724, Saadat Khan, another great Mughal nobleman, becomes ruler of Oudh; rules practically independent of emperor. Also, Ali Vardi Khan, governor of Bengal 1740-1756, ceases to forward revenues regularly; no longer, in practice, recognizes sovereignty of Mughal emperor.

Rohilla Afghans take rich lands north of Ganges, set up Rohilkhand; and in 1737 Marathas invade Delhi, but do not seize it. Instead, they leave to wage war against the Nizam in Deccan.

Knowing of Mughal wealth and weakness, Persian Nadir Shah invades India and sacks Delhi in 1739. Great slaughter. He returns to Persia with loot, including Peacock Throne, greatest symbol of Mughal rule, and many albums and manuscripts, as well as gold, precious stones, etc.

Muhammad Shah dies in comparative tranquility in 1748.

1724 Nizam of Hyderabad becomes independent of Mughal Empire, while retaining his titles and appointment as viceroy of the Deccan. Marathas force him to pay *chauth*, one-quarter of his revenue. In 1750, the French, under the leadership of Joseph Francois Dupleix, are ceded Pondicherry and other territories by Nizam in return for military help.

1748-1754 Reign of Emperor Ahmad Shah. Repulse of Ahmad Shah Durrani, Afghan chief who had inherited eastern part of Nadir Shah's territories. Nevertheless, Ahmad Shah Durrani exacts tribute from Punjab and later obtains formal cession of that area from emperor.

1752 Ghazi-ud-din ousts Safdar Jang of Oudh and becomes Wazir. Two years later, he blinds and deposes Ahmad Shah; replaces him with Emperor Alamgir II (r. 1754-1759).

1756-1775 Nawab Wazir Shuja-ud-daula of Oudh reigns, mostly at Faizabad, a center of painting and poetry. He succeeds in resisting both Marathas and British until 1773. (See no. 35)

1756 The Mughal governor of Bengal, Siraj-ud-daula, suffering from the attacks of Marathas, is angered by the British, who had fortified Calcutta, and had aided his enemies. He attacks the British fort; and although the governor escapes by sea, 146 British persons were captured and confined in the so-called "Black Hole," an eighteen-foot by fourteen-foot space. The Company appeals to the Nawab, while the Council in Madras equips an army and fleet to assure a suitable outcome. Robert Clive, leading the army, recaptures Calcutta in January, 1752. He then

won over Mir Jafar, one of the Nawab's generals, who treacherously advised the Nawab to yield at the battle of Plassey (June, 1757). The Nawab was murdered a few days later, and Mir Jafar enthroned by Clive as his reward.

1762 A letter of Mir Kasim, son-in-law and successor of Mir Jafar, to the governor of Bengal: "And in this way your gentlemen behave; they make a disturbance all over my country, plunder the people, injure and disgrace my servants…setting up the colours and showing the passes of the Company, they use their utmost endeavours to oppress the peasants, merchants, and other people of the country.… They forcibly take away the goods and commodities of the peasants, merchants, etc. for a fourth part of their value, and by the ways of violence and oppression they oblige the peasants to give five rupees for goods which are worth but one rupee."

1765 Transfer of authority from Mughal Nawab of Bengal to British. Previously, Company merely trading organization with a private army but no sovereign status. In 1765 Robert Clive forced Emperor Shah Alam II (r. 1759-1788, see no. 43) to legalize Company's position in Bengal by giving it the right to collect revenue. Judicial branch of government, however, remained. A deputy Nawab (Muhammad Reza Khan, see no. 4) appointed to implement both tasks.

1770-1790 Richard Johnson, employed by the East India Company from 1770 to 1790, forms one of the major collections of Indian paintings before leaving India. He served in Lucknow from 1780 to 1782 and was Resident at the court of the Nizam of Hyderabad from 1784 to 1785. His collection was bought by the Company, in 1807, shortly before his death and is now in the India Office Library, London.

1770-1794 Marathas (hardy, aggressive warriors from Maharashtra, hence name) move north, gain control over Mughal emperor, Shah Alam II. But in 1772 their young leader, the Peshwa, dies, resulting in dissension.

1772 Warren Hastings, as governor-general (1774-1785), tries to prohibit private trade among officers of Company; but his own position is weak and he fails to correct this practice, which was not changed until 1786 when Lord Cornwallis (governor-general 1786-1793), supported by William Pitt, raised Company salaries and prohibited it. In 1787 Hastings was impeached as a moneymaker and oppressor on twenty-three counts. After eight years, during which he lost most of his fortune, he was acquitted. Generally considered to have been one of the ablest British statesman in India during the British period, he died at eighty-six in 1818.

1773 Shuja-ud-daula, Nawab Wazir of Oudh, agrees to give Company two and a half million rupees per year, to maintain a troop of Company soldiers in Oudh, and to receive a permanent British Resident in exchange for the return of the territory of Allahabad. His revenues twenty-seven million rupees at this time. (See no. 35)

1773 Parliament passes the Regulating Act, asserting legal right of Company to administer the territories of India, but with the proviso that this right emanated from Parliament. Office of governor-general created with control over territories in Madras and Bombay as well as Bengal.

1775 William Hickey (1749-1830?), whose *Memoirs* (742 finely written manuscript pages) are the liveliest account of eighteenth-century British life in India, settles in Calcutta, following a checkered young manhood, when he fleeced his father, a rich London solicitor. In India, he became under-sheriff and clerk to the chief justice; but his autobiography is more concerned with Calcutta trivia and diversions. Like most of his companions, he seldom met socially with Indians—other than women of low repute and servants—and always dressed as though in London. Before retiring to England in 1808 with a comfortable fortune, he released all but one (whom he took to England) of his sixty-three servants, and sold his five horses, buggy, billiards table, chamber organ, and "a very elegant chair palankeen." (See no. 3)

ca. 1778 Social note from Calcutta: "A captain Morrison had repeatedly expressed his abhorrence of pelleting (hurling little breadballs at the dinner table), and announced that if any person strike him with one, he should consider it as an insult and resent it accordingly. In a few minutes…he received a sharp blow in the face from a very recent acquaintance. He therefore without the least hesitation took up a dish that stood before him and contained a leg of mutton, which he discharged with all his strength at the offender, and with such well-directed aim that it took place upon the head, knocking him off his chair and giving a severe cut upon the temple. This produced a duel in which the unfortunate pelleter was shot through the body, lay upon his bed many months, and never fully recovered. This put a complete stop to the absurd practice." (William Hickey, *Memoirs*, vol. II, p. 137)

1780-1839 Ranjit Singh dominates the Punjab. (See no. 54)

1780-1783 William Hodges (1744-1797), landscape painter, in India. The son of a blacksmith, he became a pupil and assistant of Richard Wilson. From 1772 through 1775, he accompanied Captain Cook to the Pacific on his second voyage. Upon returning, his work was used in publication of expedition. In 1780, he went to Madras; and later to Calcutta and up-country as far as Agra, leaving India at the end of 1783. In 1786, he published *Select Views in India;* followed in 1793 by *Travels in India during 1780-3.* He retired from painting in 1795, became a banker, and committed suicide in 1797. His Indian sketching tour and aquatints were instrumental in the Daniells' longer travels of 1786-93.

1780-1799 Anglo-Mysore Wars. Under self-made Haidar and son Tipu, Sultans of Mysore menace Company. They invade Hyderabad, are bought off. In 1780, Haidar defeats English, seizes Arcot. Hastings sends Sir Eyre Coote, who defeats Haidar at Porto Novo in 1781. Haidar dies in 1782; Coote in 1783. Tipu Sultan succeeds Haidar, attacks Travancore, despite peace

treaty of 1784. Triple alliance forms against him and he is defeated. Treaty of Seringapatam. He yields half of dominions, has to pay indemnity and send two sons as hostages; but is not destroyed.

In last bout of wars, Tipu allies with French in 1798. Wellesley goes to war. Tipu killed (1799); Seringapatam plundered. Descendant of Hindu rulers of Mysore reinstated. Mysore becomes a virtual dependancy.

1781 Warren Hastings, governor-general (1774-1785), establishes a madrasa in Calcutta for Muslim traditional education. He was also one of founders of the Asiatic Society of Bengal, the initiator of an Arabic college, and a student of Persian, Arabic, and Sanskrit, which he studied in order to ascertain the nature of Indian law. A substantial patron of the painters Hodges and Zoffani.

1782 Company treaty of Salbai with Marathas. Peace for twenty years.

New leader, Mahadaji Sindhia hires officer Benoit de Boigne to reorganize army on European plan.

1784 William Pitt's India Act introduced a board of control headed by chancellor of the Exchequer with powers to modify Company orders and make its own. A system of dual control by Company and Crown in operation until Mutiny of 1857.

1784 Asiatic Society of Bengal founded, with help of Sir William Jones, a judge, who translated Kalidasa's drama *Sakuntala* from Sanskrit into Latin and then into English in 1789. Ultimately, his work inspired both the German romantics and the American transcendentalists.

1785 The *Bhagavad Gita*, a philosophical dialogue between the god Krishna and Arjuna is the first published translation from the Sanskrit, the work of Charles Wilkins (1749-1836).

1786-1793 Thomas Daniell (1749-1840) and his nephew William (1769-1837), landscape painters, in India. First two years spent preparing *Views of Calcutta*, published there between 1786 and 1788 in aquatint, a process introduced in London by Paul Sandby in 1775. Next, partly guided by William Hodges's *Select Views,* they went up-country, traveling by riverboat and land, visiting and sketching many monuments. After reaching Garhwal, in the Punjab Hills, they returned to Calcutta in autumn of 1791. A second tour, to south, begun April, 1792, took them to Mysore and ended in Madras in February, 1793. They returned to England in 1794, spent next thirteen years "translating" sketches into plates for *Oriental Scenery,* issued in six parts between 1795 and 1808. Together, they also published a reduced edition of *Oriental Scenery* (1812-16), *The Taje Mahal at Agra* (1801), and *A Picturesque Voyage to India by Way of China,* (London, 1801). Aided by H. Caunter's text, based on his own recollections, William Daniell made many illustrations for *The Oriental Annual* between 1834 and 1839. Both Daniells also painted numerous watercolors and oil paintings, specializing in Indian subjects.

1786-1793 Governor-general Lord Cornwallis assumes whole judicial as well as revenue administration of Bengal. British judges appointed, assisted when needed by learned Hindu and Muslim assessors. For forty years after 1793, administration of Bengal in hands of British officials.

A capable, orderly, and creative administrator, Cornwallis established a police service and Europeanized the army, in which all commissioned officers were British, though the proportion of English to Indian soldiers remained small. He also reorganized Company service into general and commercial branches, the former including revenue and judicial branches, the latter carrying on all European trade. The civil service had begun.

1780's Lord Cornwallis insisted that his guests dance as well as drink at parties. Previously "gentleman dancers were commonly too far gone in drink to venture upon any experiments demanding the preservation of the perpendicular."

1791 Sanskrit College, Banaras, founded by Jonathan Duncan, the British Resident there. (See no. 32)

1792 Sindhia controls Shah Alam II, Rajputs, and Jats. Dies in 1794.

1793 William Roxburgh (1751-1815) appointed first official superintendent of the Calcutta Botanic Gardens. Previously, he had come to Madras in 1776, was appointed assistant surgeon, was stationed at Samalkot in 1781, where he made collections of plants, and became Company's botanist in Carnatic. He sent home hundreds of botanical drawings made by Indian artists he had trained. Three hundred of them published in *Plants of the Coast of Coromandel,* issued by Company in 1795, 1802, and 1819. Left India in 1813. William Carey appointed in his place.

1795-1798 British fail to make good promises of military aid to Nizam of Hyderabad, who is defeated by Marathas at Kharda. French further strengthened at Hyderabad, until Wellesley convinces Nizam of good intentions. In 1798, treaty is signed: Nizam agrees to expel French officers, to receive and support six battalions of Company troops, and to accept a British Resident. Henceforth, even during Mutiny of 1857, Hyderabad allied to British. Most internal and external affairs in British hands. But only in 1926 does Hyderabad accept assertion of British paramountcy.

1799, 1800 Tanjore and Surat compelled to surrender administrative powers to Company by Wellesley.

1799-1803 Government House, Calcutta, built in Palladian style; so grand that it brought complaints from many quarters. George Annesley, Viscount Valentia, admired it during his Indian travels, and rose to its defence: "...remember that India is a country of splendour, or extravagance, and of outward appearances; that the Head of a Mighty Empire ought to conform himself to the prejudices of the country he rules over; and that the British, in particular, ought to emulate the splendid works of the Princes of the House of Timour, lest it should be supposed that we merit the reproach which our great rivals the French

have ever cast upon us, of being alone influenced by a sordid mercantile spirit. In short, I wish India to be ruled from a palace, not from a counting house; with the ideas of a prince, not those of a retail-dealer in muslins and indigo." (*Voyages and Travels*, pp. 235ff.; for his pictures, see no. 18)

Late 18th century The Nawab of Lucknow, Asaf-ad-daula, a great Muslim prince, enjoyed dressing up at times as a British admiral or as a Church of England clergyman. His English drayhorse so delighted him that he fed it on rich, succulent food, and the wretched animal became too fat to move.

Late 18th century "The one period of Anglo-Indian history which throws grave and unpardonable discredit on the English name," according to Sir Alfred Lyall.

ca. 1800 In Calcutta, it was no longer fashionable in Government House circles to profess interest in Persian poetry or Indian metaphysics. Such matters were now left to academics and eccentrics.

1800-1806 Although Wellesley sought stabilizing alliances in India due to Napoleonic crisis in Europe, death of Nana Fadnavis in 1800 brings fierce struggle of Daulat Rao Sindhia against Jaswant Rao Holkar for control of Marathas, with disrupting results for Company. When Holkar defeats Sindhia and puppet Peshwa, the latter seeks Wellesley's protection. Treaty of Bassein, 1802; Company allied with Peshwa. 6,000 troops to be stationed in Peshwa's territory, with 26 lakhs of rupees in revenues to support them.
 In 1803, Sindhia mobilizes 250,000 of his troops plus 40,000 French against Company. Company attacks on all fronts, with army of only 55,000. Arthur Wellesley (the future Duke of Wellington) wins in Deccan, Lord Lake takes Delhi and Agra. Marathas sue for peace, accept Resident (Mountstuart Elphinstone) at Sindhia's court.
 Holkar now attacks, defeating Monson south of Kotah in Rajputana. He advances on Delhi; indecisive battles against Ochterlony (see no. 46). Company directors upset by Wellesley's aggressive policies. He resigns, sails home. Cornwallis replaces him; dies at once. Sir George Barlow concludes peace with Marathas. Both Sindhia and Holkar regain most of their territories in 1806.

1801 British annex Carnatic and part of Oudh. Oudh compelled to conclude treaty surrendering rich lands in Rohilkhand and the Lower Doab; except to north, they are encircled by British. Previously (1799), Nawab had been forced to increase number of Company troops and amount of subsidy.

1801 The New Testament in Bengali, translated by William Carey, printed by his Mission Press at Serampore.

1801 Richard Wellesley (governor-general 1798-1805) started Fort William College, Calcutta, to train new arrivals ("griffins") before they were posted to the districts. But this was disallowed by the Company directors in London, who soon founded a college of their own, Haileybury, for the same purpose. There cadets were given preliminary training before proceeding to India. (Addiscombe was founded simultaneously to train military cadets.) Thus, India received a civil service which was disciplined and trained.

1801 East India Company founds its Library and Museum, London.

1802 Wellesley orders female infanticide to be suppressed as result of Baptist missionary William Carey's investigation of custom of throwing Hindu children to sharks at Saugor Island in Bengal.

1803 Lord Lake occupies Delhi. British become protectors of Emperor Shah Alam II, and accord him imperial status, addressing him as superior, while disregarding his wishes in all practical matters. British Resident now holds power beyond limits of Red Fort. (See nos. 43, 46)

1804 Marquis Wellesley, governor-general of Fort William, establishes Institution Promoting Natural History of India at Barrackpur, on grounds of governor-general's house, "for the collection and description of birds and animals."

1810 One Captain Williamson noted that "Europeans have little connection with natives of either religion," and in the same year, Mrs. Graham complained that "Every Briton [in Calcutta] appears to pride himself on being outrageously John Bull."

1813 Charter Act: Parliament declares its sovereignty over the Company's dominions. It also appoints a bishop of Calcutta, whose see includes all British dominions in India. An annual appropriation for education is also required.
 Such measures were sponsored by the "Evangelicals" led by Charles Grant whose high-minded views we quote: "We cannot avoid recognizing in the people of Hindostan a race of men lamentably degenerate and base; retaining but a feeble sense of moral obligation; yet obstinate in their disregard of what they know to be right."

1814-1816 Nepal War. Gurkhas (tribe of west Himalayas) conquered Katmandu Valley in 1768, built powerful state, pushed southward. By 1801 they were making inroads on Company dominions. Attacked Bhutwal in 1814. Company declared war, but campaign troublesome. Signed treaty same year. When Gurkhas refused to ratify it, David Ochterlony advanced within fifty miles of Katmandu, forced issue. Garhwal and Kumaon ceded; Gurkhas withdrew from Sikkim, received permanent Resident at Katmandu. English got sites for hill stations: Simla, Mussoorie, Almora, Ranikhet, and Naini Tal.

1814-1831 Company's Pilgrim Tax on Hindu shrines showed a profit of 99,000 pounds sterling, some of which was used to maintain temples.

1816-1818 Pindari wars. Pindaris (robber bands) plundered and ravaged Central India and Rajputana. British mobilized

113,000 men, 300 guns against them; drove them from Malwa across Chambal River, then hunted them down. One chief given estate; another slain by tigers. Most of the Pindaris mingled with population and became farmers.

1816-1818 Maratha Confederacy finally crushed, in third Maratha War. Company now the government in India. With arrival of Lord Hastings (see no. 41) Company's policy of neutrality reversed, replaced by one of paramountcy. Treaties forced on Marathas: with Peshwa, Baji Rao, who is pensioned off at Cawnpore; with Holkar at Indore; with Sindhia at Gwalior; with Bhonsla at Nagpur.

1817 Thomas Moore's *Lalla Rookh*, published in England gives a romantic view of the India he never visited.

1817-1823 British paramountcy over Rajputana, as result of Lord Hasting's policy "to hold the other states vassals in substance, if not in name." Establishment of defensive alliances for protection of the paramount government. In 1817, Kotah; in 1818, Mewar, Bundi, Kishangarh, Bikaner, Jaipur, Pratabgarh, Banswara, Dungarpur, and Jaisalmer; and in 1823, Sirohi. Political agents received; tribute often paid.

1818 Bombay, formerly hemmed in by Marathas, becoming a greater center.

1819 The first English house built at Simla, soon to become the hill station to which the most prestigious and powerful British retreated from the heat of the plains. It was a center of fashion, health resort, and hot weather capital. Lord Amherst, governor-general 1823-1828, moved the government there during the summer in 1827. Later in the century, Rudyard Kipling made it the setting of his satirical tales of adultery in the Raj.

1821 Clara Rainitz, wife of an interior decorator, describing herself as "of Cairo and Constantinople," sets up dental practice in Bombay. Among her self-proclaimed talents were "clearing the teeth and playing them up, extracting and fixing new ones."

1822 Signor Constantino Augusto establishes School of Art for Ladies in Bombay. He is "well-versed in the doctrine of the angles of animo-anatomic proportion, and peculiarly correct in his treatment of landscape with chaste colouring and perspective." Other favored activities in Bombay at this time were cricket, riding to the Bobbery Pack of Hounds, and picnics.

1823 General Committee of Public Instruction established to administer educational grants. A new college of Sanskrit studies set up. Ram Mohan Roy, Bengali reformer, wrote governor asking for Indian access to such fields as mathematics, natural philosophy, chemistry, anatomy, and other useful sciences. Request denied, despite general desire among Indians for European education.

1824 Dec. 30 Reginald Heber, D. D., lord bishop of Calcutta, visits the Red Fort, Delhi, to see Emperor Bahadur Shah II (see

no. 50). After pointing out that the fort is militarily weak, proof only against bows and arrows, he says "...as a kingly residence it is one of the noblest that I have seen. It far surpasses the Kremlin, but I do not think that, except in the durability of its materials, it equals Windsor." (*Narrative of a Journey*, vol. II, p. 298)

1824 Bishop Heber enumerates his entourage while traveling through Gujarat: "three elephants, above twenty camels, five horses, besides ponies for our principal servants, twenty-six servants, twenty-six bearers of burthens, fifteen clashees to pitch and remove tents, elephant and camel drivers, I believe thirteen...and a guard of eighteen irregular horse and forty-five Sepoys on foot." (*Narrative of a Journey*, vol. III, p. 344)

1825 Bishop Heber, writing from Malwa, in Central India, says that "...the general conduct of the lower order of Europeans in India is such, as to shew the absurdity of the system of free colonization...."

1825 Bishop Heber on moffusil (the interior): "Society, both civil and military, is less formal up the country than in Calcutta, and this plainness and cordiality of manners increases as we approach the northern and western frontier, where everything still remains, as they themselves call it, 'Camp Fashion.'" (*Narrative of a Journey*, vol. III, p. 335)

1827 King of Oudh's Sauce reaches London: "I looked in vain among the cruets [on the King of Oudh's table] for the King of Oude's Sauce, which delicacy I hear is boldly placarded for sale in the window of some noted pickler in London." Peter Mundy, p. 16

1827 Peter Mundy is approached by "an old coin seller, with certificates of character which he could not read, [one of which said] 'The bearer is a d----ed old rascal, kick him out of camp.'" Mundy, p. 23

1827 Sir Walter Scott publishes *The Surgeon's Daughter*, a parable of British rule in India combining romanticism and cupidity.

1829 W. Sleeman appointed by Lord William Bentinck to investigate and destroy *thuggee*. (A thug is "a robber and assassin of a peculiar class, who sallying forth in a gang...and in the character of wayfarers, either on business or pilgrimage, fall in with other travellers on the road, and having gained their confidence, take a favourable opportunity of strangling them by throwing their handkerchiefs round their necks, and then plundering them and burying their bodies." *Hobson-Jobson*, p. 916) From 1831 to 1837, 3,000 thugs were convicted; 500 became informers. By 1860 this criminal practice had virtually disappeared.

1829 Suttee, the rite in which a widow burns on her husband's funeral pyre, declared illegal in Bengal Presidency. In 1830, it was prohibited in Madras. Nevertheless, the practice survived in the princely Rajput states of Rajasthan and the Punjab (see

no. 66). Occasional cases were reported as recently as 1932.

1829-1832 Colonel James Tod (1782-1839) publishes his classic *Annals and Antiquities of Rajasthan* in London. His father, also James Tod, was married in New York to Mary Heatly, prior to emigrating to India, where they became indigo planters at Mirzapur. Through the influence of his uncle, Patrick Heatly, James Tod the second obtained a cadetship in the East India Company. From 1812 to 1817, he made surveys between Central India and the Indus; and in 1818 he was appointed political agent of western Rajputana, a post he held until his retirement in 1822. During these years, he became friendly with the Rajput rulers of Mewar, Bundi, Kotah, and other states. Assisted by native pundits, he translated many historical documents which supplied much of the information for his *Annals.*

1830 First road built between Bombay and Poona by the government.

1832 Prohibition of sale of slaves between one administrative district and another. Although Parliament passed anti-slavery legislation in 1807, sale of children in Calcutta continued until 1843, when an act was passed prohibiting legal recognition of slavery in India. As there was no emancipation, slaves gradually drifted into other occupations.

1832 May Fanny Parks, whose very personal and lively account of India fills nearly one thousand pages in two volumes, enthused that "Allahabad is now one of the gayest, and is, as it has always been, one of the prettiest stations in India. We have dinner-parties, more than enough; balls occasionally; a book society; some five or six billiard tables; a pack of dogs, some amongst them hounds; and (how could I have forgotten) fourteen spinsters!" (*Wanderings,* vol. I, p. 238)

1833 Parliament declared Company's possessions as its own possessions and ordered Company to relinquish the China trade monopoly and the tea trade in India as well as to end all its commercial business. Indian Law Commission set up to survey existing police and legal system and report on ways India might obtain codified system of law and justice.

1833 First ice imported from North America, packed in sawdust; but only available at port of arrival.

1835 English language made language of instruction in higher education, inasmuch as the purpose of education is to disseminate Western knowledge. Formerly, education in India almost entirely religious.

1835 Charles Metcalfe (acting governor-general 1835-1836) makes English official language of India.

1835 Lord Macaulay's Education Minute proposes creation of an élite "Indian in blood and colour, but English in taste, morals, and intellect." In 1836 he forecast that in thirty years "there would not be a single idolator among the respectable classes of Bengal." However, in 1820 Bishop's College was

founded in Calcutta to create missionaries; and for twenty-five years there were never more than eleven scholars in attendance.

1835 Fanny Parks describes costume of Nawab Hakim Mehdi of Farrukhabad when he called upon her: "...his dress was most curious; half European, half Asiatic...brown corduroy breeches, with black leather boots, thick leather gloves; over this...a dress of fine flowered Dacca Muslin; and...over that, a dress of pale pink satin, embroidered in gold." (*Wanderings,* vol. II, p. 40)

1839 Tea Companies Act granted tax relief and free land to develop industry. Tea grew wild in Assam until 1820's. By 1855 one company alone grew 327,000 pounds of it. As tea drinking grew in popularity, dividends to investors grew from 5% to 35% between 1860 and 1865. Coolies, named after a tribe in Gujarat, worked in fields. At first, largely due to malaria and bad housing, one third died every six months.

1839 Calcutta to Delhi highway begun: "The Grand Trunk Road," over 1,000 miles. Others begun from Madras to Bombay (800 miles) and from Bombay to Agra (900 miles).

1840's Englishmen in India becoming more and more provincial in outlook. In Bombay, Lady Falkland, almost in despair for subjects of conversation, mentions to an officer "a great event which had lately taken place in Europe. He stared at me and said, 'I know nothing at all about it.'"

1840's Photography reaches India, and gradually gains in importance as a documentary and artistic medium. Painters at first ignore the new technique, then strive to outdo it (see no. 66). The camera won; and many descendants of artist families became photographers, while others concentrated on decorative wall paintings for weddings and other such work.

By the end of the century, a new breed of painter was emerging; aesthete-artists, inspired and trained by English equivalents at art schools in Bombay and Calcutta, whose work combined the traditional styles of Ajanta and Mughal and Rajput miniatures with Pre-Raphaelitism and a touch of Aubrey Beardsley. But their lives and work, along with those of artists who turned to India's folk traditions, and of a few inner-directed visionaries, belong to a later chapter, beyond the compass of this exhibition and book.

1845 17,360 pupils being educated at government expense in all parts of the British dominions in India; among them, 13,699 Hindus, 1,636 Muslims, and 236 Christians.

1852 At this time, there were 6,000 male Europeans, excluding the army, in India. The Company restricted European immigration.

1852 William Sleeman, in *A Journey Through the Kingdom of Oudh 1849-1850,* predicts the Mutiny of 1857. The excessively rare first edition was printed by Sleeman himself, on a "parlour press," in order to circulate a report which he considered vital to

British India. The second edition printed in London in 1858.

1853 The first railway was opened and the electric telegraph was introduced. In the same year, Landon, an American, built a cotton mill at Baroach.

 The railway had been proposed in 1844 but discouraged. By 1857, 300 miles of track had been laid. The first section in service, 120 miles, went from Raniganj to Calcutta. By 1867, the railway reached Delhi; and in 1873 the Rajputana State Railway connected Delhi with Bombay. (see no. 61 d)

1855 William Knighton publishes *The Private Life of an Eastern King*, in which are described the antics and vagaries of the Nawab of Oudh, Nasir-ud-din (r. 1827-1837), whose master of revels, favorite, and most powerful courtier was a European hairdresser. The Nawab's absurdities, cruelty, and childishness, as described by Knighton, in this "best-seller," shocked and delighted Victorian England.

 Fanny Parks, who visited his court, was more tolerant. She could not resist pointing out, however, that "The King has five queens, although by Mahummadan law he ought only to have four. His majesty of Oude possesses to a considerable extent, that peculiarly masculine faculty of retaining the *passion,* and changing the object." (*Wanderings*, vol. I, p. 193)

1857 The Mutiny. To some it was a war of liberation, to others a conservative reaction to the modernization resulting from British rule. In any event, the British had offended many Indians, including princes and landowners. A chief conspirator, Ahmad Ullah, had been adviser to Wajid 'Ali, the last Nawab of Oudh, whose state was annexed in 1856. Another was the Rani of Jhansi, whose state had been annexed in 1854; and yet another was Nana Sahib, whose ancestor the Peshwa (see entry for 1816-1818) had also been dethroned. Yet another cause was the widening separation between Europeans and Indians.

 Fearing conversion and caste pollution, the sepoys (native troops) of the Company army posed a threat. When in January, 1857 the "Brown Bess" rifle was replaced by the Enfield, which was loaded with a greased cartridge, the end of which had to be bitten off, a rumor spread that the grease was beef or hog fat, enough to contaminate either Hindus or Muslims.

 On February 26, in Bengal, a soldier of the 19th Native Infantry refused to use the Enfield. Although no British troops were present, the regiment was marched to Barrackpur, near Calcutta, and placed in irons. (At this time, out of 300,000 men in the army in India, 40,000 were Europeans.)

 On March 29, the imprisoned soldiers were released by comrades from three regiments, who shot their officers. The Mutineers then headed for Delhi, where they pursuaded the aged Mughal emperor, Bahadur Shah II (see no. 52) to become their leader.

 It is unnecessary to recount the rest of this gory history, although it must be pointed out that atrocities were carried out by both sides (see nos. 52, 53) and that the bitterness of 1857 took many years to dissipate.

 During the next decades, a militant mood prevailed among the Europeans, who showed slight respect for indigenous traditions. Rulers and communities that had remained loyal, however, were rewarded.

1857 In this year of the Mutiny, modern India's first three universities were founded. Among British-educated Indians, nationalism was growing.

1858 John Lawrence, a paternalist who served as viceroy from 1864 to 1869, stated the post-Mutiny mood aptly: "We have not been elected or placed in power by the people, but we are here through our moral superiority, by the force of circumstances, by the will of Providence. This alone constitutes our charter to govern India. In doing the best we can for the people, we are bound by our conscience, not by theirs."

1858 November 1. The Crown assumed the government of India. The governor-general now the viceroy. The Company's army was absorbed into the Royal Army. Queen Victoria's Proclamation was read throughout India: "Whereas, for divers weighty reasons, we have resolved, by and with the advice of the Lords Spiritual and Temporal, and Commons, in Parliament assembled, to take upon ourselves the government of the territories in India, heretofore administered in trust for us by the Honourable East India Company...."

1860's Palanquins no longer popular; replaced by carriages, chariots, curricles, sociables, britzkas, and clarences. Social life increasingly Victorian.

1861 Indian Penal Code introduced.

1863 William Johnson of Bombay civil service publishes volume on Oriental Races and Tribes illustrated with photographs. Photographers replacing painters as recorders of picturesque as well as documentation.

1865 Famine in Orissa; others in South India (1876-1878) prompt Famine Code of 1883, after the publication of the Famine Commission report in 1880.

1870 Act passed enforcing registration of births and verification that girl children still alive.

1874-1877 Two Bengali sisters, Aru and Toru Dutt, write poems on Indian subjects in English.

1875 Aligarh College founded by Sayyid Ahmad Khan; Arya Samaj begun by Swami Dayananda.

1876 Famine Relief and Insurance Fund started.

1877 Indian civil service ever more difficult for Indians to join. Minimum age for examination is lowered from 21 to 19.

1877 Queen Victoria proclaimed Empress of India, which brings Indian States within British Empire; their princes and people now vassals of the British sovereign.

Lord Lytton (viceroy 1876-1880) concludes that government of India should seek support from at least one level of society and proposes that it be the aristocracy. The days of the Maharajas are in full swing.

Lord Lytton brings his French chef to Simla, along with his Italian confectioner, Peliti, who stays on to open the Grand Hotel.

1887 Jamshed Tata, the Parsi industrialist, opens the Empress Cotton Mill at Nagpur. In 1907, the Tata Iron and Steel Company is founded.

1901 Words of an Englishman in India: "Here we stand on the face of the broad earth, a scanty pale-faced band in the midst of three hundred millions of unfriendly vassals." (F. H. Skrine, *Life of Sir W. W. Hunter* [London, 1901], p. 68)

1903 An experimental agricultural college, the Pusa Research Institute of Bihar founded, with help of £30,000 donation from Mr. Henry Phipps of Chicago.

1904 A. C. Wilson writes in *Hints for the First Year's Residence in India* (London, 1904, p. 36): "Never let any servant enter your presence coatless or *en deshabile,* or when in full toilette, carrying a duster as a badge of office. Discourage any effort on his part to wear one end of his turban down his back. He should never wait on table without wearing his kamarband. Trifling as these offences are, they indicate a want of respect. No one understands better than the Indian the maintenance or loss of prestige."

1911 The Coronation Darbar ("a court or levée") of King George V, the first and last British monarch to be crowned in India. The festivities lasted ten days. Twenty thousand workers prepared the sight in Delhi. There were 233 camps spread over 25 square miles. The king's occupied 85 acres, with red roads, green lawns, and imported English roses.

1947 March. Earl Mountbatten of Burma, great-grandson of Queen Victoria, becomes last viceroy of India, in order to bring about the transfer of power. On August 15 of the same year, India and Pakistan gain independence.

Selected Bibliography

Historical Works

Primary sources including memoirs, journals, letters, etc.

Abu Talib. *History of Asafu'd-Daulah* (Tafzihu'l Ghafilin). Translated by W. Hoey. 1885, reprinted Lucknow, 1971.

Annesley, George (Lord Valentia). *Voyages and Travels to India, Ceylon, The Red Sea, Abyssinia and Egypt in the Years 1802-1806.* London, 1809.

Baden-Powell, Robert. *Pig-sticking or Hog-hunting; a Complete Account for Sportsmen and Others.* London, 1924.

Barr, W. *Journal of a March from Delhi to Peshawur and from Thence to Cabul, Including Travels in the Punjab.* London, 1844.

Buchanan, Francis H. *Journal of Francis Buchanan Kept during the Survey of the Districts of Patna and Gaya in 1811-1812.* Edited by V. H. Jackson. Patna, 1925.

Burton, Richard F. *Sindh and the Races that Inhabit the Valley of the Indus.* 1851, reprinted Karachi, 1973.

Devi, Gayatri, and Rau, Santha Rama. *A Princess Remembers: The Memoirs of the Maharani of Jaipur.* Philadelphia and New York, 1976.

Dufferin and Ava, Hariot Georgina Hamilton-Temple-Blackwood. *Our Viceregal Life in India.* 2 vols. London, 1893.

Eden, Emily. *Up the Country: Letters Written to Her Sister from the Upper Provinces of India.* Edited by E. J. Thompson. Oxford, 1930.

Fay, Eliza. *Original Letters from India (1779-1815).* Edited by E. M. Forster. New York, 1925.

Fayer, J. *Notes on the Visits to India of their R. H. The Prince of Wales and the Duke of Edinburgh, 1870-1876.* London, 1879 (privately circulated).

Forbes, James. *Oriental Memoirs.* London 1913.

Germon, Maria. *Journal of the Siege of Lucknow.* Edited by Michael Edwardes. London, n.d.

Graham, Maria (Lady Callcott). *Journal of a Residence in India.* Edinburgh, 1812.

Graham, Maria. *Letters on India.* London, 1814.

Heber, Reginald. *Narrative of a Journey through the Upper Provinces of India, from Calcutta to Bombay, 1824-1825,* 2nd ed. London, 1828.

Hickey, William. *Memoirs of William Hickey, 1749-1809.* Edited by Alfred Spencer. 4 vols. London, 1913-1925.

Hickey, William. *Memoirs.* Edited and de-bowdlerized by Peter Quennell under the title *The Prodigal Rake,* New York, 1962.

Knighton, William, *The Private Life of an Eastern King.* London, 1856.

Locke, John Courtenay, ed. *The First Englishmen in India.* London, 1930.

Lucas, Samuel. *Dacoitee in Excelsis or the Spoilation of Oude by the East India Company.* London, 1857.

Mundy, Godfrey C. *Journal of a Tour in India.* 3rd ed. London, 1858.

Nawaz Khan, Nawab Samsam al-Daulah Shah. *The Maathir-ul-umara; Being Biographies of the Muhammadan and Hindu Officers of the Timurid Sovereigns....* Translated by H. Beveridge. Calcutta, 1911-52.

Newby, Eric. *Slowly Down the Ganges.* London, 1966.

Osborne, William G. *The Court & Camp of Runjeet Sing.* London, 1840.

Panter-Downes, Mollie. *Ooty Preserved: A Victorian Hill Station.* London, 1967.

Parks, Fanny. *The Wanderings of a Pilgrim in Search of the Picturesque during Four-and-Twenty Years in the East.* 1850, Reprinted Lahore, 1975.

Polier, Antoine Louis. *Shah Alam II and His Court.* Edited by P.C. Gupta. Calcutta, 1947.

Roberts, Emma. *Scenes and Characteristics of Hindostan with Sketches of Anglo-Indian Society.* 3 vols. n.p., n.d.

Roe, Thomas. *The Embassy of Sir Thomas Roe to India, 1615-1619.* Edited by William Foster. London and New York, 1926.

Rousselet, Louis. *India and its Native Princes.* London, 1882.

Russell, William H. *My Indian Mutiny Diary.* Edited by Michael Edwardes. London, 1957.

Russell, William H. *The Prince of Wales' Tour: A Diary in India.* London, 1877.

Sita Ram Pandey. *From Sepoy to Subedar.* Translated by James Norgate, 1873, edited

by James D. Lunt, London, 1970, reprinted Delhi, Bombay, and Bangalore, 1973.

Sleeman, William H. *A Journey through the Kingdom of Oudh in 1849-1850.* 2 vols. London, 1858.

Sleeman, William H. *Rambles and Recollections of an Indian Official.* 2 vols. London, 1844.

Tod, James. *Annals and Antiquities of Rajasthan.* 2 vols. London, 1829-32.

Vigne, Godfrey T. *A Personal Narrative of a Visit to Ghuzni, Kabul, and Afghanistan.* London, 1840.

Wellesley, R.C., and Dundas, Henry. *Two Views of British India.* ed. E. Ingrams. London, 1969.

Wheeler, James T., ed. *Early Travels in India, 16th and 17th Centuries.* Delhi, 1975.

Yeats-Brown, Francis. *The Lives of a Bengal Lancer.* New York, 1930.

Secondary Sources including Historical Essays and Popular History

Ayyar, K.V. Krishna. *The Zamorins of Calicut.* Calicut, 1938.

Banerji, Brajendranath. *Begam Samru.* Calcutta, 1925.

Bearce, George D. *British Attitudes towards India, 1784-1858.* London and New York, 1961.

Bellasis, Margaret. *Honourable Company.* London, 1953.

Bence-Jones, Mark. *Palaces of the Raj; Magnificence and Misery of the Lord Sahibs.* London, 1973.

Bhatnagar, G. D. *Awadh under Wajid Ali Shah.* Varanasi, 1968.

Burgess, James. *The Chronology of Modern India for Four Hundred Years from the Close of the Fifteenth Century.* Edinburgh, 1913.

Busteed, H. E. *Echoes from Old Calcutta.* 1882, reprinted Shannon, Ireland, 1972.

Chaudhuri, Nirad C. *The Continent of Circe.* Bombay, 1974.

Compton, Herbert, comp. *A Particular Account of the European Military Adventurers of Hindustan from 1784 to 1803.* London, 1892.

Cunningham, Joseph D. *A History of the Sikhs.* Edited by H.L.O. Garrett. Oxford, 1849.

Dodwell, Henry H., ed. *The Cambridge History of India,* vol. V: *British India.* Delhi, n.d.

Duff, James Grant. *A History of the Mahrattas.* Edited by J.P. Guha. Delhi, 1971.

Edwardes, Allen. *The Rape of India: A Biography of Clive and a Sexual History of the Conquest of Hindustan.* New York, 1966.

Edwardes, Michael. *Bound to Exile: The Victorians in India.* London, 1969.

Edwardes, Michael. *British India 1772-1947.* London, 1967.

Edwardes, Michael. *Glorious Sahibs: The Romantic as Empire-Builder, 1799-1838.* London, 1968.

Edwardes, Michael. *The Last Years of British India.* London, 1963.

Edwardes, Michael. *Plassey: The Founding of an Empire.* New York, 1970.

Foster, William. *John Company.* London, 1926.

Francklin, W. *The History of the Reign of Shah-Aulum.* 1798, reprinted Lucknow, n.d.

Garrett, H.L.O., and Grey, C. *European Adventurers of Northern India, 1785 to 1849.* Lahore, 1929.

Golant, William. *The Long Afternoon: British India 1601-1947.* London, 1975.

Golish, Vitold de. *Splendeurs et Crépuscules des Maharajas.* Paris, 1963.

Hambly, Gavin. *Cities of Mughal India: Delhi, Agra, and Fatehpur Sikri.* Photographs by Wim Swaan. New York, 1968.

Hearn, Gordon R. *The Seven Cities of Delhi.* Delhi, 1974.

Holman, Dennis. *Sikander Sahib: The Life of Colonel James Skinner, 1778-1841.* London, 1961.

Irvine, William. *Later Mughals.* Edited by Jadunath Sarkar. 2 vols. Calcutta, 1922.

Ivory, James. *Autobiography of a Princess.* New York, 1975.

Keene, Henry G. *Hindustan under Free Lances, 1770-1820.* 1907, reprinted Shannon, Ireland, 1972.

Kincaid, Dennis. *British Social Life in India 1608-1937.* London, 1938.

Kincaid, Dennis. *The Grand Rebel: An Impression of Shivaji, Founder of the Maratha Empire.* London, 1937.

Kohli, Sita Ram. *Sunset of the Sikh Empire.* Edited by Khushwant Singh. Delhi, 1967.

Lach, Donald F. *Asia in the Making of Europe.* Vol. II: *A Century of Wonder, Book 1: The Visual Arts.* Chicago and London, 1970.

Maclagan, Edward D. *The Jesuits and the Great Mogul.* London, 1932.

Majumdar, R.C.; Raychaudhuri, H.C.; and Datta, Kalikinkar. *An Advanced History of India.* 3rd ed. London, 1953.

Malleson, George B. *An Historical Sketch of the Native States of India in Subsidary Alliance with the British Government,* London, 1875.

Malleson, George B. *An Historical Sketch of the Native States of India in Subsidary Alliance with the British Government.* London, 1875.

Malleson, George B. *The Indian Mutiny of 1857.* New York, 1891.

Mudford, Peter. *Birds of a Different Plumage: A Study of British-Indian Relations from Akbar to Curzon.* London, 1974.

Sardesai, G.S. *New History of the Marathas.* 3 vols. Bombay, 1946-48.

Sarkar, Jadunath. *The Fall of the Mughal Empire.* 4 vols. Calcutta, 1932-50.

Sarkar, Jadunath. *The History of Bengal.* Patna, 1973.

Sen, Surendra Nath. *Eighteen Fifty-Seven.* Delhi, 1957.

Sharar, Abdul Halim. *Lucknow: The Last Phase of an Oriental Culture.* London, 1975.

Singh, Karni. *The Relations of the House of Bikaner with the Central Powers.* Delhi, 1975.

Singh, Khushwant. *Ranjit Singh, Maharajah of the Punjab.* London, 1962.

Singh, Khushwant. *Ranjit Singh, Maharaja of the Punjab 1780-1839.* London, 1962.

Smith, Vincent A. *The Oxford History of India.* 3rd ed. Edited by Percival Spear. Oxford, 1958.

Spear, Percival. *India: A Modern History.* Ann Arbor, 1961.

Spear, Percival. *Master of Bengal: Clive and His India.* London, 1975.

Spear, Percival. *The Nabobs: A Study of the Social Life of the English in Eighteenth-Century India.* Rev. ed. Oxford, 1963.

Spear, Percival. *Twilight of the Mughuls: Studies in Late Mughul Delhi.* Cambridge, 1951.

Srivastava, Ashirbadi Lal. *Shuja-ud-Daulah.* 2 vols. Lahore, 1945.

Stacton, David. *A Ride on the Tiger: The Curious Travels of Victor Jacquemont.* London, 1954.

Stanford, John K., ed. *Ladies in the Sun: The Memsahibs' India, 1790-1860.* London, 1962.

Wilkinson, Theon. *Two Monsoons.* London, 1976.

Woodruff, Philip. *The Men Who Ruled India.* Vol. I: *The Founders.* Vol. II: *The Guardians.* New York, 1954.

Literature, Novels, Poetry, and Belles Lettres

Ackerley, J. R. *Hindoo Holiday, an Indian Journal.* London, 1932.

Ali, Ahmed, ed. and trans. *The Golden Tradition: An Anthology of Urdu Poetry.* New York and London, 1973.

Forster, E. M. *The Hill of Devi.* New York, 1953.

Forster, E. M. *A Passage to India.* London, 1924.

Khosla, G. D. *The Last Mughal.* (A novel). Delhi, n.d.

Prichard, Iltudus. *Chronicles of Budgepore.* Edited by F. G. Hutchins. Reprinted Delhi, 1972.

Russell, Ralph, and Islam, Khurshidul. *Ghalib, Life and Letters.* Cambridge, Mass., 1969.

Russell, Ralph, and Islam, Khurshidul. *Three Mughal Poets: Mir, Sauda, Mir Hasan.* Cambridge, Mass., 1968.

Ruswa, Mirza; Singh, Khushwant; and Husaini, M. A., eds. *The Courtesan of Lucknow.* Delhi, 1961.

Taylor, Philip M. *Confessions of a Thug.* London, 1839.

Art and Architecture

Aijazuddin, F. S. *Pahari Paintings and Sikh Portraits in the Lahore Museum.* London, New York, Karachi, and Delhi, 1977.

Archer, Mildred. "Arthur William Devis: Portrait Painter in India (1785-95)." *Art at Auction 1971-72,* pp. 80-83. London, 1972.

Archer, Mildred. *Artist Adventurers in Eighteenth-Century India: Thomas and William Daniell.* London, 1974.

Archer, Mildred. "An Artist Engineer—Colonel Robert Smith in India (1805-1830)." *The Connoisseur* (February, 1972), pp. 78-88.

Archer, Mildred. "Aspects of Classicism in India: Georgian Buildings of Calcutta." *Country Life* (3 November 1966), pp. 1142-1146.

Archer, Mildred. "Baltazard Solvyns and the Indian Picturesque." *The Connoisseur* (January, 1969), pp. 12-18.

Archer, Mildred. "Benares and the British." *History Today* (June, 1969), pp. 405-410.

Archer, Mildred. *British Drawings in the India Office Library.* 2 vols. London, 1969.

Archer, Mildred. "British Painters of the Indian Scene." (Sir George Birdwood Memorial Lecture). *Journal of the Royal Society of Arts* 115 (1967), pp. 863-879.

Archer, Mildred. "British Painting In India." *Europe and the Indies: The Era of the Companies, 1600-1824.* London, 1970, pp. 28-32.

Archer, Mildred. "British Patrons of Indian Artists: Sir Elijah and Lady Impey." *Country Life* (18 August 1955), pp. 340-341.

Archer, Mildred. "'Company' Architects and Their Influence in India." *The Journal of the Royal Institute of British Architects* (August, 1963), pp. 317-321.

Archer, Mildred. *Company Drawings in the India Office Library.* London, 1972.

Archer, Mildred. "Company Painting in South India: The Early Collections of Niccolao Manucci." *Apollo* (August, 1970), pp. 104-113.

Archer, Mildred. *The Daniells in India, 1786-1793.* Washington, D. C., 1962.

Archer, Mildred. "The East India Company and British Art" *Apollo* (November, 1965), pp. 401-409.

Archer, Mildred. "Gardens of Delight." *Apollo* (September, 1968), pp. 172-184.

Archer, Mildred. "A Georgian Palace in India: Government House, Calcutta." *Country Life* (9 April 1959), pp. 754-755.

Archer, Mildred. "Georgian Splendour in South India." *Country Life* (26 March 1964), pp. 728-731.

Archer, Mildred. "Hunting with Cheetahs." *The Geographical Magazine* (March, 1960), pp. 485-492.

Archer, Mildred. "India and Archaeology: The Role of the East India Company, 1785-1858." *History Today* (April, 1962), pp. 272-279.

Archer, Mildred. "India and Natural History: The Role of the East India Company, 1785-

1858." *History Today* (November, 1959), pp.736-743.

Archer, Mildred. *Indian Architecture and the British.* London, 1968.

Archer, Mildred. "Indian Mica Paintings." *Country Life* (16 February 1956), pp.298-299.

Archer, Mildred. *Indian Miniatures and Folk Paintings.* London, 1967.

Archer, Mildred. "Indian Paintings for British Naturalists." *The Geographical Magazine* (September, 1955), pp.220-230.

Archer, Mildred. *Indian Paintings from Court, Town, and Village.* London, 1970.

Archer, Mildred. "Madras's Debt to a Father and Son: The Work of John and Justinian Gantz." *Country Life* (17/24 December 1970), pp. 1191-1193.

Archer, Mildred. *Natural History Drawings in the India Office Library.* London, 1962.

Archer, Mildred. *Patna Painting.* London, 1947.

Archer, Mildred. "The Social History of the Nautch Girl." *The Saturday Book* (1962), pp. 242-254.

Archer, Mildred. "The Talented Baronet: Sir Charles D'Oyly and His Drawings of India." *The Connoisseur* (November, 1970), pp. 173-181.

Archer, Mildred. "Tilly Kettle and the Court of Oudh." *Apollo* (February, 1972), pp. 96-106.

Archer, Mildred. *Tippoo's Tiger.* London, 1959.

Archer, Mildred. "The Two Worlds of Colonel Skinner." *History Today* (September, 1960), pp. 608-615.

Archer, Mildred. "Wellington and South India: Portraits by Thomas Hickey." *Apollo* (July, 1975), pp. 30-35.

Archer, Mildred and Archer, W.G. *Indian Painting for the British, 1770-1880.* Oxford, 1955.

Archer, W. G. *Bazaar Paintings of Calcutta.* London, 1953.

Archer, W. G. *A Concise History of Pahari Painting.* Bombay, 1975.

Archer, W. G. *India and Modern Art.* London, 1959.

Archer, W. G. *Indian Miniatures.* London and New York, 1960.

Archer, W. G. *Indian Painting in Bundi and Kotah.* London, 1959.

Archer, W. G. *Indian Painting in the Punjab Hills.* London, 1952.

Archer, W. G. *Indian Paintings from the Punjab Hills.* 2 vols. London, New York, and Delhi, 1973.

Archer, W. G. *Kalighat Drawings.* Bombay, 1962.

Archer, W. G. *Kalighat Paintings.* London, 1971.

Archer, W. G. *Paintings of the Sikhs.* London, 1966.

Archer, W. G. *Visions of Courtly India.* London, New York, Delhi, and Karachi, 1976.

Archer, W. G., and Binney, Edwin, 3rd. *Rajput Miniatures from the Collection of Edwin Binney, 3rd.* Portland, Ore., 1968.

Ashton, Leigh, ed. *The Art of India and Pakistan.* London, 1950.

Beach, Milo Cleveland. "The Gulshan Album and Its European Sources." *Bulletin of the Museum of Fine Arts,* Boston, no. 332 (1965), pp. 62-91.

Beach, Milo Cleveland. "The Mughal Painter Kesu Das." *Archives of Asian Art* 30 (1976-77), pp. 34-52.

Beach, Milo Cleveland. *Rajput Painting at Bundi and Kota.* Ascona, 1974.

Binney, Edwin, 3rd. *Indian Miniature Painting from the Collection of Edwin Binney, 3rd.* Portland, Oregon, 1973.

Brown, Percy. *Indian Architecture.* Vol. II: *The Islamic Period.* Bombay, 1942.

Brown, Percy. *Indian Painting under the Mughals.* Oxford, 1924.

Chandra, Moti. *The Technique of Mughal Painting.* Lucknow, 1949

Cohn, Marjorie. *Wash and Gouache.* Cambridge, Mass., 1977.

Dickinson, E., and Khandalavala, K. *Kishangarh Painting.* Delhi, 1959.

Edwardes, Michael, et al. *The British in India.* (Catalogue of an exhibition at Brighton Pavilion, May-August, 1973.) Ditchling, Hassocks, Sussex, 1973.

Eyre, Giles. *Company Paintings, India 19th Century.* London, 1974.

Eyre, Giles. *Indian Painting for the British, 1770-1880.* London, 1972.

Irwin, John C., ed. *Art and the East India Company*. London, 1970.

Loan Exhibition of Antiquities, Coronation Durbar. Calcutta, n.d.

Maggs Bros. Ltd. *Oriental Miniatures and Illuminations Bulletin* nos. 1-27 (December, 1962-June, 1977).

Mehta, N. C. *Studies in Indian Painting*. Bombay, 1926.

Nilsson, Sten. *European Architecture in India, 1750-1850*. New York, 1968.

Ray, N. R. *A Descriptive Catalogue of the Daniells Work in the Victoria Memorial*. Calcutta, n.d.

Skelton, Robert. "Murshidabad Painting." *Marg* 10, no. 1, pp. 10-22.

Skelton, Robert, *Rajasthani Temple Hangings of the Krishna Cult*. New York, 1973.

Stchoukine, Ivan. *La Peinture Indienne à l'Epoque des Grands Moghols*. Paris, 1929.

Sutton, Thomas. *The Daniells, Artists and Travelers*. London, 1954.

Webster, Mary. *Johann Zoffany*. London, 1976.

Welch, Stuart Cary. *The Art of Mughal India*. New York, 1963.

Welch, Stuart Cary. *Imperial Mughal Painting*. New York, 1978.

Welch, Stuart Cary. *Indian Drawings and Painted Sketches*. New York, 1976.

Welch, Stuart Cary, and Bearce, G. D. *Painting in British India, 1757-1857*. Brunswick, Maine, 1963.

Welch, Stuart Cary, and Zebrowski, Mark. *A Flower from Every Meadow*. New York, 1964.

Color plate and photographic Books

Atkinson, George F. *"Curry & Rice," on Forty Plates: or, The Ingredients of Social Life at "Our Station" in India*. London, n.d.

Barron, Richard. *Views in India, Chiefly among the Neelgherry Hills*. London, 1837

Bourne, Samuel, and Shepherd, Charles. *Royal Photographic Album of Scenes and Personages Connected with the Progress of H.R.H. The Prince of Wales*. Calcutta, Bombay, and Simla, 1876.

Cameron, Roderick. *Shadows from India; an Architectural Album*. London, 1958.

Hendley, Thomas H. *The Rulers of India and the Chiefs of Rajputana*. London, 1897.

Singh, Raghubir, and Lelyveld, Joseph. *Calcutta*. Hong Kong, 1975.

Worswick, Clark, and Embree, Ainslie. *The Last Empire: Photography in British India, 1855-1911*. Millerton, New York, 1976.

Miscellaneous

Archer, W. G. *The Hill of Flutes: Life, Love and Poetry in Tribal India, A Portrait of the Santals*. London, 1974.

Bombay Presidency. *Gazetteer of the Bombay Presidency*. Vol. 18, part 1. Bombay, 1885.

Crooke, William. *The Tribes and Castes of the Northwestern Provinces and Oudh*. 4 vols. 1896, reprinted Delhi, 1974.

Cumming, John G., and Williams, L.F.R., eds. *Murray's Guide to India, Pakistan, Burma and Ceylon*. London, 1924.

de Bary, William T., et al. comps. *Sources of Indian Tradition*. New York, 1958.

Douie, James McC. *The Panjab, Northvest Frontier Province, and Kashmir*. Cambridge, 1916.

Dubois, J. A. *Hindu Manners, Customs, and Ceremonies*. 1816, reprinted Oxford, 1953.

Enthoven, R.E. *The Tribes and Castes of Bombay*. 1920, reprinted Delhi, 1975.

The Gazetteer of India. Vol. I: *The Country and People*. Delhi, 1973.

Hamilton, Walter. *A Geographical, Statistical, and Historical Description of Hindostan*. 2 vols. 1820, reprinted Delhi, 1971.

Ja'far Sharif. *Islam in India, or The Qanun-i-Islam*. Translated by G. A. Herklots. 1921, reprinted Delhi, 1972.

Meer Hassan 'Ali, Mrs. *Observations on the Mussulmauns of India*. 1832, reprinted Karachi, 1974.

Oman, John C. *The Mystics, Ascetics, and Saints of India*. 1903, reprinted Delhi, 1973.

Phillips, C. H., ed. *Handbook of Oriental History*. London, 1961.

Prater, S. H. *The Book of Indian Animals*. Bombay, 1965.

Russell, Robert V. *The Tribes and Castes of the Central Provinces of India*. 4 vols. London, 1916.

Thurston, Edgar. *Castes and Tribes of Southern India*. 8 vols. Madras, 1909.

Thurston, Edgar. *Ethnographic Notes in Southern India*. 2 parts. 1906, reprinted Delhi, 1975.

Whistler, Hugo. *Popular Handbook of Indian Birds*. London, 1928.

Yule, Henry, and Burnell, A. C. *Hobson-Jobson: A Glossary of Colloquial Anglo-Indian Words and Phrases*. 1903, reprinted New York, 1968.

WILL